FIND YOUR FLOW

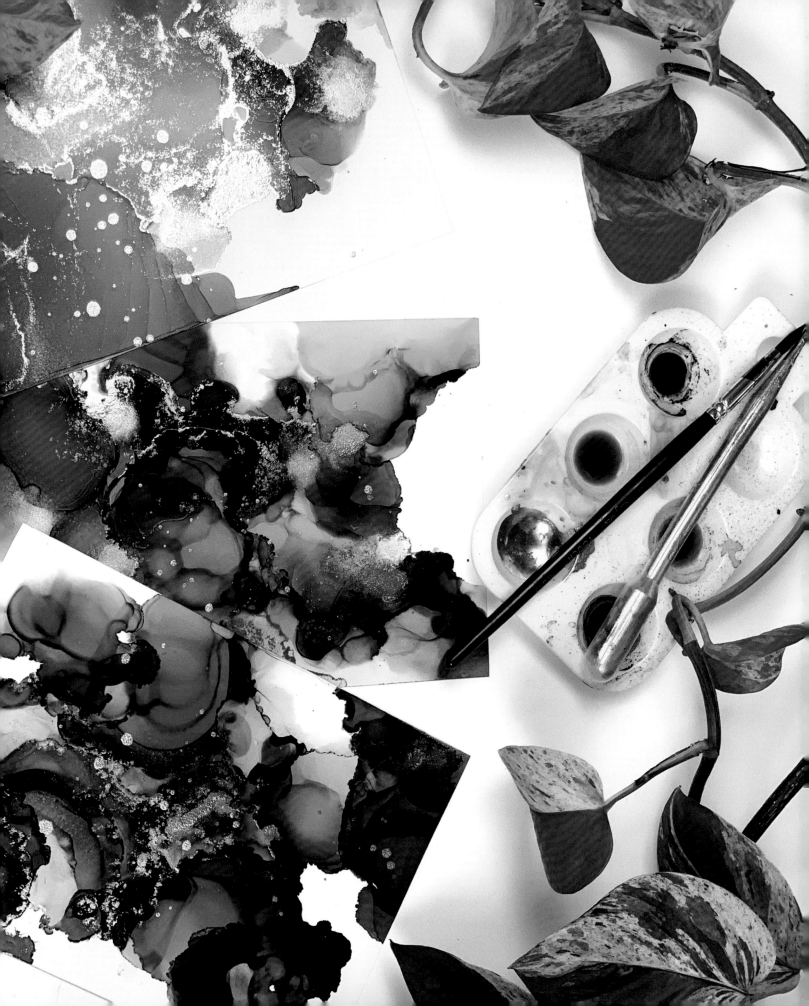

ART FROM ☾ THE HEART

FIND
YOUR
FLOW

A BEGINNER'S GUIDE TO
UNLOCKING CREATIVITY
THROUGH INTUITIVE
FLUID ART
with alcohol ink & more

Jessica Young

M.Ed, LMHC

Find Your Flow © 2023
by Jessica Young and Better Day Books, Inc.

Publisher: Peg Couch
Book Designer: Llara Pazdan
Cover Designer: Ashlee Wadeson
Photographer: Jessica Young
Editor: Colleen Dorsey

Library of Congress Control Number: 2023932535

ISBN: 978-0-7643-6712-0
Printed in China
10 9 8 7 6 5 4 3 2 1

Copublished by Better Day Books, Inc., and Schiffer Publishing, Ltd.

BETTER DAY BOOKS®

Better Day Books
P.O. Box 21462
York, PA 17402
Phone: 717-487-5523
Email: hello@betterdaybooks.com
www.betterdaybooks.com
@ @better_day_books

Schiffer Publishing
4880 Lower Valley Road
Atglen, PA 19310
Phone: 610-593-1777
Fax: 610-593-2002
Email: info@schifferbooks.com
www.schifferbooks.com

This title is available for promotional or commercial use, including special editions. Contact info@schifferbooks.com for more information.

DEDICATION

To the inner child and artist residing within the depths of our souls, as well as to my incredible husband and partner, whose unwavering support and endless inspiration light up my creative path. This book is dedicated to the beautiful synergy between love, artistry, and the boundless potential that lies within each of us.

CONTENTS

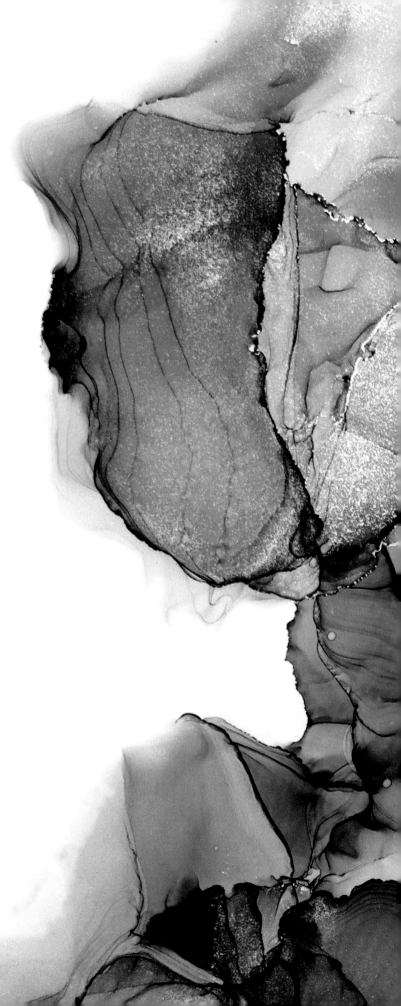

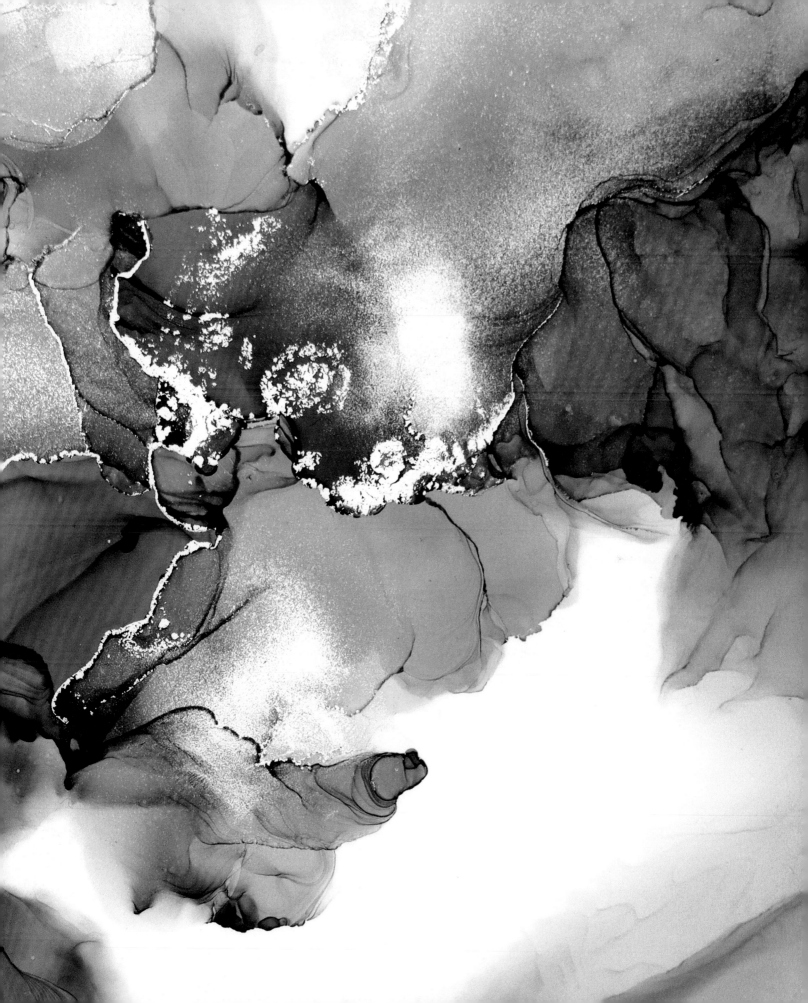

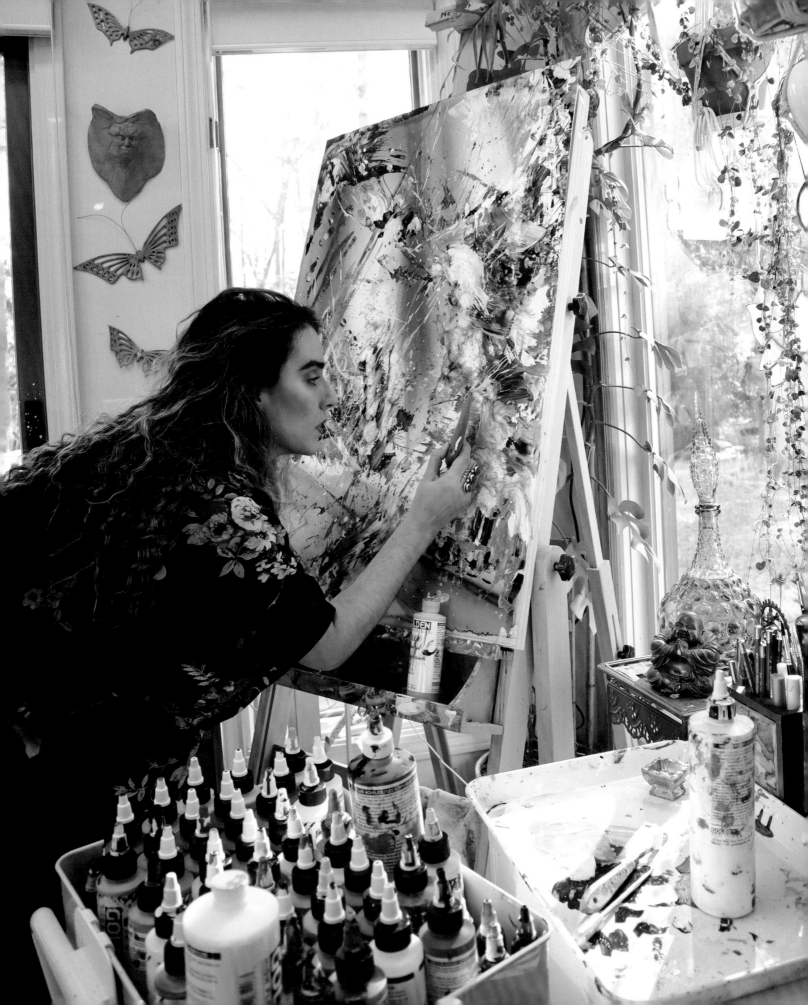

WELCOME

I am so glad you're here. If you're reading this book, you are likely intrigued by the idea of creating fluid artwork and curious about how to tap into your own artistic flow.

This book is dedicated to helping you discover your innate creative abilities and find healing through fluid abstract painting techniques. Whether you are an experienced artist or just starting out, you will find valuable insight and inspiration in these pages. If this book does nothing else but get you to consider creating as a means of processing and healing, I've done my job.

Creative flow is not some magical state that only a few chosen ones attain; flow is a state of being within all of us, accessible to all of us. Flow is about finding a space within ourselves, outside of the noise and chaos of day-to-day life. The process of creating fluid art through a state of flow is mesmerizing and therapeutic and is available to all ages and abilities. Fluid artwork is a fantastic foundational practice that helps build confidence in any other medium you may choose to pursue.

With fluid abstract painting, there is no limit to what you can create. The paint flows freely, creating dynamic and unique patterns and designs on the canvas. By embracing the fluidity of the art form, you can unleash your inner creative energy and allow it to flow freely, creating bold, beautiful works of art.

But with freedom comes the fear of the unknown, and it is extremely common for artists to face inner criticism or impostor syndrome during their creative process. This is where this book comes in. Throughout these pages, I provide practical guidance on how to cultivate confidence in your intuitive techniques. I believe that even the most critical inner voice can be tamed and nurtured through this artistic practice.

This book is ideal for those who crave a deeper connection to their art or who want to explore this unique method of painting to release their emotions. My hope is that you will be inspired by the benefits of fluid painting and the therapeutic healing aspects this art form has to offer. By embracing your intuition and trusting in your creative process, you can become the artist you are meant to be. Let's unleash the magic of fluid painting together and join in this revolution of creativity and healing art.

JYoung

MEET THE AUTHOR

Intuitive Painter, Author & Healing Practitioner

How did you first get into art? Have you always been creative?

I have always been creative, but art did not become a serious focus until the last six years or so. Growing up, dance, art, and creativity were a safe space for maintaining a sense of stability and agency in a chaotic environment. However, maintaining my GPA came front and center, and there was little time for creating outside of art class. Pursuing art never felt like a realistic path. Instead, I pursued straight A's, two higher education degrees, and a professional psychotherapy license—all of which severely burnt me out. After needing to take medical leave from my work, painting brought me back down to earth and back to life.

What inspires your artwork?

Emotions, healing, and the human psyche. Taking something abstract like an emotion and turning it into tangible artwork is such a liberating feeling that is hard to access through any channel other than art making.

You're also a therapist. Can you tell us about that part of your life and how being a therapist affects your art?

My work as a psychotherapist is what I am most proud of in terms of my accomplishments. The clients I've worked with over the last 15 years have made a profound impact on how I view the world and carry myself through it. My work with survivors of complex trauma becomes quite heavy, and, through art, I am able to process their stories and give anonymous imagery to the healing work we do.

What do you struggle with as an artist?

Comparison and feeling like I am not "good enough," i.e., imposter syndrome. Oh, and organization, big time!

What advice can you give readers who want to spend more time making art?

You can make your life art without ever picking up a paintbrush. You do not need a long window of time, an art studio, or fancy art supplies to create. Some of the biggest growth comes from the quickest sketches; it's the consistency and commitment to living a creative life that is the art.

What do you hope readers will get from this book?

The spark to create and the confidence to do so without the presence of shame.

What's next for you as an artist, as a therapist, or simply as a person?

Hopefully authoring more books and publishing more creative healing content! I will also be expanding my therapeutic retreat company @healingartretreats with new retreat locations and offerings.

Where can we learn more about you?

Find me at www.jessicayoungartist.com and www.jessicayounglmhc.com, as well as on Instagram/TikTok/Threads/Lemon8/YouTube: @jessicayoungart

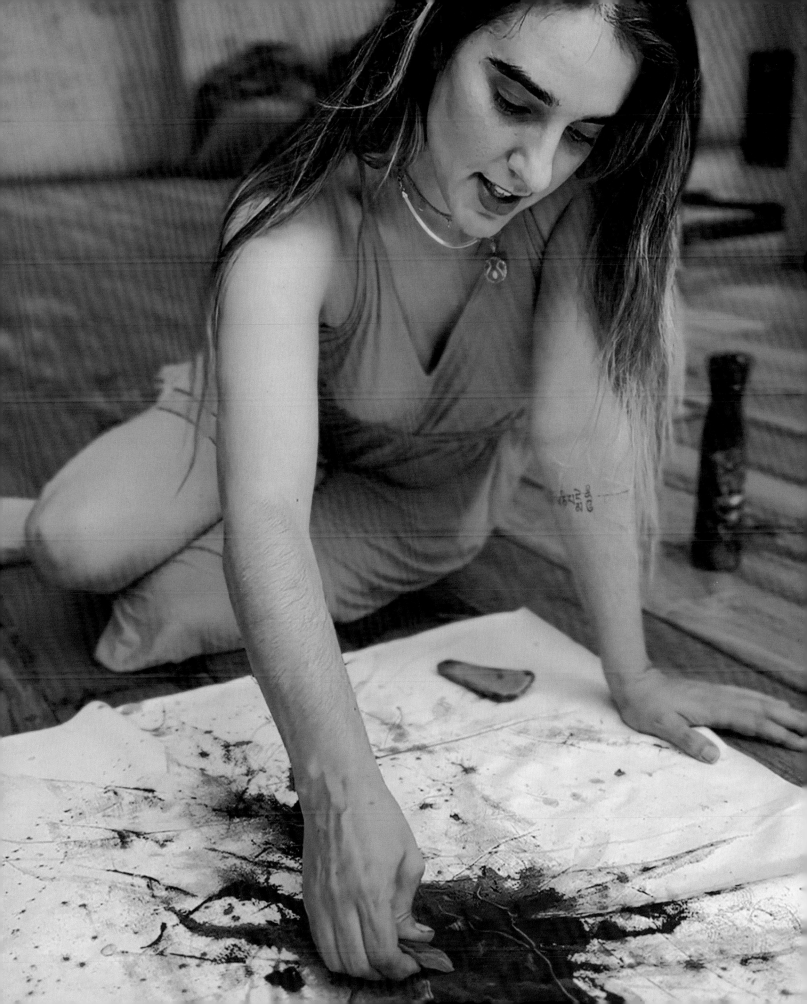

HOW TO USE THIS BOOK

This book is meant to serve as a road map for the beginning stages of finding your creative flow with fluid mediums. I strongly recommend starting with Chapter 1 and then choosing your own path through the book after that. I want this book to be a tool you can come back to over and over when you need a reminder of where you started on your creative journey and how to start again if you lose your way. The creative process can be frightening and messy, and my hope is that this book will give you insight into how to tap into a flow state that feels natural and familiar.

> I encourage you to keep a studio journal where you log your thoughts, questions, and reflections while working through this book. This can be a regular lined journal, a notebook, or a sketchbook. Throughout this book, I include prompts and ideas for your journal to get the ball rolling.

Chapter 1 provides the nuts and bolts of my approach to developing creative flow and sets the tone for successfully working through the rest of the exercises and projects. Use Chapter 1 as a checkpoint you can come back to when you're feeling creatively stuck or when you're struggling with a project. The questions and reflections in this chapter are not meant to be asked only once; the answers you provide will differ at every new point in your creative journey. Notice how your answers to the questions evolve over time; notice how *you* evolve.

Chapter 2 provides several basic techniques and exercises to get you familiar with the mediums used in the projects in Chapter 3. Use Chapter 2 as your warm-up and practice guide for basic techniques using alcohol inks and fluid/high-flow acrylics. Do not underestimate how important it is to revisit the basics, even once you no longer consider yourself a beginner!

Chapter 3 contains 10 step-by-step projects for you to explore as a means of expressing yourself. Each project is designed to help you flex your creative muscles and tap into your own unique flow state. At the start of each project, I provide an overview of the project theme and how it relates to accessing an intuitive creative flow. Alongside the step-by-step tutorials are lessons and affirmations to help you develop creative flow. It may be hard to fully tap into your creative flow when you're in the process of doing these projects for the first time, so be patient with yourself. I recommend utilizing your studio journal to log your thoughts and reflections as you start and complete each project. It can be incredibly rewarding to look back at how your approach to each project changes.

Refer to the materials list at the start of each project for a list of suggested materials, but do not feel limited to the materials or colors listed. My projects are meant only to serve as templates for *your* creative process and ideas. Feel free to reinterpret any project in your own unique way and substitute any materials you would like. This process is yours and yours alone; your work is not meant to look exactly like anyone else's. Fluid artwork is extremely hard to re-create exactly, so please remember that your piece should look like *yours*. If your work does not look like my work, then that just means you are developing your own unique style, which is the goal!

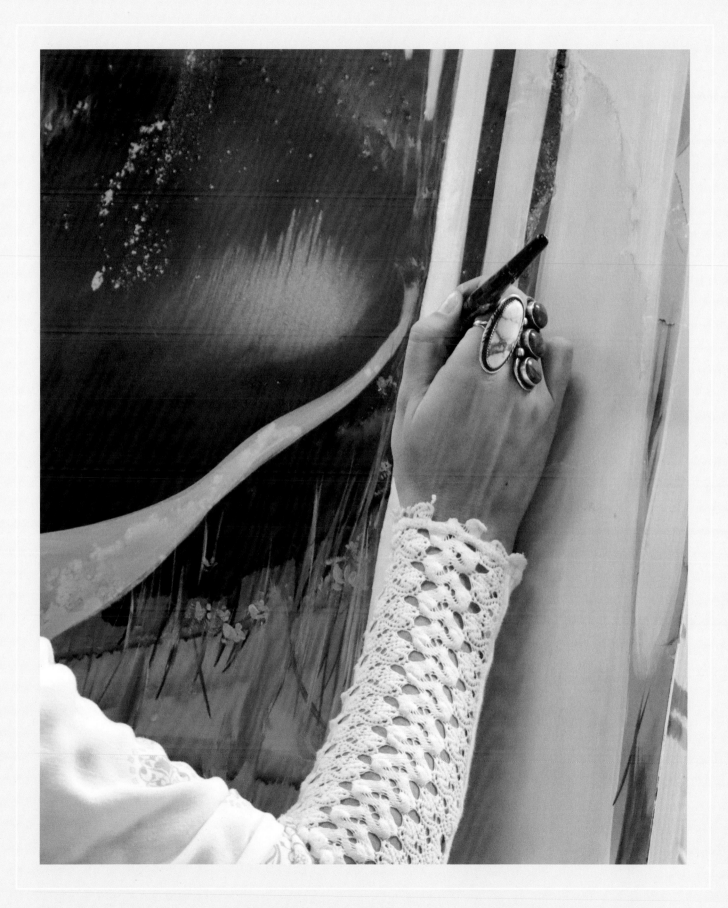

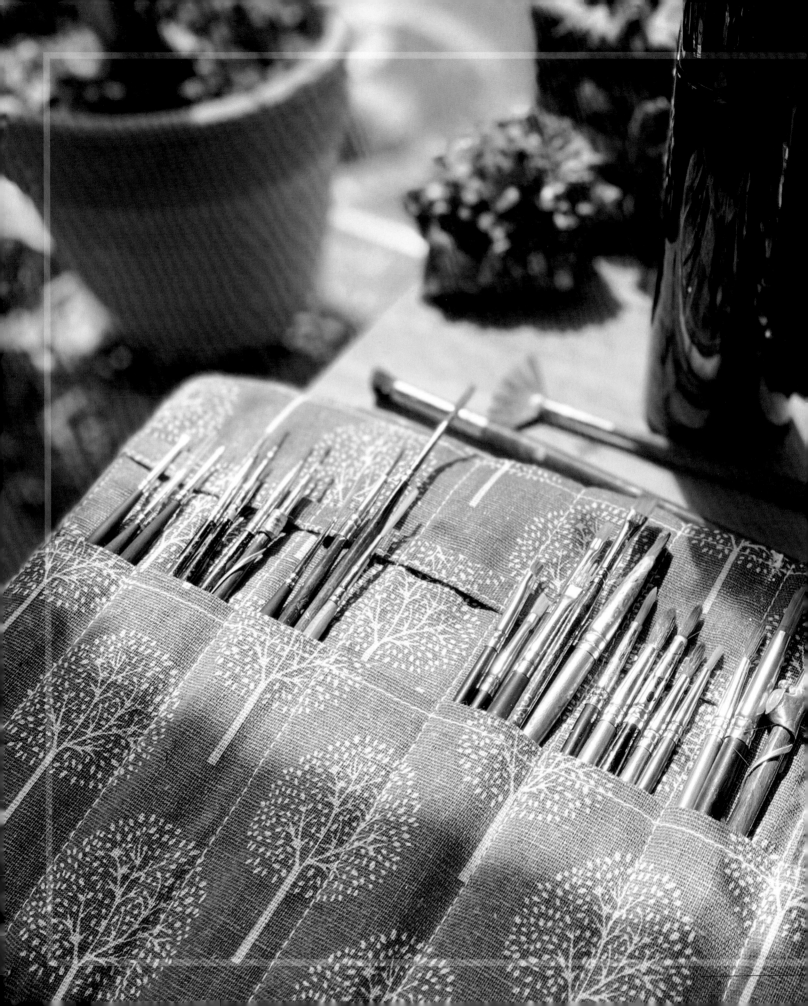

GETTING STARTED

It's time for us to dive into the fascinating world of fluid abstract expression! Before we start the creation process, let's explore some of the major themes that come up in the journey toward confidently expressing yourself creatively. As a psychotherapist who leads a double life as an artist, I find it hard to miss how much the creative struggle mirrors the human struggle. We are faced with our inner critic, impostor syndrome, self-doubt, and fear of failing. You will quickly learn that choosing a creative path is not always easy and colorful. Let this first chapter serve as a foundation for how you can mentally and emotionally prepare for the ups and the downs of the creative process.

It can be tempting to swan-dive right into creating, only to feel like you land with a poorly executed belly flop. But it's hard to learn to dive without a few flops along the way. This journey to finding a creative flow, especially with fluid mediums, is about learning to love your process no matter what the outcome. This chapter will help you consider how you show up to the creative process and tackle some of the hurdles before you get started. And, of course, we'll cover all the essential info about the tools and materials you'll use so that you're prepared practically as well as mentally!

THE INNER CRITIC & CREATIVE FLOW

Before we get started, I want to tell you how proud you should be of yourself for just showing up today to learn or create. Showing up can often be the hardest part of the creative process, especially when we tend to be our own worst critic. Does the voice in your head ever shout nonsense like "You're not an artist; you won't be able to do this" or "But you can't even draw a stick figure"? Maybe you have your own version of this voice, but throughout this book, we will refer to that voice as the "inner critic." Luckily for us, the inner critic is wrong most of the time, and we do *not* have to listen to it.

> While working on the exercises and projects in this book, be mindful of when your inner critic shows up, and *nicely* ask that voice to find a cozy place elsewhere. Instead of engaging this nagging part of yourself in a stressful inner dialogue, you can allow yourself to tap into something that is actually true: that you *are* an artist and you *can* do this.

Why does the inner critic show up during the creative process in the first place? It wants to keep you safe from failure. That not-so-trusting inner voice is doing what it thinks it needs to do to protect you from creating something disappointing or ugly. The inner critic wants us to believe that everything we create must be beautiful (and perfect) the first time, every time. But this is impossible; messing up is part of the process. I hold a strong and sometimes controversial opinion that

you must create disappointing or ugly artwork in order to grow as an artist. Ugly art is a necessary hurdle to the creative journey, and the sooner you learn to live with and accept ugly art as a gift to your creative process, the sooner you will create artwork you are proud of.

When we allow the inner critic to run the show, we often end up anxious or tense and either walk away from the creation process or end up not fully enjoying it. By treating the inner critic with kindness and compassion—rather than getting frustrated by it—we reinforce that we are the ones in control of our creative journey. We also reinforce how far a bit of compassion can go in breaking negative cycles—not just regarding our inner critic, but in so many ways in life. When we negatively engage with the inner critic, we end up fueling our nervous system and the anxiety we feel, which reinforces chaos rather than calm. Feeling in control of our creative journey makes showing up to create easier and more empowering day after day.

This is a process that many of us will need to confront many times before getting it right. You may have to face your inner critic over and over again as you approach your creative flow. In fact, it might even get louder once you start truly becoming aware of it. This does not mean you are doing anything wrong—this just means you are human. As with anything else, it is all about practice: do the task over and over until whatever you are practicing feels like second nature. Be patient with yourself and feel empowered by knowing that just by being aware of the inner critic, you are already well on your way to a creative flow that may have otherwise been out of your reach.

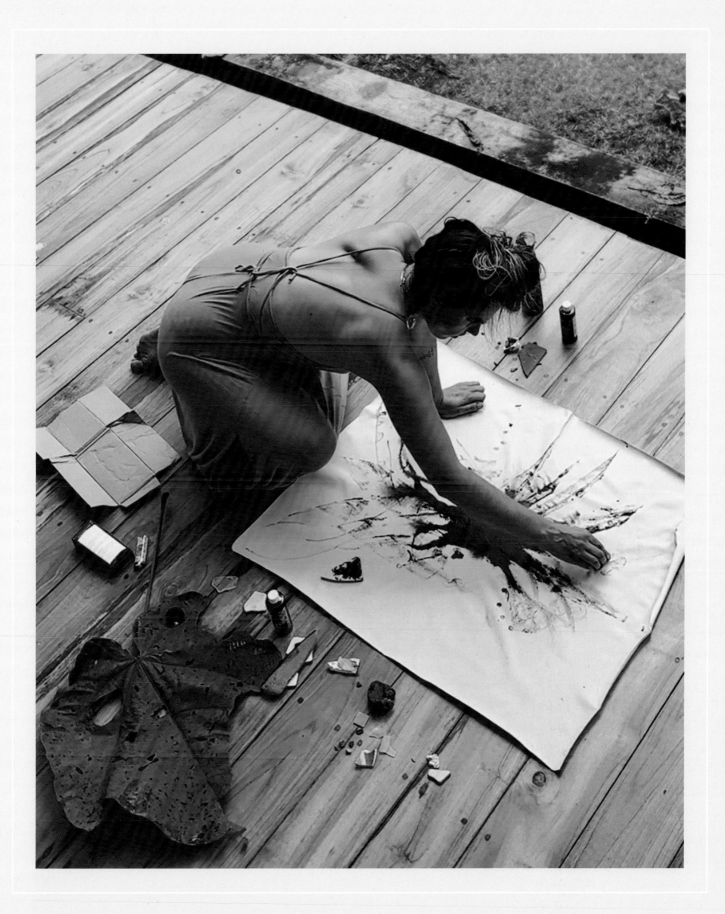

YOU ARE AN ARTIST

Another controversial opinion I hold is that we are *all* artists and *all* capable of showing up to the artistic process. You are allowed to call yourself an artist, even if it's not out loud. The more you embrace this title, the more you fulfill your potential as the artist you've always wanted to be. The only thing you need to do in your process is show up and create something, without the expectation of creating a masterpiece every time holding you back. If you do that as much as possible, you will consistently grow as an artist. Every time you show up to the process, you give yourself and your creative muscles a chance to flex and grow, which makes it easier to show up again the next time. Creative blocks are bound to happen, and you may feel blocked even before you've started—but that's okay! The only wrong way to approach a creative block is to give up. Taking a break is one thing; giving up on your artistic journey altogether is another.

If you are feeling creatively blocked before you even start, I challenge you to just read through the exercises and projects in this book and start daydreaming about creating. You can start your studio journal by writing down the thoughts that are feeding your creative block. What are you telling yourself about this block? Are there any emotions present? Is there anything you need or that might be loving or helpful for you in this moment? Taking the time to journal or reflect before painting will not slow down or hinder your creative process, despite what the inner critic might try to tell you. You can take your time to become curious about your inner and outer world before painting, and, in turn, this will likely enhance the process and outcome of your work.

FINDING YOUR WHY

Once you are ready to dive into the process of creating, especially with an intuitive style like fluid art, it can be helpful to understand your "why." Your why is your reason for showing up to the creative process in the first place. Why are you showing up today to create art? Why did you choose fluid art over another style? Catalog these thoughts in your studio journal. I use a sketchbook as my studio journal, where I keep all the affirmations, ideas, questions, and answers that come up during my creative process. A studio journal will allow you to examine your inner process and see how it evolves over time. Your art is a reflection of the outer process; your studio journal can serve as a reflection of the inner process.

Don't have a why? Just want to paint, tap out, and not think about anything in particular? You can do that too! It's okay to just want to create and not think about any deeper meanings. There are times we just want to lay down color on canvas, and that is enough. Sometimes, the meaning can come after the piece is done! Intuitive art is what we make of it. Flow is not defined by a deeper meaning, but rather by the state of mind we have while creating, and as long as you are tapped into the painting process, you are doing exactly what you are supposed to be doing.

PROCESS OVER OUTCOME

Fluid artwork is a creative outlet that allows your imagination to flow while also giving you a chance to explore your emotions. It is naturally an intuitive style. There are no hard rules for creating intuitive fluid art, and you are given full permission to forget about the outcome and focus on the process. Creating intuitively, without a set plan, challenges the inner critic and the perfectionism it produces in all of us. It requires that we give up control of outcomes and allow ourselves to really let loose.

> Repeat to yourself: "Do not become attached to outcome." It is important that you focus on the experience of creating rather than on what you create, especially as a beginner.

Even if fluid art is not your typical style, you can utilize fluid artwork as a warm-up and catalyst for whatever style you are usually drawn to. Creating fluid artwork is soothing for the mind, body, and heart, and it teaches us how to be present with the flow of painting. Once you become familiar and comfortable creating fluid-style artwork, you will fully understand what is meant by the phrase "trust the process." When working with fluid mediums, you might have an image in mind of how you'd like your piece to turn out, but, given the intuitive nature of fluid paint, you may find yourself surprised by the actual outcome.

You may notice that when the inner critic is not able to run the show, your creation process goes more smoothly, and the outcome of your work is more appreciated. When we approach our process from a place of loving kindness for ourselves and our inner dialogue, we give ourselves permission to relax into the process. When we approach our process from a place of grounded awareness, rather than a place of frenzied perfectionism, the flow we are so desperate to reach finds us, rather than us having to find it.

If you do not like the art you create, ask yourself the following questions to tap into the process instead:

▲ What about the piece do I dislike?

▲ Was there anything about the process I enjoyed?

▲ Was there a point in the process where I liked the piece and maybe could have stopped?

▲ How did my inner critic show up during the process of creating this outcome?

▲ How did I engage with the inner critic?

▲ Did I process any emotions or thoughts when working on this piece?

Use your studio journal to log these reflections. The more you get into the habit of asking yourself these questions after the creation process, the more evidence you will have of how your process might hinder you or catalyze outcomes you are happy with.

THE ENERGY YOU BRING

If the words "grounded" and "calm" immediately make you tense, that might be a sign that your nervous system could use some soothing. Fluid artwork is the perfect outlet for accessing calm. However, while it is nice, you do not *need* to be calm or grounded before creating fluid art. In fact, tension and frustration can lead to some pretty amazing outcomes in the art process. The point is not to always approach your process from a calm place, but rather to approach it from an aware one. You will benefit hugely if you are aware of what

energy you are bringing to the creation process. Present-moment awareness guides creative flow, and utilizing it is how we build a mindful art process. Whatever emotional or energetic baggage you might be carrying into your creation process, fluid art can serve as a conduit for processing the weight of that baggage. Equally, fluid art can be a means to tap into the joy and excitement in our lives. Fluid art can support us through so much of what we experience as creative humans.

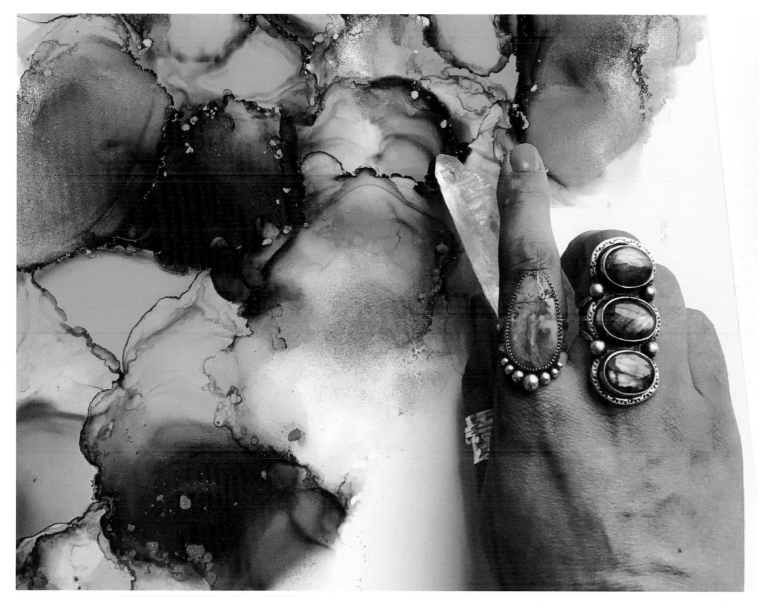

SETTING UP YOUR SPACE FOR CREATIVE FLOW

It's helpful to have a dedicated space in which to create. For tapping into my own creative flow, I like to be in a space that feels comfy and inviting; I do my best to engage all five senses. How can you make your space smell, look, feel, sound, and taste better? Yes, I said taste. Would a piece of chocolate or your favorite tea make the process more enjoyable? A candle or incense? Some of your favorite music? Is what you're sitting on comfortable? We can get used to working in silence, on empty stomachs, and standing or sitting in uncomfortable positions for hours, but that's not ideal. All these factors can enhance or dampen your flow during the creative process. Pay attention to them.

Remember, too, that you are the tool by which your art is channeled. Creating art with a dull tool that's never taken care of doesn't usually provide an enjoyable process or end result. It's okay to forget to take care of your paintbrushes occasionally; what's not okay is forgetting to take care of yourself. Your creative flow will be hindered if you are creating on an empty stomach, while dehydrated, while in unbearable physical pain, while exhausted, or while in any condition where you are putting yourself or your nervous system under unnecessary stress. Do what you can to make the creative process and your creative space like a nest or cocoon—a place where you feel like you can fully relax and express yourself.

It's also helpful to clean up your space right after every work session. I am giggling to myself as I write this because I am sitting in front of a very messy studio that I did not clean up after my last session, but if there's any advice I wish I would take from myself, it is that. Coming into a fresh workspace every day is a huge boost to creative flow. Not having to clean or push things around and reorganize before a session allows you to utilize all your energy for accessing your flow. Start tidying right after you paint and make it a habit you adopt early on; you will be a much-happier artist, I promise.

Now that it's time to start creating, remember: there are no rules, and the process is yours and yours alone. You are an artist—now start acting like one.

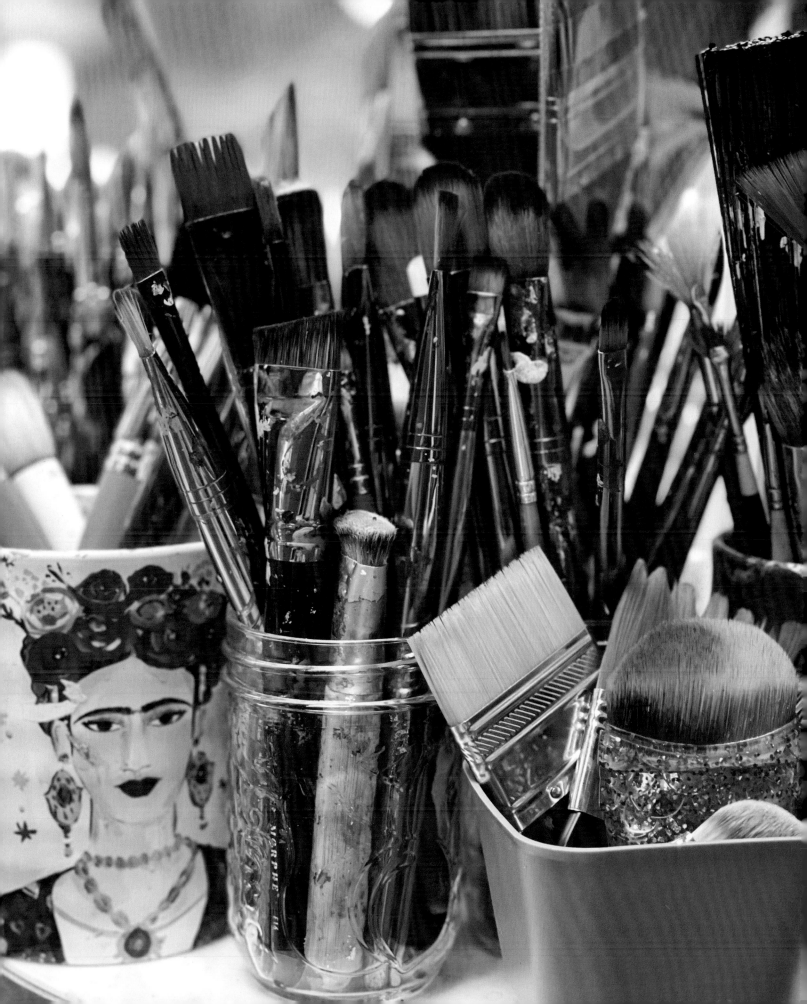

ALCOHOL INKS

THE BASICS

Alcohol inks are quick-drying, highly pigmented liquid inks made from dyes dissolved in isopropyl alcohol. They can be layered and blended to create depth and texture and can be applied to a variety of surfaces, including glossy paper, Yupo paper, ceramics, glass, and metal. Due to their quick-drying nature, they can be used for creating dynamic and spontaneous effects. Alcohol inks are popular for their unpredictable and unique qualities—every piece created using them is always different and one of a kind. Many people compare alcohol inks to watercolors, but one of the major differences between the two is alcohol ink's ability to reactivate once dry. You can start over and wipe away your work if you need to when working on Yupo paper or other nonporous surfaces like glazed ceramic tile. Alcohol inks are great to work with in fluid art due to their vibrant colors, spontaneity, blendability, versatility, and unpredictability. I love working with them because they allow artists to create beautiful, abstract art that is unique and cannot be replicated.

91% ISOPROPYL ALCOHOL OR BLENDING SOLUTION

Isopropyl alcohol is an important component for working with alcohol inks. It is mixed into the ink to create a fluid consistency and to help the ink spread and adhere to a variety of surfaces. Alcohol ink is highly pigmented, and adding isopropyl alcohol to it helps to dilute the ink and create a thinner consistency that spreads more easily. This makes it possible to create a variety of effects, such as washes, gradations, and glazes. Alcohol inks can be blended together with isopropyl alcohol to create new colors or to add depth and texture to artwork. The degree to which the colors are blended can be controlled by adding more or less alcohol. Isopropyl alcohol evaporates quickly, which dries the ink and allows for more-immediate layering and experimentation with other colors or techniques.

Blending solution is a product specifically designed for use with alcohol inks. Blending solution is preferred by some artists due to its

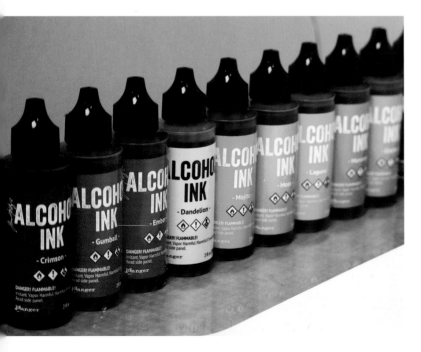

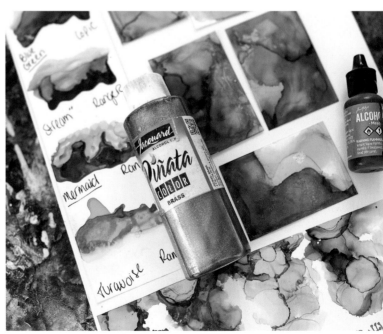

slower evaporation rate, smoother blending, lack of streaks or lines, and ability to maintain color intensity. While isopropyl alcohol can still accomplish many of these same goals, blending solution provides a slightly different consistency that some artists prefer when working with alcohol inks.

CARING FOR YOUR INKS

Despite what you might notice in some of the photos in this book, it is important to close your alcohol ink bottles as frequently as possible while you work. Oxygen impacts the ink inside the bottle, especially over time if bottles remain open for prolonged periods. You may notice that ink bottles you've been working with for a long time do not behave quite the same as fresh bottles. Store bottles in a cool, dry, and dark space. Keep them away from direct light and warm temperatures.

PROTECTING YOUR WORKSPACE

Alcohol ink will stain porous surfaces such as wood. If you spill, use 91% alcohol or higher to clean the area right away. I recommend placing a hard plastic sheet under your work area. You can purchase thick acrylic sheets in custom sizes at the hardware store.

Alcohol ink will also stain your skin, so wear gloves. I work using nitrile medical gloves, but you can use whatever gloves you prefer.

SAFETY

Alcohol inks contain fumes that are not safe to be inhaled. Always work in a well-ventilated space and wear a mask with organic vapor filters. And don't forget about your pets—keep them out of the room while you're working.

I do not recommend using your breath to blow around or quickly dry alcohol inks—I recommend only using the tools listed in this book (see page 28) and the ambient air. If you do not protect yourself, you may develop sensitivity to the fumes, even if you do not notice any ill effects right away.

Do not touch alcohol inks with bare hands—wear gloves—and do not put alcohol or alcohol inks into spray or aerosol bottles.

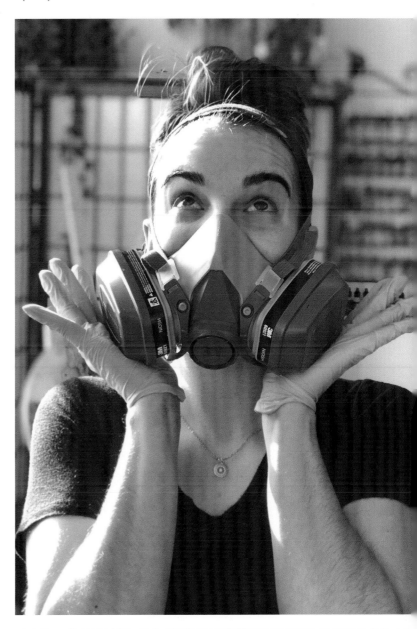

HIGH-FLOW ACRYLICS

Fluid and high-flow acrylics are types of acrylic paint that have a thin consistency and a high pigment load. (I use the term "high-flow acrylics" throughout this book to refer to both high-flow acrylics and fluid acrylics—use whichever specific product you prefer.) Their high concentration of pigment means that a little paint goes a long way. They are wonderful for adding vibrant and intense color into your work. Their thin consistency, similar to ink, allows the paint to flow smoothly and evenly; they also dry quickly, which means that artists can layer colors on top of one another without waiting too long between layers.

High-flow acrylics can be mixed with other acrylic paints, mediums, and additives to create a variety of effects. They can be thinned with water or fluid medium to create a waterier consistency or used

as is for a more intense color. High-flow acrylics are ideal for painting, whether it be on canvas, paper, or other surfaces. Their thin consistency allows for smooth brushstrokes and fine detail work. They can be used like ink for drawing and creating intricate designs or even used with dip pens or brush pens to create thin, flowing lines and curves.

Unlike when working with alcohol inks, you do not need ventilation precautions and do not have to wear a mask when working with high-flow acrylics. It is strongly recommended, however, that you wear protective gloves when working with paint. The pigments in many paints have toxic chemicals in them that are not ideal for skin contact, just as with alcohol ink.

Fluid acrylic products (as opposed to high-flow acrylic products) may be preferred for a heavier-body paint or more opaque application, but, generally speaking, you can use either for the projects in this book.

PREPARING A CANVAS FOR HIGH-FLOW ACRYLIC WORK

There is nothing worse than getting into a fluid painting and realizing as you begin to pour the paint that the canvas is sagging or dented. Do not fret—we can fix that! It is important to make sure your canvas is not sagging anywhere for fluid paintings because of how fluid mediums move—the paint will pool and gather in areas where there is sagging. Preparing your canvas to tighten it and fix any dents caused by packaging or storage will save you a lot of headaches later. Before starting any canvas-based fluid acrylic project, follow these instructions to ensure the best results.

Bonus tip: If the canvas wood stretcher bars are warped, you can wet the stretcher bars and put weight on all four corners until the wood dries. If you're lucky, the warping will be fixed!

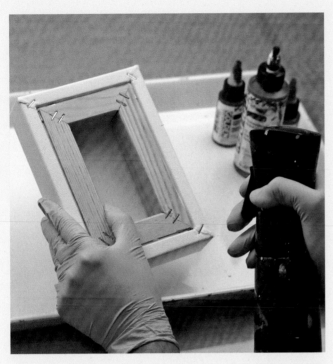

1 Mist the back of the canvas with water using a fine-mist spray bottle.

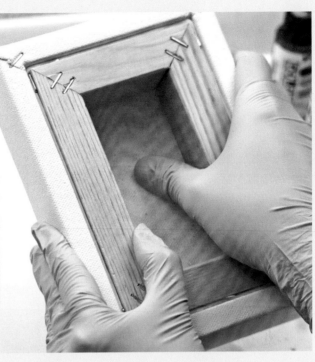

2 Rub the water into the canvas.

3 Turn the canvas over, mist the front of the canvas, and rub the water into the canvas.

4 If dents or sags worsen or do not tighten, continue to wet and rub the canvas—it will eventually tighten.

ESSENTIAL TOOLS

YUPO PAPER

Yupo paper is a synthetic paper designed to be waterproof, tear resistant, and highly durable, making it an ideal surface for a variety of fluid art techniques, including working with alcohol inks. Yupo paper has a nonporous surface, which means that it does not absorb liquids like traditional paper does. This allows alcohol inks to stay on the surface of the paper instead of being absorbed, resulting in brighter and more-vibrant colors. Because the surface is nonabsorbent, this also means that ink can be reworked and manipulated even after it has dried. Alcohol inks can be lifted and moved around on the surface of Yupo paper, allowing for greater flexibility and experimentation. Yupo paper is acid-free and pH neutral, making it an archival-quality material. It can resist discoloration and fading over time, so it is ideal for artists who want to create artwork that will last.

VARNISH

Alcohol inks need to be sealed with a protective varnish to prevent them from fading or reactivating. Alcohol ink is not UV resistant, so extended sunlight exposure can cause the colors to shift and fade over time. You need to use either Kamar spray varnish from Krylon or Jacquard's paint-on varnish. Other varnishes will likely react with your inks and cause them to run.

BLOWING AND DRYING TOOLS

When it comes to moving alcohol inks around and drying them, you have several options. Handheld air tools, such as one from Ranger that is made specifically for alcohol inks and that you see me using throughout the book, look a bit like turkey basters—you squeeze the tool to push air out. You can also use a low-heat heat tool. Many heat guns get too hot for Yupo paper and cause warping; believe it or not, when I want heat, I use a hair-drying brush tool and remove the detachable brushes. You can also use a travel blow-dryer. I do not recommend using your breath, since this opens you up to a greater risk of inhaling alcohol ink into your lungs—and you should be wearing a mask while you work anyway! Alcohol ink fumes are not meant to be inhaled, and you may put your health at risk if you regularly use your breath as a tool.

When you are choosing a tool during a project, keep in mind your goal: is it just to move the ink around while not drying it quickly? Or is it to dry the ink quickly (with heat)? Choose the tool that suits the moment best, or the tool I am using during that step.

PAPER CUTTER

You can use scissors or a cutting tool to cut Yupo paper. A cutting tool will make your life much easier, so if you're debating investing in one and you plan to work with Yupo paper and abstract mixed media, get one!

PAINTBRUSHES

Because of the unique qualities of alcohol ink, not all paintbrushes work well with it. Synthetic brushes work better than natural-hair brushes. They are less absorbent, which allows the ink to flow and blend better on the surface without being absorbed by the brush. Additionally, synthetic brushes tend to be more durable and easier to clean than natural-hair brushes. You can use inexpensive craft store paintbrushes or brushes specifically made for alcohol inks, such as the ones from Ranger, which you can find online from most craft retailers.

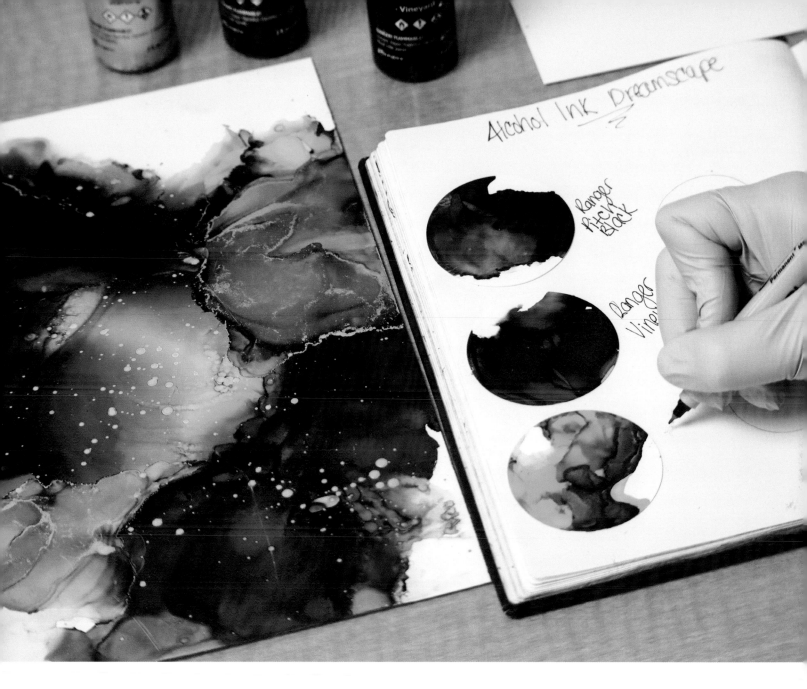

Round brushes are a good choice for alcohol ink because they allow you to control the flow of ink and create fine details. The round shape enables the ink to flow in a controlled manner, and you can apply the brush at an angle to create a broad stroke. Liner brushes are great for creating fine, delicate lines and details with alcohol ink. A liner brush is a long and narrow brush that can create controlled, thin lines and longer strokes. Foam brushes are useful for creating smooth surfaces with a thin layer of ink. They allow the artist to gently apply the ink and avoid manipulating it, allowing it to flow and spread on its own.

DISHES

During most projects, you will want to keep isopropyl alcohol or blending solution in one small dish for you to dip your paintbrush in and another, separate dish of alcohol to clean your paintbrush between colors. I recommend glass dishes for these uses, because alcohol ink does not stain glass and it is easiest to clean.

BOTTLES AND PIPETTES

The squeeze bottles I use for alcohol and blending

solution have an almost needlelike tip; when working small, the finer the tip is, the better. For the alcohol ink itself, you can drop ink straight out of the manufacturer's bottle in many cases, and you'll see me doing this in many step photos in this book. However, transferring limited amounts of ink into a needlenose bottle will allow you to have precise control over the flow of the ink. The thin, needlelike tip allows you to apply small amounts of ink exactly where you want it and with minimal wasted ink. With a needlenose bottle, you can ensure that you are applying ink evenly and consistently. This can be especially useful when retouching an area with more ink or when fine tuning.

Pipettes are great for applying a splatter effect to your pieces—you'll see this technique several times throughout the book!

PALETTE KNIFE

Palette knives give you more control and flexibility when painting and help you achieve a texture completely unique to the process of abstract art.

By experimenting with palette knives and learning different techniques for using them, you can manipulate the paint and create unique effects that reflect your own personality, technique, and skill.

FOUND OBJECTS

Some of the most interesting found objects can serve as painting tools—a leaf can become a paintbrush; a rock can create texture. Use your imagination and do not let material inaccessibility limit your ability to create. Sometimes, certain substitutes will have different outcomes; for example, if you replace alcohol inks with watercolor, that will require other substitutions like using water instead of alcohol-based blending solution, etc. Just be aware of how the change in materials might change the process, and, as they say, trust the process.

SETUP

Before starting any project, make sure to have everything you need out in front of you or within arm's reach. One of the most frustrating things you can do is be in the middle of something when the ink is actively drying, and you need to run to the other side of the house to grab something you didn't realize you didn't have on hand.

Work in a space free of pet hair if you can. To bring down the pet hair in the air, mist the air with a water bottle. Adding too much humidity to the room will impact your ink, however, so I do not recommend working in a room with a humidifier. If the space is humid, adding a dehumidifier can help.

Choose a well-ventilated area with a flat workspace to work on. Always keep your work area clean and free of clutter so you can work effectively and enjoy the process. It's crucial to have proper ventilation, as the fumes from alcohol inks can be hazardous. Adding an air purifier can also help. Even with ventilation, always wear a double respirator mask with organic vapor filters when working with alcohol ink.

Cover your workspace with a plastic tablecloth or other protective layer, as working with alcohol inks can be quite messy and stain the surface of your table. Since alcohol inks can stain your skin and acrylic paints can have toxic chemicals in them, it's also a good idea to protect your hands with gloves.

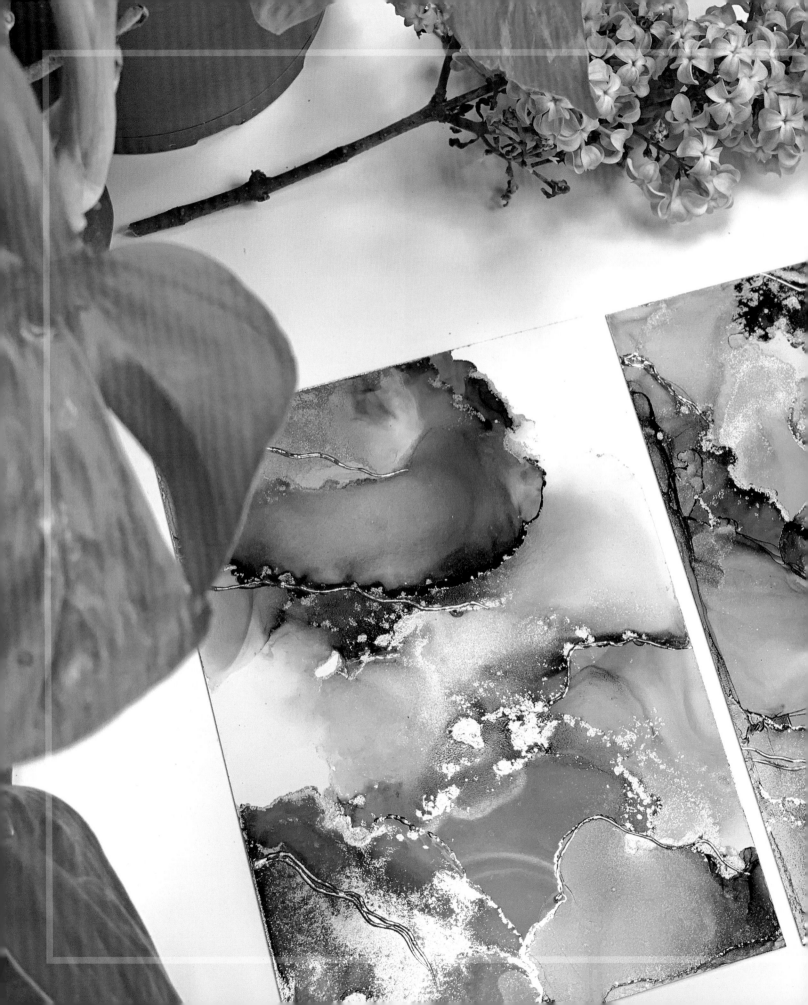

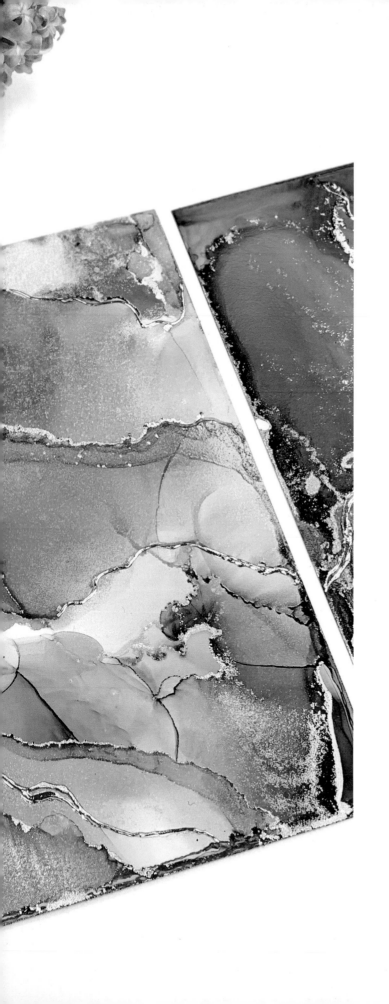

Chapter 2

EXERCISES

In this part of the book, we will explore nine simple fluid art exercises to help get you warmed up for the full projects in Chapter 3. I chose these exercises to help you build a foundational trust in your ability to create intuitive fluid art. These exercises are also intended to help you build a creative process that is rooted in confidence and activates your unique creative flow. I personally come back to these exercises whenever I need to strengthen my foundational skills, and I hope they will serve a similar purpose for your process.

There is an affirmation at the beginning of each exercise. Say these statements silently to yourself or out loud, even if it feels silly. Science has proven over and over the power of affirmation, even for those who don't believe in their benefit. There are also journal prompts to help you reflect on your process in your studio journal.

Remember: the outcome of what you create through these exercises is not important. What is important is what you learn along the way. The entire point of this book is to help you trust your process and forget about the outcome. Allow yourself to learn from a place where shame and judgment do not exist. This is your chance to go back to a childlike state of play. Now go get messy and create!

MAKING A COLOR SWATCH RING

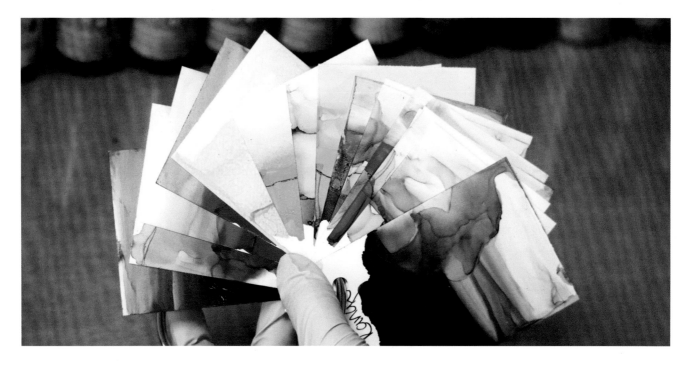

Our first exercise is an introduction not only to getting yourself organized, but also to getting comfortable with your chosen medium. With fluid painting, color is an integral part of the language you are using to express yourself. The way to a consistent and reliable creative flow is through getting to know your materials and being patient with yourself as you establish a practice that is built on a strong foundational understanding of your medium.

Often, the bottle color, especially for alcohol ink, is not an exact (or even close) representation of the color inside the bottle. Creating swatch cards of each color you own is an excellent way not only to see the true color inside the bottle, but to begin to understand how the color works as you use it. For this exercise, we will create a color swatch ring of your alcohol ink colors. Swatching every new color allows you to understand not only the real color, but also its viscosity and how it reacts to thinners. You can even make swatch cards for each custom color you create—just be sure to add the formula for how you created it on the back, because you *will* forget!

I invite patience within myself as I start this creative journey

BEFORE YOU BEGIN

Put some isopropyl alcohol or blending solution in one small glass dish for you to dip your paintbrush in, some in another, separate glass dish to clean your paintbrush between swatches, and some in a fine-tip squeeze bottle. Be mindful of your work surface and remember that alcohol ink will stain porous surfaces like wood.

TOOLS & MATERIALS

- Alcohol ink in every color you have!
- Yupo paper
- 91% isopropyl alcohol or blending solution
- Two small glass dishes
- Fine-tip squeeze bottle

- Scissors or paper cutter
- Ruler
- Drying tool
- Paintbrush
- Paper towels (for wiping brush between cleanings)

- Permanent marker
- Varnish
- Hole punch
- Binder ring
- Gloves
- Protective face mask

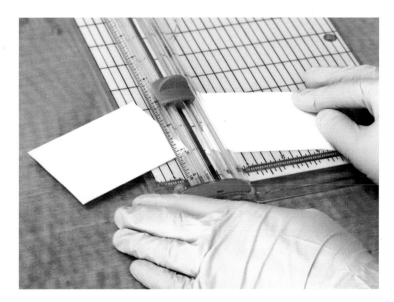

1 CUT CARDS. Cut the Yupo paper into 2" x 3" (5 x 7.6 cm) swatch cards using a cutting tool or scissors. Make sure you have one or two cards for each color. Having more than one blank card is a good idea in case you're not happy with how one of the cards comes out.

2 DROP SOME INK. Add 1–2 drops of ink onto a card. You want to show a true representation of the color, so try not to overdo it; less is often more with alcohol ink. You will notice that lighter and more-translucent colors might need a few more drops of ink than darker colors.

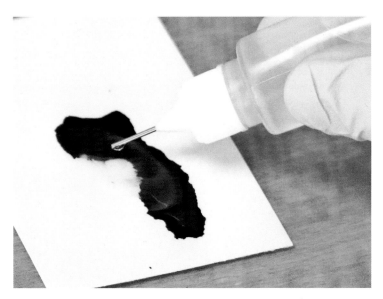

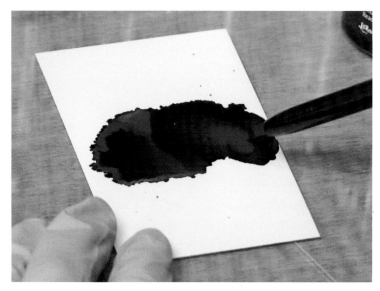

3 DROP SOME ALCOHOL. Dilute the ink with 1–2 drops of alcohol or blending solution. The more you practice and play with alcohol inks, the more you will understand the best ratio of alcohol ink to blending solution for the outcome you desire. For me, it's more about muscle memory than precise measuring when working with fluid mediums.

4 DRY THE INK. Use an air tool to blow and move the ink around on the card until it is dry. I am using a handheld air tool (which looks a lot like a small turkey baster) from Ranger that is made specifically for alcohol inks.

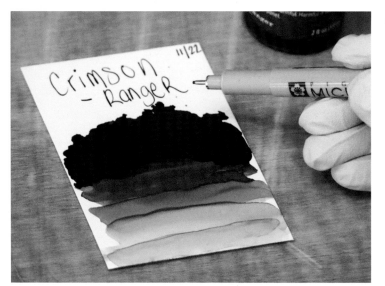

5 LIFT SOME INK. Use a paintbrush dipped in alcohol or blending solution to remove some of the ink in one area. This will show you how the ink reacts when it's lifted off the paper, which will be how you create certain effects in projects later.

6 ADD THE INFO. Add the name of the ink and the date you created the swatch on the front or back of the swatch card. This way, you won't forget which color is which, and you'll be able to see how the ink behaves over time.

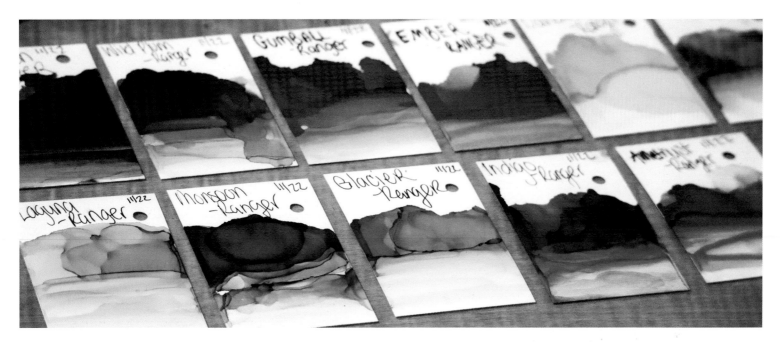

7 VARNISH AND FINISH. Varnish your swatches so that they stand the test of time (read more about varnishing on page 28). To complete your swatch ring, punch a hole in each card and add it to a binder ring. Create a swatch for every new color you acquire and watch your ring grow!

⊙ REFLECTION ⊙

Getting to know a new medium can invite in a "beginner mentality," the state of mind in which you have just begun learning something, like being a child all over again. For some people, feeling like a beginner can bring up emotions of fear and doubt. If you ever hear a voice in your head saying, "I suck at this" or "just give up," remind yourself that slowing down and trusting yourself is an important part of the creative process. These exercises require you to be present and patient, which is not always easy. Work through each exercise and project with grace. Allow yourself the gift of imperfection.

What feelings came up during this first exercise?

What was your brain communicating to you as you completed the exercise? What were you telling yourself?

What was difficult about this first exercise?

BLENDING INKS
WITH AIR

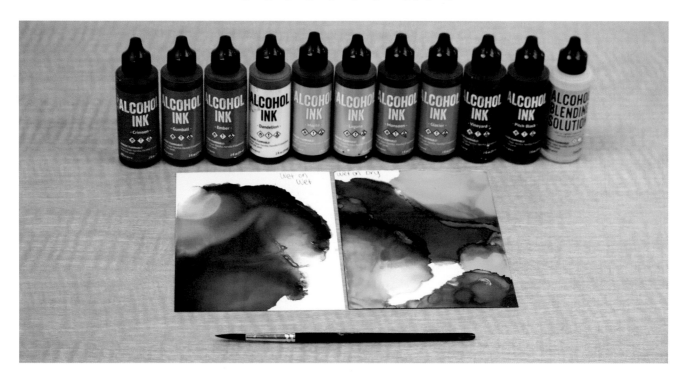

Let's explore different ways to blend two or more colors of alcohol ink with isopropyl alcohol or blending solution. Alcohol ink may seem easy to manipulate, but, when starting out, you will quickly learn how unpredictable it can be. It is important to understand how the isopropyl alcohol or blending solution reacts with the ink as you work to build confidence in your ability to achieve the outcome you want. It is also important to understand how different colors and even different brands of ink react with each other. As you expand your color collection, you'll notice that different colors behave differently on their own, and different color combinations and brands also behave differently. This is part of what makes it such an interesting intuitive medium.

It is up to you whether you use isopropyl alcohol or blending solution; each produces a slightly different outcome. Experiment with both. Remember that less is more when working with a highly pigmented medium like alcohol inks. Don't forget to breathe and take your time. There is no need to rush through these exercises or projects.

Time, practice, and persistence get me to my goals

BEFORE YOU BEGIN

Put some isopropyl alcohol or blending solution in a fine-tip squeeze bottle. I used 5" x 7" (12.7 x 17.8 cm) pieces of Yupo paper for this exercise, but you can use any size you'd like. As you work, try not to get too caught up on the ratio of ink to alcohol.

TOOLS & MATERIALS

- Alcohol ink: 2 colors
- Yupo paper: 2 or more sheets in any size
- 91% isopropyl alcohol or blending solution

- Fine-tip squeeze bottle
- Drying tool
- Permanent marker
- Varnish

- Gloves
- Protective face mask

WET-ON-DRY BLENDING

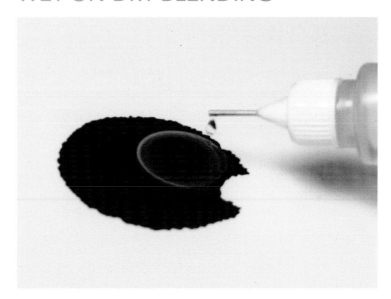

1 **DROP SOME INK AND ALCOHOL.** Drop 1–2 drops of one of your chosen ink colors onto the paper, followed by 2–3 drops of alcohol or blending solution either right on top of or right beside the ink. Do not let the ink dry before putting down the alcohol—this may cause unwanted paper staining.

2 **MOVE AND DRY THE INK.** Use the drying tool to move the ink into and out of the alcohol to blend the ink. Then, either continue to use the tool to completely dry the ink, or allow to the ink to air-dry once you've blended it into the alcohol a bit. I recommend experimenting with both techniques—see the Tip about this on page 41.

3 ADD THE SECOND COLOR. Add a few more drops of alcohol and 1–2 drops of the second ink color in one spot along the edge of the dried color. Use the drying tool to gently blend the wet alcohol ink into the dried alcohol ink. The dried ink will reactivate and begin to blend with the wet ink. If you push the air backward and forward over and over in this border area, you will create a seamless blend.

4 ADD MORE COLORS. Repeat steps 1–3, using as many colors as you'd like, until you are happy with your composition. Label and varnish your work.

WET-ON-WET BLENDING

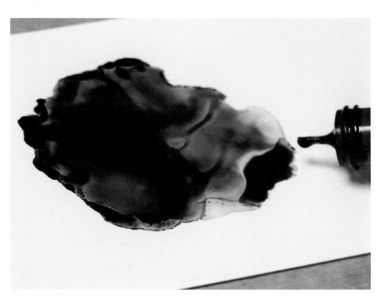

1 BLEND THE FIRST COLOR. Follow step 1 of Wet-on-Dry Blending, then use the drying tool to blend the ink into the alcohol a bit—but don't let it dry.

2 ADD THE SECOND COLOR. Before anything dries, add 1–2 drops of your second color of alcohol ink next to the first color, along with 2–3 drops of alcohol or blending solution. Do not let this dry either.

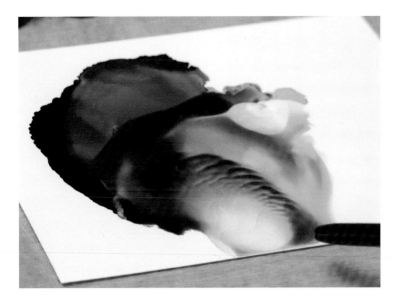

TIPS

▲ Using a drying tool to completely dry wet ink will create harder lines in the finished work; air drying will create a more ethereal and cloud-like effect. Air drying requires you trust the process and not manipulate the wet liquid too much, as tempting as it may be!

▲ Experiment with putting down alcohol ink first versus blending solution first; both will work.

3 BLEND AND REPEAT. Using the drying tool, blend the two colors together to your desired mix. Continue to add more colors and alcohol to the mixture before letting any part of it dry. Once you have the desired amount of liquid on your page, you can continue drying with the air tool or you can let the piece air-dry. Label and varnish your work.

·❯ REFLECTION ❮·

You can practice this exercise countless times before getting the outcome you desire or the outcomes you see in this book. If it was trickier than you thought and you are not satisfied with your end results, you are not alone. Just keep practicing. There is not a precise formula for working with alcohol inks. The process of creating confidently with them is an intuitive one, one that comes to you with time and patience. Don't compare your progress with someone else's. If what you are creating does not look like what I have created here, that is okay! These exercises are about what you learn along the way.

What feelings came up during this exercise?

What were you telling yourself about the process as you completed this exercise?

How do you feel about your final product(s) for this exercise?

BLENDING INKS WITH A PAINTBRUSH

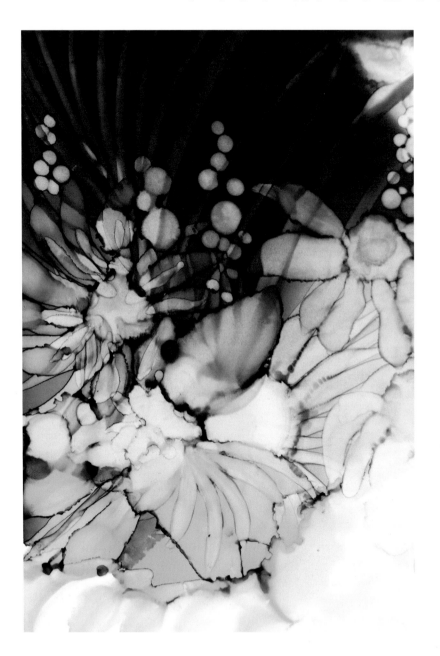

For this exercise, we will explore how alcohol inks can be reactivated and reworked using alcohol and a paintbrush, allowing you to lift the ink from the paper and essentially "etch" textures and shapes into your background. You can also use a paintbrush to rework and blend harsh lines. I created a floral-inspired foreground on a simple background for this exercise, but don't feel limited to florals—use your imagination. Draw strokes and textures; play with splattering the alcohol by tapping your paintbrush. The sky is the limit.

Allow this exercise to be as relaxing as possible, and do your best to remain fully present during it. Notice your thought process as you explore the technique, but try not to engage with your thoughts and become distracted by them. Notice when you get caught up in thinking rather than creating. It can be frustrating when you do not immediately love the piece you're working on, and it can feel difficult to tap into any kind of flow when you feel like you keep messing up. Remember that alcohol inks are a forgiving medium that can be reactivated and reworked at any time! Until you varnish your piece, you can always change it.

I am present, I am focused

BEFORE YOU BEGIN

Put some isopropyl alcohol or blending solution in one small glass dish for you to dip your paintbrush in and some in another, separate glass dish to clean your paintbrush between swatches. A paper towel to wipe your paintbrush on is also helpful. Water will not clean alcohol ink from paintbrushes or surfaces.

TOOLS & MATERIALS

- Alcohol ink: 2 colors
- Yupo paper
- 91% isopropyl alcohol or blending solution
- Two small glass dishes
- Drying tool
- Paintbrush (I am using a round brush)
- Paper towels (for wiping brush between cleanings)
- Varnish
- Gloves
- Protective face mask

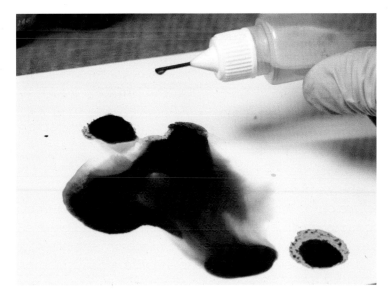

1 MAKE A BACKGROUND. Create a background for your piece using one of the blending methods from Exercise 2 (page 38), allowing it to dry completely. Be mindful of how much you saturate your background with ink—the more ink you use on the background, the harder it will be to lift the dried ink from the paper and the less contrast you'll achieve through lifting.

2 LOAD THE PAINTBRUSH. Load your paintbrush with isopropyl alcohol or blending solution. Loading the brush means to fully submerge the bristles in the liquid and gently tap, wring, or dab the brush so that it is not freely dripping onto the page. Practice with different amounts of alcohol on your brush to create different effects.

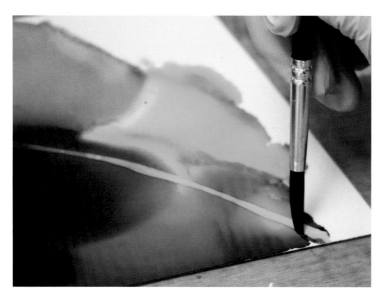

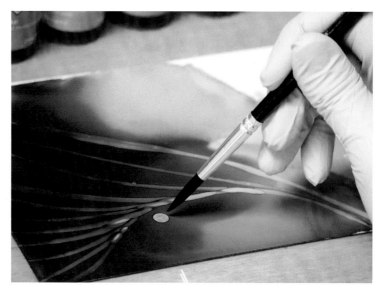

3 DRAW A STROKE. It's time to "paint" with the alcohol on the completed background! Start by trying a stroke. Place your paintbrush where you want the stroke to start, then drag your paintbrush along the paper to create a line, applying enough pressure to lift some dried ink from the paper.

4 ADD MORE STROKES. You'll notice that alcohol expands as it hits the paper, so if you want your lines to be thin, apply very light pressure and less alcohol. If you want your lines to be thicker, apply more pressure and a bit more alcohol. Too much alcohol will cause close-by lines to bleed together.

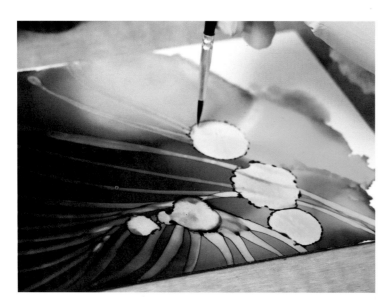

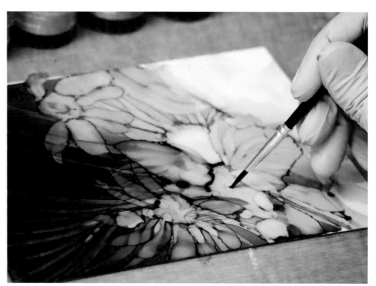

5 ADD BUBBLES AND DOTS. Play with creating bubbles and dots by lightly dabbing the paper once with your paintbrush or allowing alcohol to drip onto the paper from the tip of your paintbrush (also shown in the previous step).

6 DRAW SHAPES. Explore applying different strokes to the page to create leaf shapes, flower petals, or abstract shapes. Go slow and allow the final image for the piece to come to you as you work.

TIPS

▲ Allow each new line and stroke to dry before adding the next stroke to prevent one from bleeding into the other.

▲ The more pigmented the background is, i.e., the more ink you apply at first, the harder it will be to create smooth lines with this technique. The better you get at creating a soft background, the cleaner the outcome will be.

▲ I like to use the wet-on-wet method and allow it to air-dry to create a softer background for this exercise.

·⟩ REFLECTION ⟨·

This exercise, while fairly simple, begins to stretch the creative muscle in a way that might feel more out of your comfort zone than the first two exercises did. It requires you to take an image in your mind and put it onto the paper rather than just relying on the way the inks abstractly move and dry. Check in with your inner critic; has it prevented you from enjoying this exploration? Noticing how your thought patterns attempt to interfere with your creative flow will allow you to eventually disengage from the distracting thoughts in order to fully engage with your creative flow.

How did it feel to try to stay present for this exercise?

What distracted you during this exercise?

CREATING A MULTICOLOR INK GRADIENT

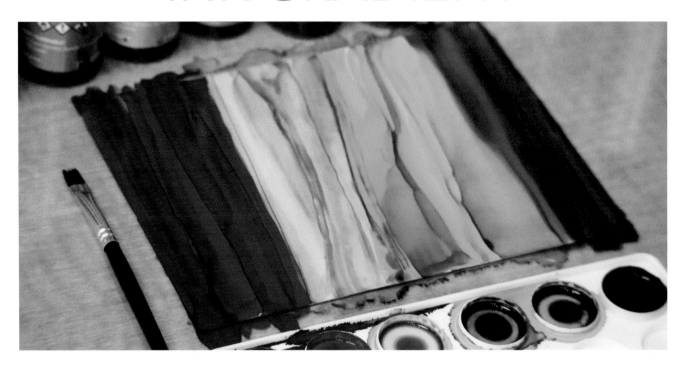

For this exercise, we are going to create a multicolor gradient with our alcohol inks. You can make stunning works of art using just this technique alone. This technique is a simple way to practice with alcohol ink that helps you stretch your blending muscles and deepen your understanding of how the inks work. It is a true practice in "less is more": it might appear like the outcome we are working toward requires a lot of ink on the paper, but you will be surprised to see how far just one paintbrush stroke of ink will get you on a nonporous surface like Yupo paper. You do not even need alcohol or blending solution to dilute the ink for this exercise. (That said, depending on your brand of ink, you may want to dilute it with a bit of alcohol.)

You will notice I use words like "quickly" in this exercise. I encourage you to work at a faster pace than when practicing other techniques. This is not to say that you should rush or blow through this exercise. "Quickly" does not mean failing to breathe, nor does it mean rushing so much that you spill, drip, or have an accident.

I challenge the urge to resist this exercise and skip ahead

BEFORE YOU BEGIN

Put some isopropyl alcohol or blending solution in a small glass dish to clean your paintbrush between swatches. If you don't have a paint palette, you can use a glass dish for each color. Alcohol ink may stain some types of ceramic, so use caution. Ranger makes a plastic palette specifically for alcohol inks, which is what I used here.

TOOLS & MATERIALS

- Alcohol ink: 6 or 7 colors
- Yupo paper
- Paint palette (preferably plastic, not ceramic)
- 91% isopropyl alcohol or blending solution (optional)
- One small glass dish
- Paintbrush
- Paper towels (for wiping brush between cleanings)
- Varnish
- Gloves
- Protective face mask

1 PREP YOUR COLORS. Drop enough ink of each of your chosen colors into individual palette spots so that you don't have to keep adding more ink to the palette as you work. The ink will eventually dry, but you can always reactivate it with alcohol. You do not have to dilute the ink in the palette with alcohol unless you want to lighten the pigment. Darker colors like black or dark purple might benefit from a bit of dilution.

2 LOAD THE PAINTBRUSH. Load a clean paintbrush with your first ink color. Loading the brush means to fully submerge the bristles in the ink so that all bristles are coated and then to scrape the brush gently on the edge of your palette so that it is not freely dripping. Good loading encourages the smoothest application of ink and paint.

3 PAINT THE FIRST COLOR. Brush a wide line of color along one edge of the paper. Try not to let this line dry fully. Quickly wash your brush in alcohol and wipe it clean on a paper towel. Don't rush—just move with haste while continuing to breathe.

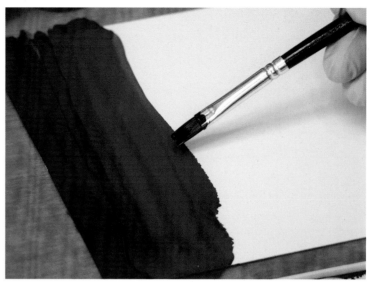

4 PAINT THE SECOND COLOR. Dip the cleaned paintbrush into your second color. Brush the second color along the edge of first color, allowing their edges to lightly blend together.

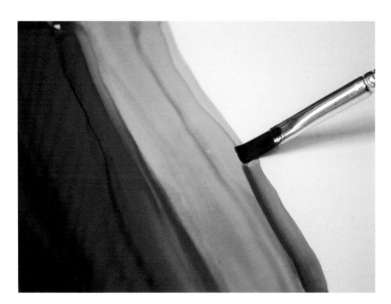

5 PAINT THE NEXT COLOR. Repeat steps 3 and 4 to continue adding colors. If one line of color dries before you apply the next, that's okay! Just use the new wet color on the paintbrush to blend the colors together. You may get more of a layered look with harsher lines between the colors, but it will still work as a gradient.

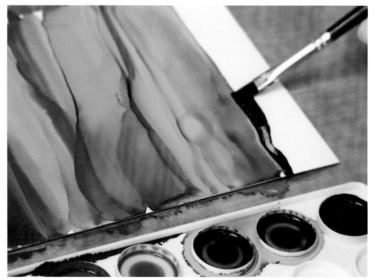

6 PAINT THE REMAINING COLORS. Continue changing colors until you reach your desired composition, working relatively quickly. You can use the paintbrush to soften and blend hard lines to some degree. Remember to breathe, and don't stress.

TIPS

▲ Try using a ceramic tile to practice this technique over and over again by simply wiping away your work and starting again!

▲ You can add metallic ink during this exercise if you want. I chose to keep it simple to show you how the colors blend seamlessly using this technique, but metallic ink can add a new element to a gradient like this. See more about metallic ink in Exercise 5 (page 50)!

·❯ REFLECTION ❮·

While simple, this technique is one that will come in handy again and again. It's also a great exercise to practice color theory and blending; you can use this technique with different color combinations to see what color effects you can achieve by using different colors together as well as different brands. Notice if during this exercise you found yourself in a place of judgment rather than flow. Notice if thoughts such as "this is easy/hard" flood your thought process. Try to interrupt such thought processes by bringing yourself back to the flow of the exercise.

What is your relationship to practice?

Do you tend to rush projects and outcomes?
What is your relationship to rushing?

ADDING METALLIC INKS

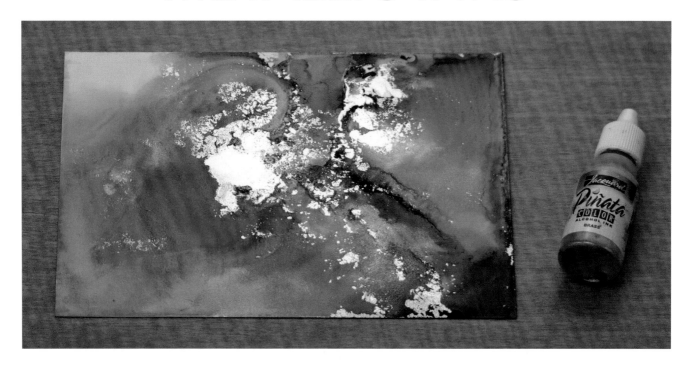

Metallic gold, brass, and silver alcohol ink are somewhat of a trademark for an alcohol ink artist. The intensity of the metallic pigment in the ink makes it an alluring and captivating addition to any work of art. Despite how beautiful metallic alcohol ink can look when done by professional alcohol ink artists, when you're just starting out, it can be difficult to achieve the high-shine outcome you're used to seeing. Working through this exercise and practicing with the metallic ink will help you avoid making mud.

Remember the adage "less is more" that applies to a lot of alcohol ink work? For metallics, *even less* is more. Metallic ink is highly pigmented, and it also stays more metallic the less you manipulate it and the longer it dries. The biggest problem I see in students who are working with metallic ink for the first time is a muddy result. A muddy metallic means you've either forgotten to shake your bottle every time you put it down (I mean it—every time you put it down), you spent too much time mixing and reworking the metallic ink into wet ink, or you're using a subpar-quality ink.

I can make magic out of mud

BEFORE YOU BEGIN

Put some isopropyl alcohol or blending solution into a fine-tip squeeze bottle.

TOOLS & MATERIALS

- Alcohol ink: 1 or more colors
- Metallic alcohol ink: 1 color
- Yupo paper

- 91% isopropyl alcohol or blending solution
- Fine-tip squeeze bottle
- Drying tool
- Pipette

- One small glass dish
- Varnish
- Gloves
- Protective face mask

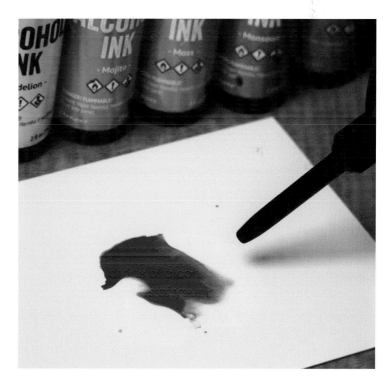

1 PREP THE METALLIC INK. Shake the bottle of metallic ink **well**. You can tell if the metallic pigment has settled to the bottom of the bottle; shake the bottle until the ball inside rattles and until you do not see a separation in the pigment. You will want to shake the metallic ink **after every time you put it down**; the metallic flake is heavy and sinks to the bottom quickly.

2 DROP YOUR NON-METALLIC COLOR. Drop 2–3 drops of alcohol down onto the paper, followed by 1–2 drops of your non-metallic alcohol ink color. Use a drying tool to gently blend the ink into the alcohol, but do not dry the ink completely before moving on to the next step.

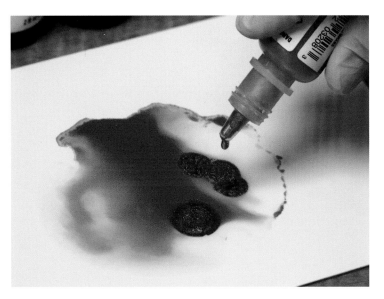

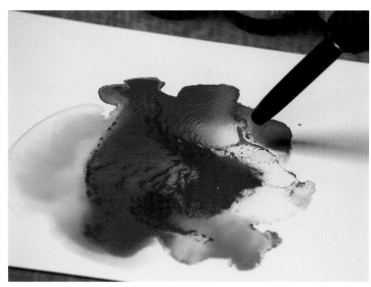

3 ADD THE METALLIC INK. Shake the metallic alcohol ink again before proceeding. Drop 1–2 drops of the metallic ink into the still-wet non-metallic ink and **immediately** use the drying tool to blend the metallic ink into the color. The longer you let the metallic ink sit without blending it, the harder it will become to blend, because the heavier metallic pigment will sink and settle onto the paper.

4 DRY THE INK. You can either continue drying with a drying tool or allow the ink to air-dry, depending on the effect you are going for. Experiment with both methods.

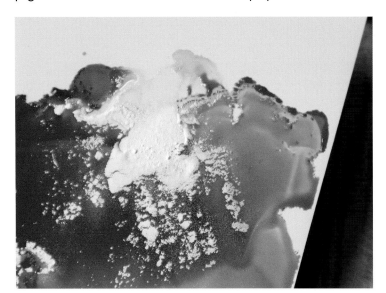

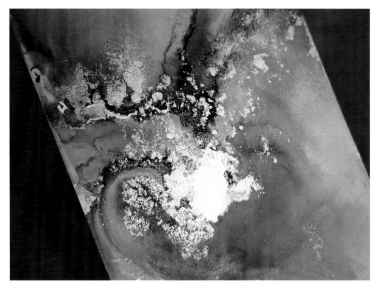

5 TILT AND CHECK. Here you can see the final effect of the metallic with the pink. If the ink is still a little wet, you can lift and tilt the paper to allow it to slowly move around a bit more.

6 CONTINUE ADDING COLORS. Build up your composition by following the preceding steps to add alcohol, color, and metallic ink in layers. I added some blues and partially blended them with more pink to create some purple zones. Include areas of subtle metallic and areas of intense metallic.

TIPS

▲ Make sure to let any metallic flecks dry before moving on to a new step or attempting to varnish the piece.

▲ The more you move around the wet metallic ink with a drying tool, the more textured the metallic effect will appear. If you allow the metallic ink to air-dry after being blended, you will get a more ethereal, cloud-like effect. I highly recommend walking away from a drying composition and not returning until it is completely dry if you are using the air-dry method.

▲ If the metallic ink settles on the paper and does not seem to be spreading easily, you can use a gloved finger or paintbrush dipped in alcohol to rub the metallic ink and bring it back to the surface. Immediately use a drying tool to move the metallic around.

·⟩ REFLECTION ⟨·

Whether you found this exercise easy or challenging, practicing with a medium will never hinder your creative pursuits. The more you practice, the more you learn and pick up on the intricacies of the medium you are learning to master. It takes 10,000 hours to become a master at something, and this exercise likely took you less than 30 minutes!

What has surprised you about your journey with alcohol inks so far?

What has been your biggest challenge so far?

CREATING INK TEXTURE WITH PLASTIC WRAP

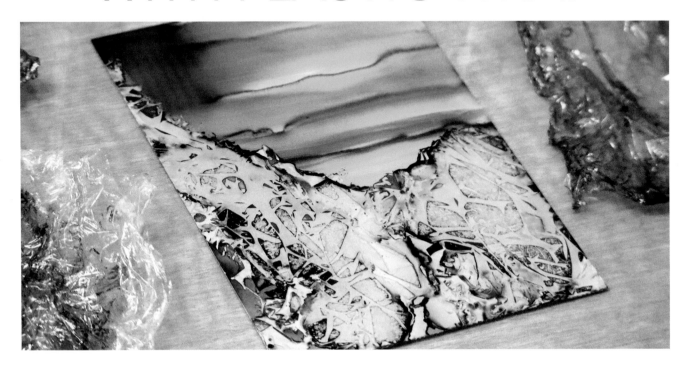

For this exercise, we are going to step outside the box a bit and incorporate a common household item to create a beautiful effect that can be utilized in a variety of ways in your abstract work. Plastic wrap may have its uses in the kitchen, but it also has a fascinating impact on drying alcohol ink! From the crunching of the plastic wrap to the application of the wrap to the paper, this exercise is a sensory experience as relaxing as it is exciting.

The end result of this technique is one of the most rewarding, but it does require the most restraint and patience of all the techniques explored in this book. Remember not to rush this exercise. Be an observer to your process and pay attention to what you learn along the way. As much as we hate to acknowledge it, especially if we are perfectionists at heart, mistakes and "mess-ups" are our greatest teachers. The more mistakes you make and the harder you push through those mistakes to accept them as lessons, the more brilliant of an artist you will become in whatever medium you choose to pursue.

The best outcomes come from patience

BEFORE YOU BEGIN

Put some isopropyl alcohol or blending solution in a small glass dish to clean your paintbrush between colors and some in a fine-tip squeeze bottle. If you are creating a gradient for the background (see Exercise 4, page 46), prepare your alcohol ink palette with your chosen colors before beginning. Also have the plastic wrap ready to go before you begin.

TOOLS & MATERIALS

- Alcohol ink: 1 or more colors for background, plus 1 or more colors for texture
- Yupo paper
- 91% isopropyl alcohol or blending solution
- One small glass dish
- Fine-tip squeeze bottle

- Drying tool (optional)
- Plastic wrap
- Paper towels (for wiping brush between cleanings)
- Varnish
- Gloves
- Protective face mask

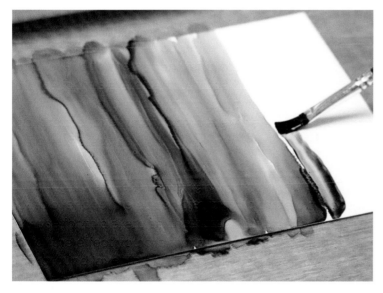

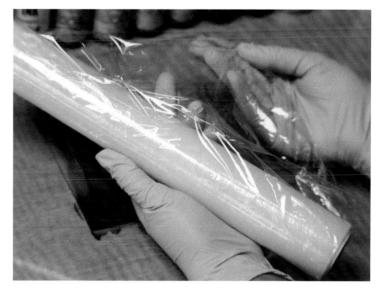

1 PAINT THE BACKGROUND. Create an alcohol ink gradient for the background of your piece. Try not to overload the paper with ink; the more pigment you use for this exercise, the harder it will be to lift the ink for the effect you are trying to achieve. Allow the background layer to dry completely before moving on to the next step.

2 SHAPE THE PLASTIC WRAP. Tear a piece of plastic wrap from the roll large enough for the composition you are looking to create. Crinkle the wrap up to create ridges and texture. You will be using this piece of wrap essentially like a stamp.

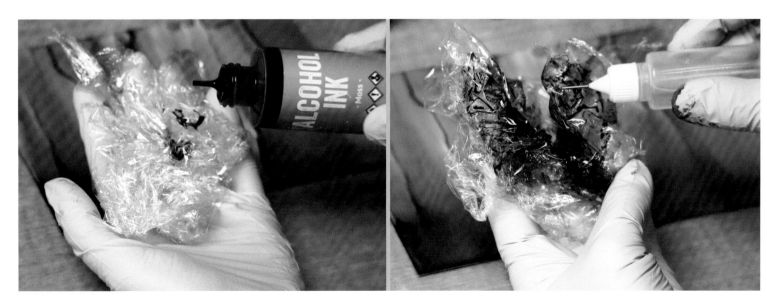

3 PREPARE THE "STAMP." Drop 1 drop of an ink color of your choice onto the crinkled plastic wrap, followed by 1 drop of alcohol, and crinkle the wrap further to spread the liquid. Do not apply too much of either. If the plastic wrap is too wet, you won't get the effect you are going for, and it will take forever to dry. Remember: less is more. You do not want ink and alcohol dripping from the plastic wrap. Think of it like a stamp: when you have too much ink on a stamp, the stamp will bleed and come out blurred and runny. The same goes here—you want just enough moisture to create an imprint on the already dried ink background.

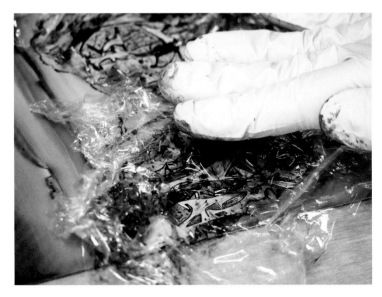

4 APPLY THE "STAMP." Apply the plastic wrap down onto the dried background. Once it's applied, press it down a bit with your fingers. Then grab something to hold the plastic wrap down on the surface. Closed ink bottles, a book, or a piece of glass are perfect for this.

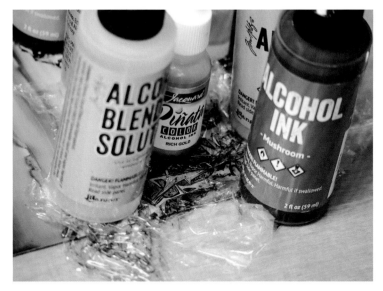

5 WAIT FOR IT TO DRY. After weighing down your stamp, you will be very tempted to move and mess with the plastic wrap as it dries and peek to see how it looks. **Do not do this!** Leave the plastic wrap and paper alone. You really need the liquid trapped in the plastic wrap to stay put so it can dry in place for this effect to work. If it is not completely dried, the effect will be compromised. I promise, you won't regret leaving it alone for a day.

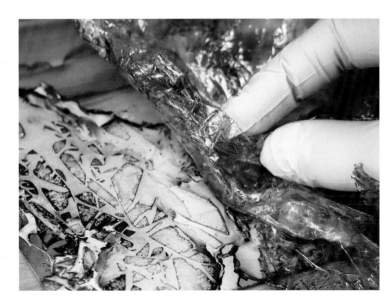

▲ Try bubble wrap for another interesting texture outcome.

▲ For your inky "stamp," you can choose the same color as the background or another color. Experiment with both.

6 PEEL OFF THE WRAP. After letting the piece dry for 24 hours, you are (most likely) ready to pull the plastic off the paper! You should be able to tell when it is completely dry. If you notice any sign of moisture under the plastic before lifting it or as you lift, do not remove it any further. Remove it only when there is absolutely no sign of moisture. Peel slowly and carefully to reveal your finished result!

·⟩ REFLECTION ⟨·

This exercise is one where if you do the smallest thing "wrong," you won't get the result you're looking for. I put "wrong" in quotation marks here because sometimes we get really interesting results when we don't follow the rules. If you do decide to break a rule, observe your results and notice if there is anything about this altered outcome that is worth saving. This exercise is a great example of using trial and error to teach you how to move through a project without rushing and without manipulating things when you don't need to. If you were able to achieve results you are proud of, I am proud of you!

Was it difficult to move through this exercise with restraint and patience?

What was it like having to wait a full day to check on your work?

CREATING INK RINGS

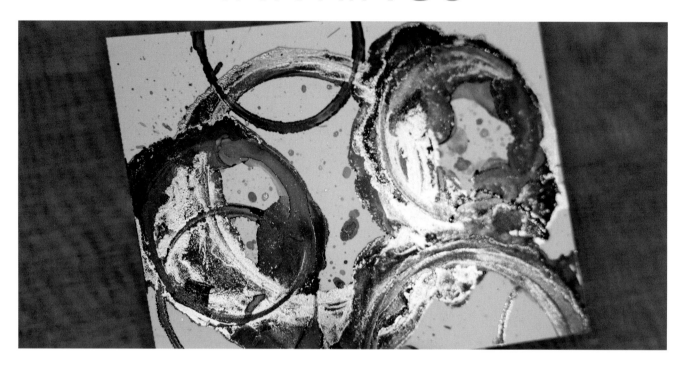

Are you intrigued yet by all the ways you can work with alcohol inks? The possibilities are truly endless, and it is so easy to get lost in a flow once you find a rhythm with alcohol inks. It can be fun to look around your home for different items to incorporate into your process. For this exercise, we are going to take another common household item—glass cups—and use them to manipulate our inks to create an interesting and unique composition.

Creating rings and bubbles with alcohol ink is a simple exercise with a really fun outcome that can be incorporated into your abstract work in a variety of ways. Remember that these exercises and projects are meant to serve only as a framework for developing a confident flow with fluid mediums. You can freestyle and improvise these exercises and projects with your own twists whenever you'd like. I am just here to show you what is possible, and it is your job to tap into your own unique process in order to discover what works best for you and the outcomes you are trying to achieve.

Anything can be a tool for making art

BEFORE YOU BEGIN

Put some isopropyl alcohol or blending solution in a fine-tip squeeze bottle. You will need at least one but ideally two or more cups of different sizes for this exercise. The heavier the cup, the better; solid glass cups work great because they're heavy and you can easily clean them with alcohol when you're done!

TOOLS & MATERIALS

- Alcohol ink: 1 or more colors
- Metallic alcohol ink: 1 or more colors
- Yupo paper
- 91% isopropyl alcohol or blending solution
- Fine-tip squeeze bottle
- Cups of varying sizes
- Manual air tool
- Electric blow-dryer or other heat-based drying tool (optional)
- Varnish
- Gloves
- Protective face mask

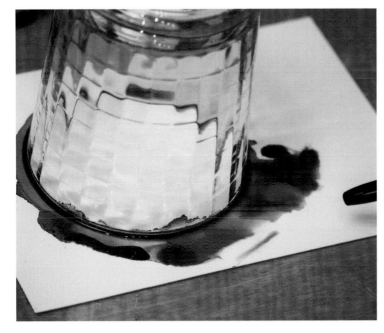

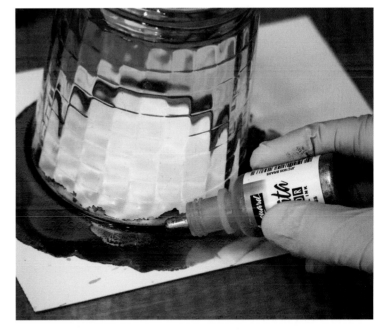

1 **START THE FIRST RING. Position a glass, rim down, wherever you'd like on your paper. Add your** first ink color along the outer edge of the glass and dilute it with alcohol. Add just enough ink to go around the entire rim of the glass. Then use an air tool to blend the ink and alcohol, guiding the ink around the rim of the glass. Do not let this layer fully dry before moving on to the next step.

2 **ADD METALLIC INK. Shake the metallic alcohol ink bottle well and add 1–2 drops to the still-wet** ink along the edge of the cup, adding more alcohol if needed to blend.

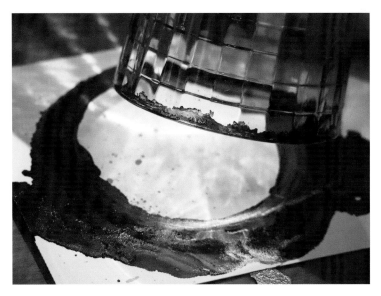

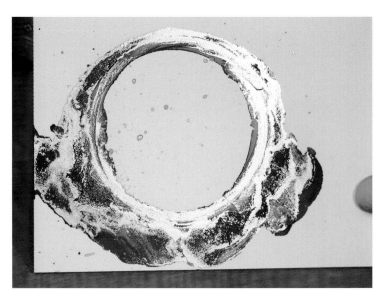

3 DRY THE INK. Use the air tool to fully dry the ring around the glass. Pay close attention to the area immediately against the glass, as this can appear dry but still have wet ink hiding. Feel free to use an electric air tool to complete the drying. Once you're sure the ink has dried, lift the glass from the paper to reveal your first ring.

4 REVIEW YOUR WORK. Here is the completed first ring. You can stop here with just one ring, or you can continue on to create different, overlapping rings in different sizes. Let's do it!

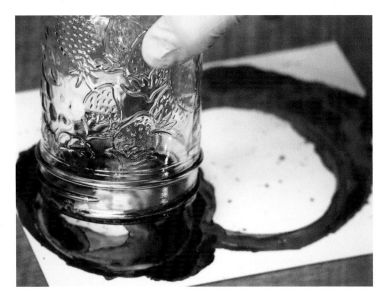

5 ADD MORE RINGS. Using a different-sized glass, repeat steps 1–3, using either the same colors or different colors. You can put more than one glass on the paper at a time if you'd like to speed up the process and change up the composition a bit.

6 EXPERIMENT. Experiment with adding different amounts of ink and creating different color combinations in each ring to achieve different results and to make the composition more interesting.

TIPS

▲ You can start with more than one cup if you'd like; it's up to you and the composition you are looking to create. Try a few different ways!

▲ Bowls or other flat, heavy objects with interesting shapes will also work for this effect.

▲ When working with a manual air tool, be careful not to push the air out too fast, or you'll cause the wet ink to splatter. If it does splatter, just use the splatter drops to guide where you go next with the composition. That is the great thing about alcohol inks—you can use your mistakes as guides rather than reasons to stop.

·❯ REFLECTION ❮·

Think about all the ways you can incorporate this interesting technique into your abstract work. Abstract art is about thinking outside the box and using your imagination. It allows you to tap into that childlike wonder of being a kid in a room full of art supplies with no rules other than to have fun and create. Abstract expression is about finding ways to manipulate and change commonly used mediums and tools to create new and unexplored outcomes. It is not about perfection—it is about practice and the pursuit of joy through the process.

How did your inner critic show up during this exercise?

What did your inner critic say as you created?

SWIPING WITH HIGH-FLOW ACRYLICS

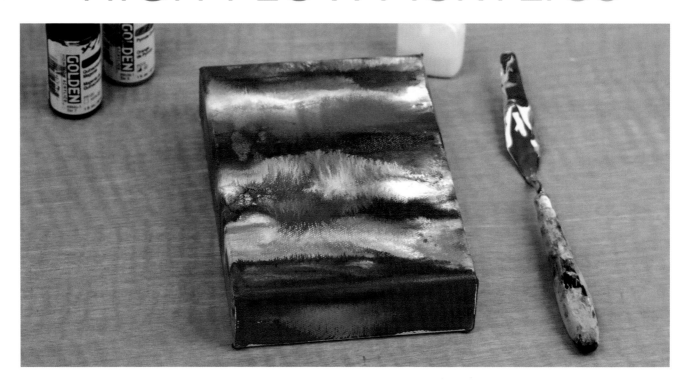

It's time to transition from working with alcohol inks to working with high-flow acrylics. Do not be intimidated! While they are quite different, they truly complement one another, both in process and in outcome. High-flow acrylics bring me back to finger painting as a kid. It's a messy medium that you can really immerse yourself in. Working with acrylics is also nice because you do not need ventilation precautions and do not have to wear a mask, unlike with alcohol inks.

For this exercise, we are going to start simple by creating a swipe effect with high-flow acrylics. It takes time to develop muscle memory for how the paints behave, so, as always, be patient with yourself. The more you practice, the more you will intrinsically remember how to work with the medium without having to resort to strict ratios and math. That's what makes this such an intuitive process—you get to know your mediums on an intimate level so that they start to do the work for you without you having to think too hard about it. The more you practice with "mindless" five-minute exercises like this one, the quicker you will master your chosen medium—and you will always learn something.

I fully immerse myself in my process and surrender the rules

BEFORE YOU BEGIN

Prepare your canvas for high-flow acrylic application by following the step-by-step instructions on page 27.

TOOLS & MATERIALS

- High-flow acrylic paint: 2 or more colors, plus white
- Stretched canvas (I am using a 5" x 7" x 1 1/2" / 12.7 x 17.8 x 3.8 cm canvas)
- Fine-mist spray bottle
- Palette knife
- Paper towels
- Gloves

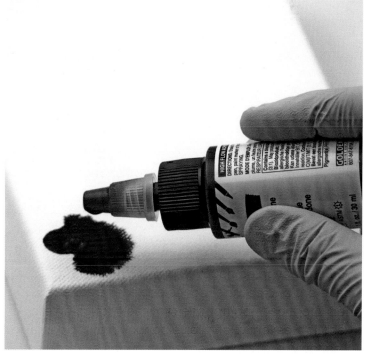

1 **WET THE CANVAS.** Start with a wet canvas—not puddly wet but lightly coated with water. If you lift and tilt your canvas, you should not see water dripping down the canvas. This is just to make the surface slick for a smoother paint spread.

2 **ADD THE FIRST COLOR.** Starting on one side and corner of the canvas, drop 2–3 drops of your first color of acrylic paint. How much paint you should drop depends on the size of your canvas and the effect you are going for. You want enough paint so that when you spread it with your palette knife, it makes it all the way across the canvas. This may take some practice and muscle memory with your paints before you get it just right.

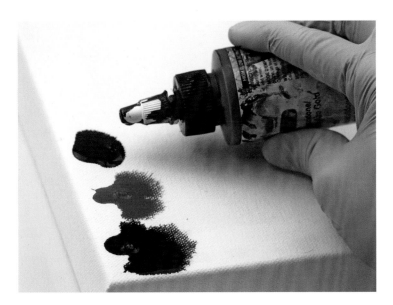

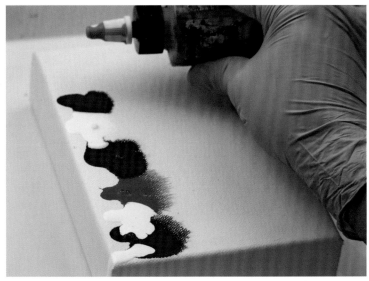

3 ADD MORE COLORS. Add the next color above the first but not touching it. Continue adding drops of color up the side of the canvas until you reach the top. If you are going for a landscape, consider the colors you might see in that landscape and create a pattern that emulates those colors.

4 ADD SOME WHITE. No matter your color palette, add a few spots of white between some of the colors to lighten up a few areas and create contrast. Without the white, you may get a very dark and possibly muddy outcome. The white also helps to break up colors that may not mix well together.

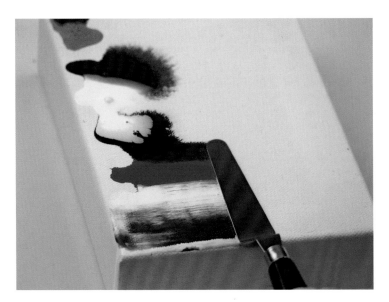

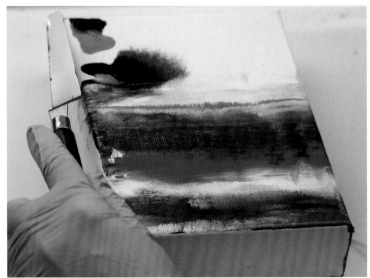

5 START SWIPING. Pick up your palette knife. Starting at the bottom corner, use the palette knife to swipe the drops of paint across the canvas until they spread all the way to the far edge. Here you can see the paint midswipe.

6 FINISH SWIPING. Continue working your way up the canvas, swiping until all the paint has been spread. Wipe off your palette knife between each swipe if you want to minimize colors mixing—I often do, but not always.

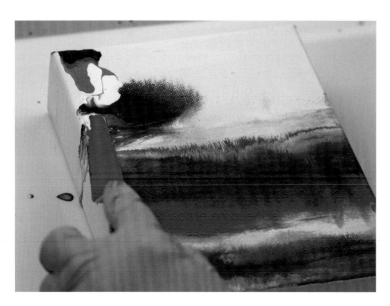

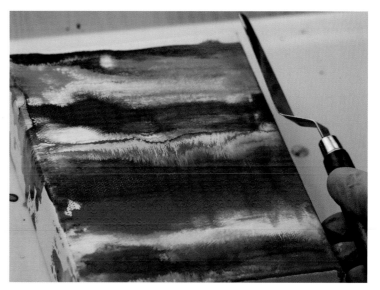

7 MAKE ADJUSTMENTS. You may want to go back over a few spots or use the tip of the palette knife to blend or spread some smaller details within the layers. There are no rules—have fun and immerse yourself in the process.

8 LET DRY. Allow the piece to dry; do not touch or move it until it is completely dry. It will be very tempting to disturb the piece while it dries, but I promise you will be much happier with the result if you just walk away and come back in a few hours.

·) REFLECTION (·

When I first started teaching myself to paint, I would skip foundational exercises and warm-ups. I did not take time for an art journal or to get to know my mediums. Looking back now, that was my biggest mistake. My creative flow suffered because I rushed through my creative pursuits and skipped building the foundation; because of this, I had a harder time creating consistently beautiful work. Do not rush the building of the foundation of your creative process. A consistent and confident creative flow leads to dependable results, whereas a quick masterpiece may just be luck that is impossible to replicate.

How was the transition from alcohol inks to high-flow acrylics?

What was challenging about this transition?

Did the inner critic make an appearance? What did it say?

CREATING SWIRLS WITH HIGH-FLOW ACRYLICS

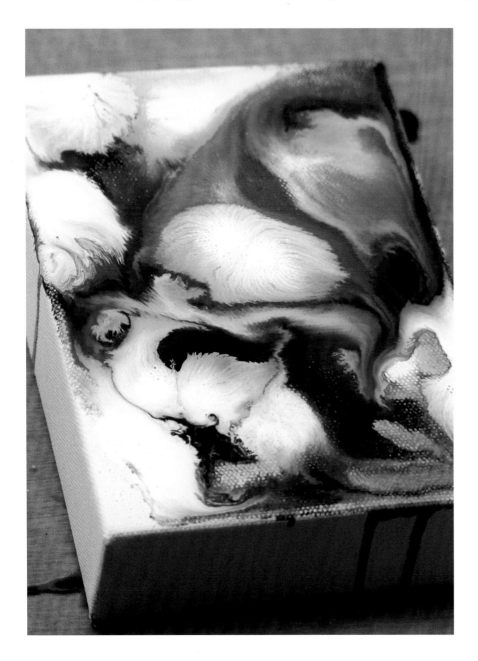

High-flow acrylics are an intuitive medium by nature, so following an intuitive process when working with them is only natural. In this exercise, you'll be using paint and water to create organic-looking, flowing swirls. It can be hard to plan or predict the outcome of working with high-flow acrylics, so practicing with small-scale studies like this to build muscle memory is key to tapping into a confident creative flow.

My biggest piece of advice when working with high-flow acrylics is to take your time and do not rush. The more you rush or try to make everything happen all at once, the more likely it is that you will create mud. Allow the process to speak to you; allow the piece you are working on to speak to you. All too often we hear that nagging voice in our heads telling us "Stop, this is perfect; if you keep going, you will mess it up," and, while I do not always recommend listening to the inner critic, this is a time to ask yourself: Is that the inner critic or is that my intuition telling me that I've done enough? There is a difference—you just have to learn how to listen for it.

Slow down and listen to the process

BEFORE YOU BEGIN

Prepare your canvas for high-flow acrylic application by following the step-by-step instructions on page 27.

TOOLS & MATERIALS

- High-flow acrylic paint: 2 or more colors, plus white
- Stretched canvas (I am using a 5" x 7" x 1 ½" / 12.7 x 17.8 x 3.8 cm canvas)
- Fine-mist spray bottle
- Tiny fine-mist spray bottle (like a perfume sample spritzer)
- Paper towels
- Gloves

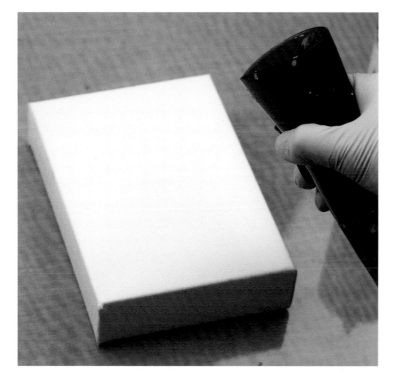

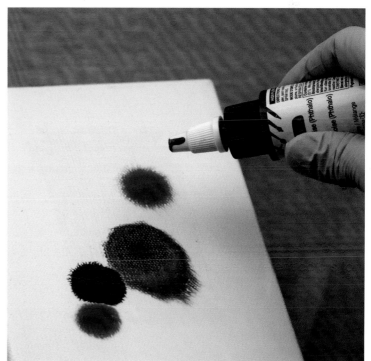

1 WET THE CANVAS. Mist the front of the canvas to wet it as you did in Exercise 8 (page 62). Misting the front of the canvas helps the initial paint drops to spread. For this exercise in particular, you may want the canvas to be a bit wetter than in Exercise 8, but you can always add more water as you go.

2 START ADDING COLOR. Add 1–2 drops of each color to the canvas. I used three different colors for this composition.

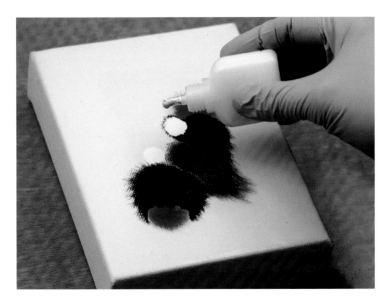

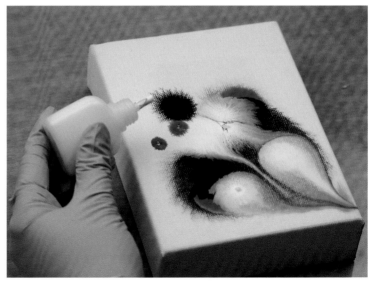

3 ADD SOME WHITE. Add a few drops of white among the colors to break them up a bit. You can already see, when you compare this photo to the previous step, how the colors have started to move and bleed due to the wet base.

4 ADD MORE PAINT. Continue adding colors and white if you'd like to further fill the composition, but note that all the drops will spread during the next step, so be mindful not to overload the canvas. Less is more—one drop at a time. Again, you can see in this photo how the colors have moved over time just due to the wet background—there was no blowing or moving of the canvas!

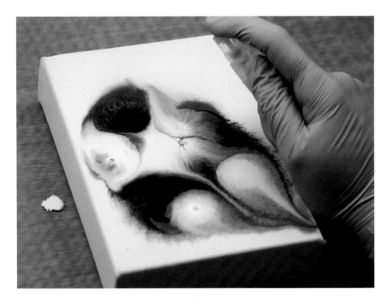

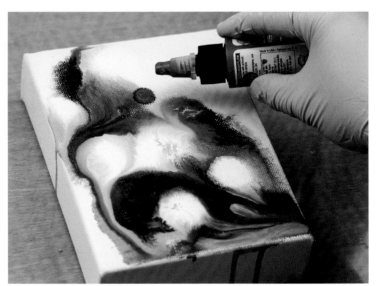

5 START MISTING. Mist the paint drops with a tiny fine-mist spray bottle for precision, going lightly at first to see how the paints react. The wetter you get the canvas, the more the paint will shift and blend, so you want to work to find a balance. I know this sounds vague, but there are many factors involved with determining how much paint to add or not add.

6 COMPLETE THE PAINTING. From now on, alternate between adding more drops of color, adding more drops of white, and lightly misting the canvas. At this point, the photo shows that I have added more blues/greens, white, and misting at the top and some orange, white, and misting at the bottom. But I'm not done yet!

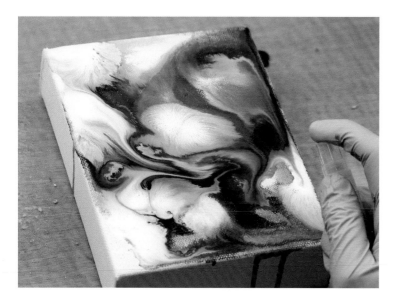

7 **ALLOW TO DRY.** When you are satisfied with your composition, stop and walk away from it completely for at least several hours. You will be happy you didn't fuss with it when you check on the piece after it has completely dried. You will be surprised to see how much it changes once the paint fully absorbs into the canvas!

TIPS

▲ The more water you add, the more translucent the paint will become and the more the paint will mix together to create one color rather than the swirl you might be hoping for. With practice, you will understand what happens when you add too much of one thing and not enough of another.

▲ This technique is truly a matter of muscle memory, which is why I recommend practicing this and the other exercises more than once to familiarize yourself with the mediums and how they behave.

·ᗒ REFLECTION ᗕ·

How was that? Did you enjoy the process? The outcome? If so, you are on your way to finding a healthy creative flow. If you enjoyed the process but not the outcome, or even if you enjoyed neither, you are still on your way to finding a healthy creative flow. It is not always about enjoying what we do, how we do it, and what comes of it. It is often just about showing up, engaging in the work, and reflecting. The trick is to keep showing up no matter what, even when the process is ugly and the outcome even uglier. You are on your way, so keep going.

Do you have a dialogue with your creative process like you do
with your inner critic?

How does your creative process communicate to you?
If it doesn't communicate to you, how would you like it to communicate to you?

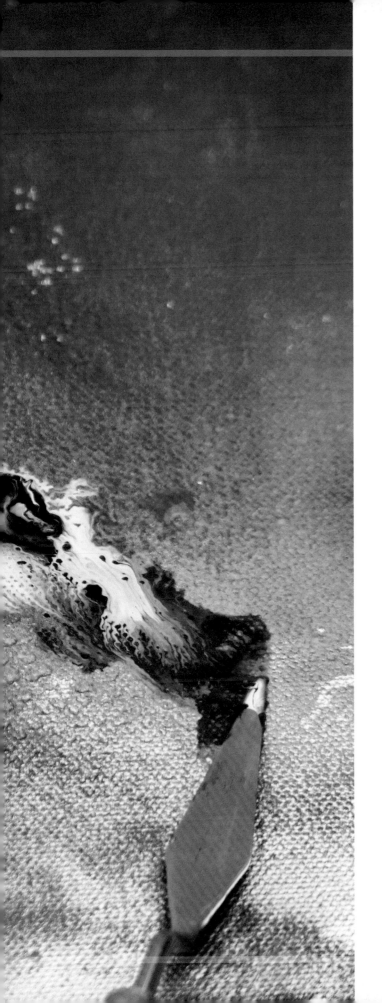

Chapter 3

PROJECTS

You made it! This is the part of the book where you get to fully express yourself. I am so excited we made it to this part of the journey, and I am so proud of you for sticking with it. If you haven't already, make sure to walk through Chapter 2 before diving into the projects. Even if you think you have a technique down just by reading it, if you've never physically done the techniques outlined in the exercise, I highly recommend practicing and warming up before you begin a project.

Before diving in, I want to introduce a trick that can make working through these projects more fulfilling and enjoyable. Try to tap into what is called a witness mindset. This is when you become the observer of your thoughts. Unlike the inner critic, the observer can be our very best friend. The observer can nonjudgmentally help keep us in the moment. The observer gives the inner critic a back seat and allows presence to take over. As you approach the 10 projects, see if you are able to invite in this witness mindset to help activate and deepen your creative flow. See what you notice about your process and how you speak to yourself during it. Allow the inner critic and all the other parts holding you back from fully embracing your creative process to finally rest. It's time to let the inner child play!

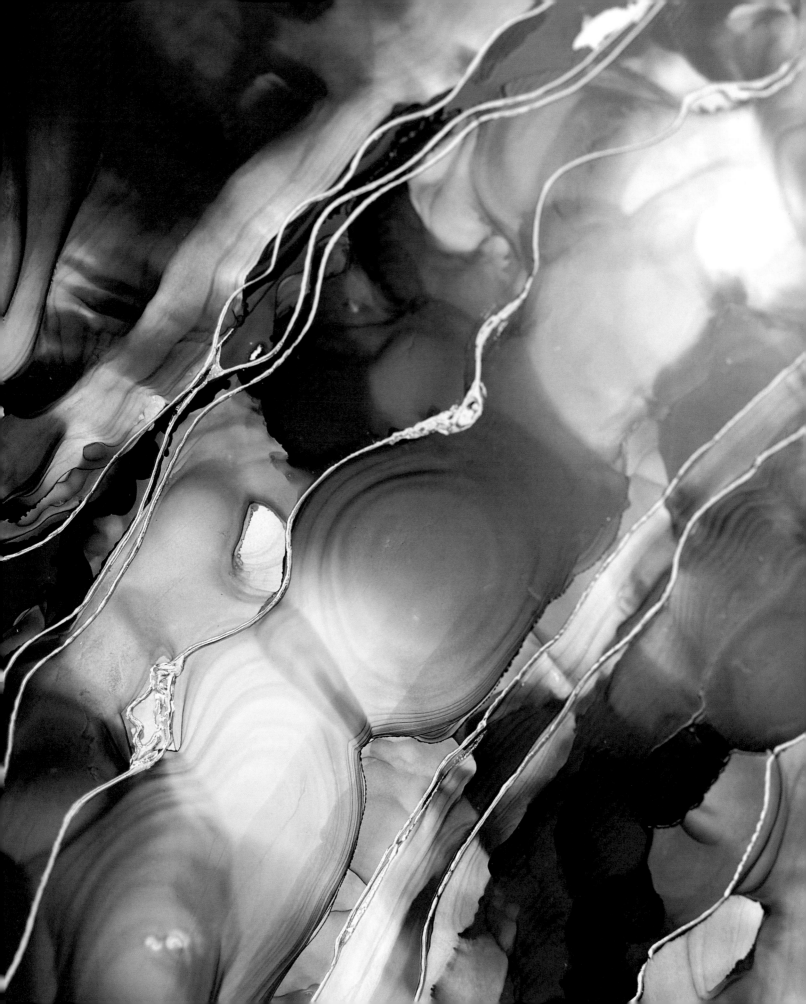

MONOCHROMATIC ALCOHOL INK GEODE

For this first project, we are creating an abstract expression of a geode or gemstone using only one alcohol ink color—a monochromatic piece. Monochromatic means using only one color, but since alcohol ink product lines often have multiple variations of each color, feel free to use more than one variation of the same color, as I did. For my composition, I wanted to capture an abstract expression of a purple agate slice up close—like a macro shot. I wanted the focus of the geode to be the striations within the layers, not the geode in its entirety. This composition also allows you to spend less time focusing on trying to make it look exactly like a geode and gives more room for abstraction. You can either use my final piece as your reference, or, better yet, find a reference image or live reference of your own to draw inspiration from.

I give my inner critic permission to rest so I can create

LIMIT MATERIALS TO FOCUS ON CREATIVE FLOW

For our first full fluid art project, we are going to ease in to developing an entire creative flow from start to finish.

To make this first process more accessible, we will use a limited number of materials; this will allow you to focus on the creative aspects of the project and on confronting the inner critic.

When we live by the voice of our inner critic or perfectionist, we tense up and become afraid of our process. We become apprehensive when creating, fearful we will waste our materials, and our flow becomes rigid. Use this project to loosen up. By using only one color and very few materials, you'll expend no energy trying not to waste materials. You also rid yourself of the stress of having to make the colors blend perfectly. Therefore, the energy you save can be used to tap into a witness mentality: you can remain present in your process and at the same time observe how judgment and the inner critic might show up. No inner critic or judgment showing up? That's the goal. When the inner critic is absent and judgmental thought processes go silent, you can work with alcohol inks like a meditation.

This simple project will benefit from you spending a bit of time preparing for the final version. Using reference photos or a live reference (in this case, a real agate slice or geode) is a great way to guide your creative process and keep you focused on your concept. To show you how creating a color study and developing a concept can be helpful, I also recommend for this project that you create a smaller study of the colors and techniques you'll be using to bring your geode to life.

By using only one color and very few materials, you'll expend no energy trying not to waste materials.

For the piece I created here, I used a small swatch-sized piece of Yupo paper to test out my colors together first, and then I created a 5" x 7" (12.7 x 17.8 cm) study to try the techniques. By having these study pieces in front of me as I worked on the final project, I had more confidence in how the colors would blend and how the techniques would look. Sometimes you think you know how two colors are going to look together or how a technique will work, but end up being thrown off by something unexpected. Remember, alcohol inks can have a mind of their own! There is nothing worse than spending precious time and materials on a large final piece only to end up unhappy with the result. Frustration before, during, and after your creative process feeds the inner critic, and the inner critic, in turn, feeds potential creative blocks. The more you can nurture a present and relaxed process, the more freely your creativity will flow. Time and materials are certainly valuable, and wasting them is never the goal. But I challenge you to ask yourself if any supply is truly wasted if you learn something in the process of it being used.

If your inner critic shows up during this project, gently coax it somewhere it can relax. Imagine sending it to your favorite place in the world for a moment, giving it permission to rest. Its primary job is to try to protect you from failing and creating bad or ugly art, but we are here to tell it that we do not need to be protected, because making "bad" art is a welcomed part of the process.

LET'S GET STARTED!

Practice with the ink color and brand you're working with by creating a small color study where you can experiment with the techniques you'd like to use on your project piece. I created two small studies for my abstract geode. The more studies you create for your final piece, the more comfortable you will be with the process.

TOOLS & MATERIALS

- Yupo paper: 11" x 14" (28 x 35.5 cm)
- Alcohol ink: 3 monochromatic colors
- 91% isopropyl alcohol or blending solution
- Fine-tip squeeze bottle
- Drying tool
- Paintbrush
- Small glass dish
- Relief adhesive (such as Pebeo MIXTION Relief or gold leaf adhesive)
- Holographic transfer foil
- Paper towels
- Varnish
- Gloves
- Protective face mask

COLOR KEY

 Purple Twilight (Ranger)

Amethyst (Ranger)

 Vineyard (Ranger)

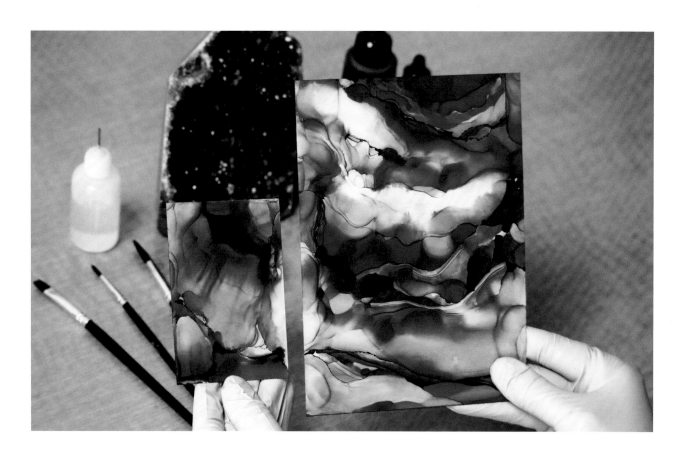

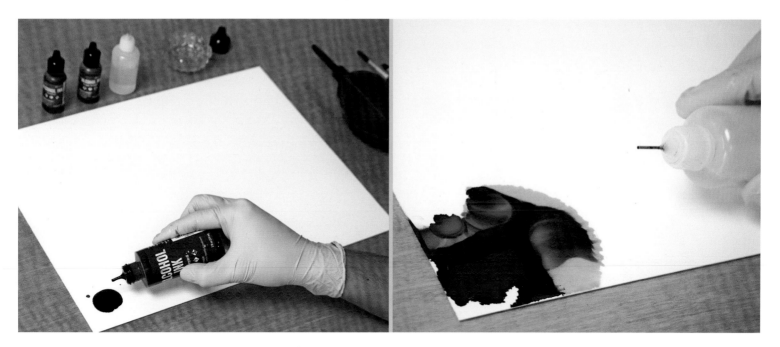

1 START WITH ONE COLOR. Pick where you'd like "center" of your geode to be. Add a drop or two of color to that spot and dilute with a small amount of alcohol along the outside edge of the ink. When blending, spread out the color only a bit. It's okay if this area is more concentrated than other areas, since this is the centermost point of the geode. You can either let this air-dry or use your drying tool; I used the air-dry method here to avoid spreading it out too much.

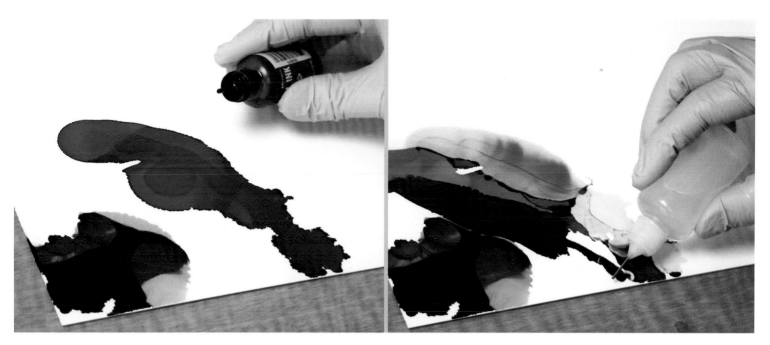

2 ADD A SECOND BAND OF COLOR. Take the next color or colors and add a line of ink along the edge of the first color without letting the colors touch. It's okay to leave a small gap of negative space between colored areas. I used three different purples at once for this layer in the geode, blending them together with a sandwich of alcohol on both sides of the wet ink, allowing the alcohol to bleed toward the center of the ink and create geode-like lines. Let air-dry or use the drying tool, depending on the effect you are getting; I did a combination of both here.

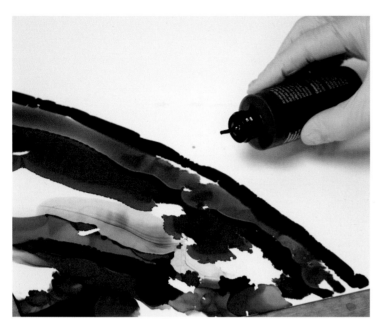

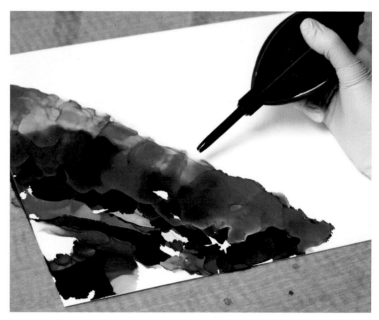

3 ADD A THIRD BAND OF COLOR. Add a new layer to your geode by alternating colors within your monochromatic color scheme. Add ink down first each time, instead of blending solution, to allow for a more defined edge and less spreading of each layer. Here, I added three colors in a closely laid band.

4 BLOW TO CREATE A STRIATED EFFECT. Change up the size of each layer of your geode by diluting your ink line with more alcohol along the edge of the line of wet ink. Using the drying tool, blow the alcohol into and away from the wet ink line. If you continuously blow the ink in one direction in long spurts, pushing the wet ink either into the dry ink or away from the dry ink in one direction, you will create more of a striated effect, as shown here.

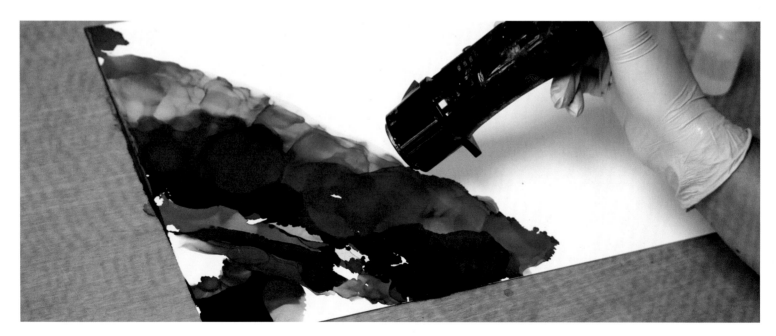

5 SWITCH TO A HEAT TOOL. Using an electric heat tool will dry the ink faster in place and create different and unique effects. Alternate between using different tools and methods of drying each layer to capture the unique variations in individual geode layers.

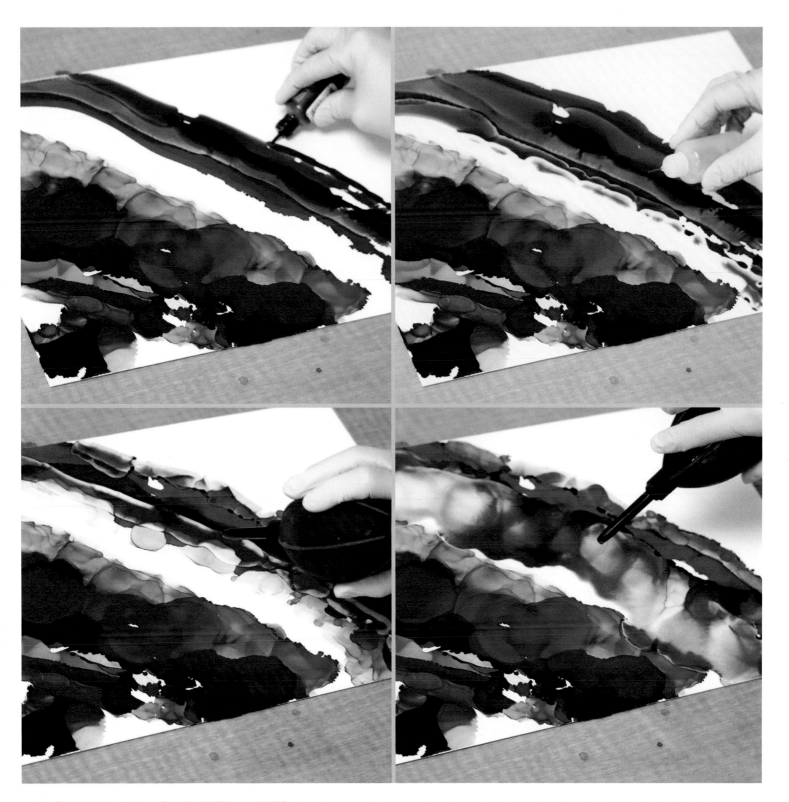

6 CREATE A BILLOWY NEW LAYER. For the next layer, after dropping bands of ink, drop alcohol into the negative space next to it and push the alcohol into the ink with your drying tool. Add down a bit more alcohol to create a billowy effect and then use the drying tool to push the alcohol and ink toward the negative space where you originally dropped the alcohol. Because you left the negative space free of ink initially, you will be able to create a beautiful translucent layer that wouldn't have been possible if you were working in an area already saturated with color.

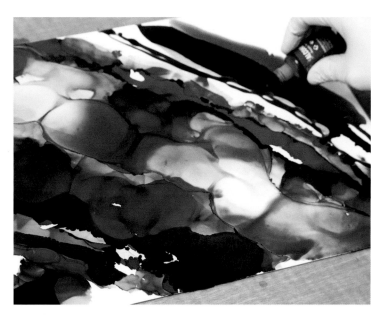

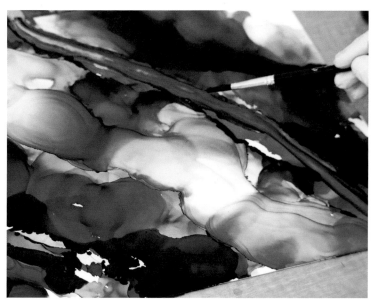

7 **FINISH THE MAIN LAYERS.** Continue filling in your composition, building the shape of your geode as you go, until you have more or less filled your paper. Allow all the ink to dry.

8 **ADJUST AND ADD DETAIL WITH A PAINTBRUSH.** Once the ink is dry, go back in with a paintbrush dipped in alcohol to soften up or add detailing to any desired areas. You can paint lines and striations that resemble the lines of a geode using this technique if you'd like. Just be careful not to oversaturate your paintbrush with alcohol; remember, the alcohol spreads once you put it down.

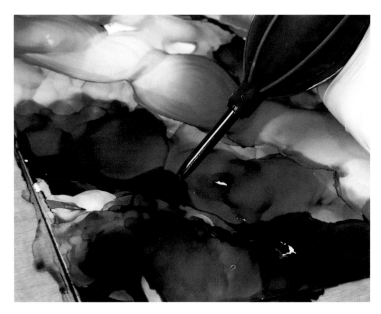

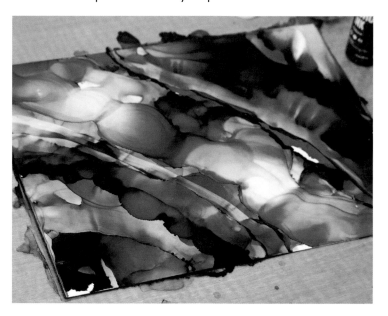

9 **CONTINUE MAKING ADJUSTMENTS.** I returned to the very first two layers of my painting to fill the white paper with color. To do this, I alternated dropping ink and alcohol and pushing the ink around with my drying tool.

10 **DRY AND VARNISH.** Let your piece dry for 12–24 hours and varnish it before moving on to the embellishment steps that follow. Some people varnish right away after drying, but I like to wait at least 12 hours to give the ink time to set. There have been times the ink has bled when I varnished too soon—let's not risk it!

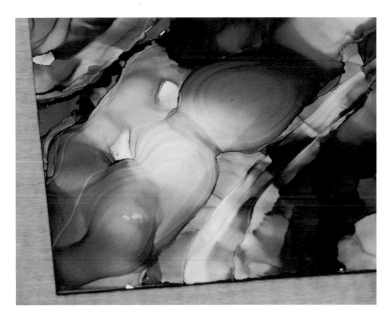

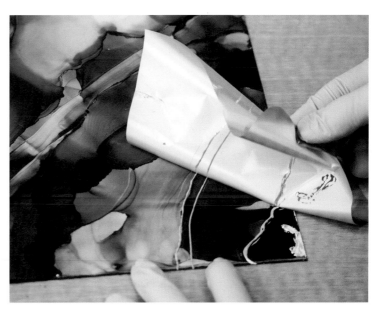

11 DRAW DETAILS WITH RELIEF ADHESIVE. For added depth and uniqueness, we're going to add embellishment using relief adhesive and holographic transfer foil. Using the relief adhesive, draw details and lines that accentuate the geode and bring it to life. In this photo, you can see some of the lines I've drawn—they appear light pink.

12 APPLY THE FOIL. Allow the relief adhesive to dry for the recommended amount of time before proceeding—you will regret it if you add the foil too soon! Once the relief adhesive has reached peak tackiness (refer to the details of your particular product), apply the foil to the lines you drew, pressing gently to make sure the foil is fully covering the relief adhesive. Peel it away and voilà!

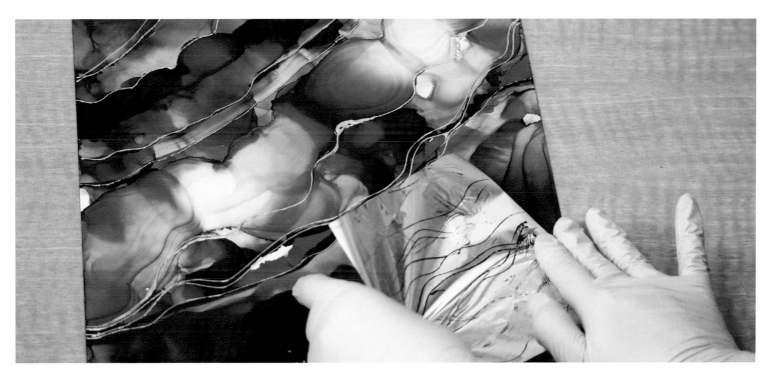

13 FINISH ADDING FOIL. Continue applying the foil and peeling it off until you've covered all the relief adhesive you added.

REFLECTION

How did that feel? What were you telling yourself before, during, and after your creative process? Were you able to tap into a creative flow easily or was it difficult? What made it easy, or what got in the way? These are all questions you can ask yourself when looking at the outcome of your project and reflecting on how you got there. I especially want you to reflect if you did not like your outcome. All too often we get immediately frustrated that we did not like our piece; we may throw it away and never consider it again. If you want to learn from everything you do in your creative process, reflection and critique are vital—even if you hate the piece. It can feel uncomfortable critiquing a piece you know you are not satisfied with, but, by giving yourself time to reflect, you will deepen the learning process and maybe even come up with a way that you can enhance the piece so that you are more satisfied with the outcome. Some of my best work has come from reworking pieces I came back to after thinking I hated them.

Notice how it felt working with only one color. You can repeat this project a thousand times and always get a different result. You can create this project again based on your mood or based on different types of geodes and crystals. We can often find ourselves relying on the colors to do the work in abstract pieces, so using one color can challenge us to focus on our composition.

Let this project be a meditation for when you need to warm up with alcohol inks. I find that after a long time of not working with inks, warming up with a simple project like this helps me find the muscle memory again.

dig deeper

What is your relationship to frustration in your creative process?

How did frustration show up in this project?

Were you able to tap into the witness mindset?
What did you observe about your process and flow?

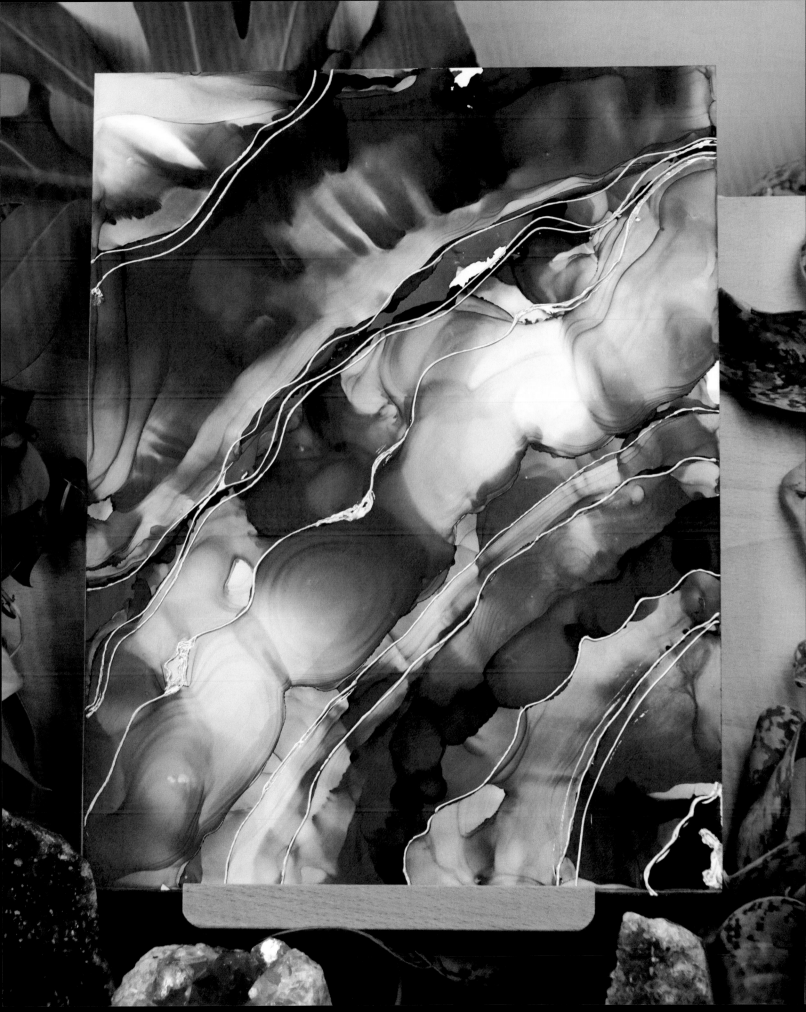

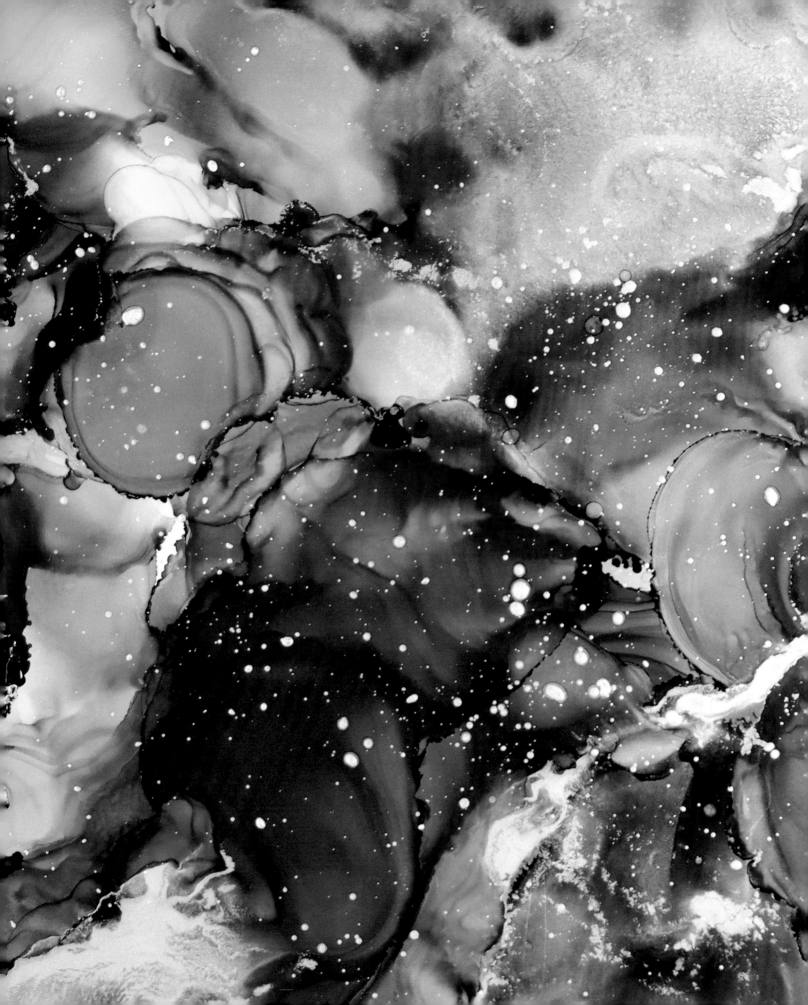

ALCOHOL INK NIGHT SKY DREAMSCAPE

Our second project brings us on a deep dive into the cosmos as we use the night sky as a reference to paint an alcohol ink abstract dreamscape. Alcohol ink is an amazing medium for creating ethereal, cloud-like dreamscapes reminiscent of a starry sky or a milky galaxy. To achieve this, we'll incorporate black alcohol ink and a few different techniques. As always, the goal is not perfection or to replicate exactly what I have created here. The goal of this project is to have you formulate an abstract expression of the night sky that feels unique to you and your process. This is where you begin to truly implement your own creative process and vision; this is where you get to express yourself in an intentional way.

I do not need to engage with my thoughts

find your flow

BALANCE MULTIPLE TECHNIQUES AND AWARENESS

For this project, we will focus both on the technical side of creation and, simultaneously, on engaging with your individual process—something that can be challenging for aspiring abstract artists.

To make a night sky dreamscape, we will combine multiple techniques for working with alcohol inks. Combining multiple techniques at once when working with fluid compositions can feel overwhelming at first. When we have a blank paper or canvas in front of us, we can have the urge to just pour all the ink out at once and create a composition in one quick stroke. While you can eventually get to a point where it feels like you are creating a piece in one stroke, learning to master the individual skills that go into a project, like we did in Chapter 2, will help a more technical project come to life with ease and flow. Creating consistently successful fluid abstract compositions is about mastering the different components of the project before trying to bring the entire project to life right away.

Leading up to this point in the book, we have confronted the inner critic and started a dialogue around how the inner critic shows up in the initial phases of your creative process. We've also identified a way to engage with the inner critic that sends it to a place where it can rest, rather than fueling it to antagonize us more. During this project, I want us to work toward further developing and cultivating the ability to notice when the inner critic comes up in the first place. Tapping into an intentional creative process means being so present in your process that you become aware of how different parts of your thought processes and psyche may inadvertently try to sabotage the flow you are trying to establish. The inner critic shows up during art making to make it so you don't take the risk of making art—but you've been called to create, so create is what you are going to do.

Balancing multiple techniques while maintaining present moment awareness in abstract fluid painting can be a challenging task. However, by practicing certain techniques and

Learning to master the individual skills that go into a project will help a more technical project come to life with more ease and flow.

mindset shifts, painters can learn to stay present and focused while utilizing different approaches to their painting process. Here are some strategies for balancing multiple techniques while staying present.

Stay grounded: Grounding practices, such as meditation or deep breathing, can help you maintain a sense of present moment awareness throughout your painting process. If you feel yourself getting distracted or overwhelmed, take a few deep breaths to center your focus.

Work in layers: An effective way to incorporate multiple techniques is to work in layers while creating abstract fluid painting. This process can be seen as a progression of changing imagery, where techniques can be switched after each layer. In doing this, each new layer presents opportunities for combining, subtracting, or introducing new colors or forms while maintaining a sense of the painting's direction.

Keep a balanced composition: It's important when using multiple techniques to balance the composition of the painting. This means the successful implementation of different techniques used should not overwhelm or unbalance the final work.

Imagine you are standing under a vast blue sky scattered with puffy white clouds. As you watch the clouds, you see them moving, and you might notice their shape, their color, or their size, but you do not leap into the sky trying to grab the clouds; you do not try to change the clouds or ask them why they chose the shapes they did. The blue sky is your mind. The clouds are your thoughts. As you move through your creative process, treat your thoughts like clouds passing in a vast blue sky. Do not grab on to them by engaging with them—just notice them and let them move along.

LET'S GET STARTED!

Before beginning the painting, start by planning a basic structure or approach to the painting that can guide your process. I do this by creating a small and loose study using the colors I intend to use for the final piece. This will keep you focused on the overall direction of the painting while also incorporating different techniques. While planning and structure can be helpful, keep yourself open to the unexpected and embrace experimentation. The best way to do this is by letting go of attachment to specific outcomes and instead approaching paint and techniques as an explorational process.

TOOLS & MATERIALS

- Yupo paper: 11" x 14" (28 x 35.5 cm)
- Alcohol ink: 2 colors of your choice, plus black
- Metallic alcohol ink: silver
- 91% isopropyl alcohol or blending solution
- Fine-tip squeeze bottle

- Drying tool
- Pipette
- Paper towels
- Varnish
- Gloves
- Protective face mask

COLOR KEY

- Pitch Black (Ranger)
- Vineyard (Ranger)
- Stream (Ranger)
- Sterling (Ranger)

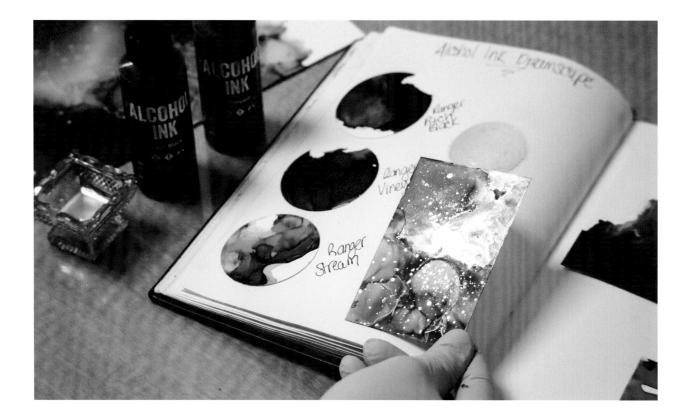

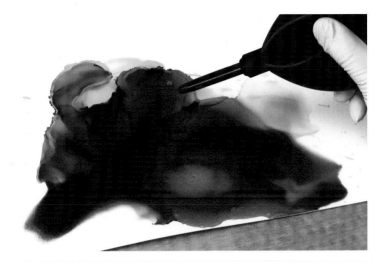

1 **START AT A FOCAL POINT.** Begin by dropping 2–3 drops of alcohol and 1–2 drops of your first ink color in the center of your paper or wherever you want the main focal point to be. Picking a focal point to start from and building around this point will create a composition that feels like you are falling into the dreamy sky in front of you. I recommend starting with a darker color as your focal point to create the illusion of distance—what is farther away from you will usually be darker, especially in a night sky.

2 **BLEND AND DRY.** Use your drying tool to blend the ink and alcohol together. Add the second color as well. I used the tool to blend the colors initially but allowed the rest of this layer of ink to air-dry. The more you manipulate the ink with air as it dries, the more hard lines and texture you will create. We are going for an ethereal, cloud-like effect for this painting, so the less you manipulate your inks once blended a bit, the better. I know watching paint dry isn't usually interesting, but presence and patience will give you the composition you are hoping for.

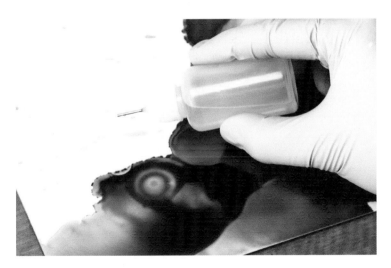

3 **PREP FOR BLACK.** Now it's time to add the black alcohol ink. Black alcohol ink is extremely pigmented, which means the tiniest bit goes a long way. First, add a few drops of alcohol next to the first color layer. Dropping your new black layer next to the first layer rather than right on top of it will help create dimension in the piece, rather than having it all blend together.

4 **ADD THE BLACK.** Then, drop a single drop of black ink with your just-dropped alcohol. Use your drying tool to move the ink around. It is up to you whether you let the previous layer fully dry or wait only until the edge of that layer begins to dry—just make sure to choose one or the other to create a layered effect. Adding wet ink to wet ink will cause the colors to blend and bleed together more than if you let one layer fully dry before adding the next.

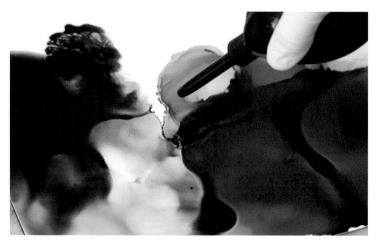

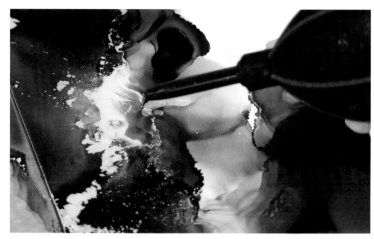

5 ADD A LITTLE MORE COLOR. Continue to build the composition by alternating between adding drops of color and alcohol, blending them with your drying tool as you go. Here, I've added new drops of blue and green along the top side edge of the black. For this piece, I am building the composition in layers by choosing one small area to fill and dry at a time, creating a billowy, cloud-like effect. This would be considered the wet-on-dry technique, but I do use the wet-on-wet technique within the layers to create differentiation in each layer as I go. Before you let this layer dry completely, move on to the next step.

6 ADD AND BLEND THE METALLIC INK. Shake the bottle of metallic alcohol ink and add 1–2 drops onto the still-wet ink layer, then immediately blend the metallic ink into the wet colors, not allowing the metallic ink to spend too much time settling onto the paper. Remember, the less you re-dilute and move the metallic ink once it has settled, the better. I usually wait until I have put down a layer or two of non-metallic color before adding in the metallic ink.

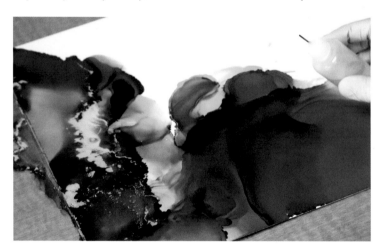

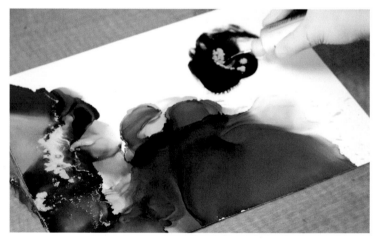

7 CHECK YOUR PROGRESS. At this point, you have probably filled about half of your paper. (If you have filled more or less, that's okay!) If you've already filled your paper, skip ahead to step 12; if you have filled less than half of your paper, continue following along, but consider increasing your ratio of alcohol to ink so that you have more of a spread with each layer.

8 ADD A NEW BLACK AND SILVER AREA. Choose an empty area of the paper to fill with another focal point of black and silver to build depth, blending with alcohol and your drying tool. Be mindful not to oversaturate the paper with black—just a drop or two, blended with a few drops of alcohol, will go a long way. I like to anchor the black by using the wet-on-wet technique with a few drops of the other color(s) so that I don't end up with a blob of black in one spot.

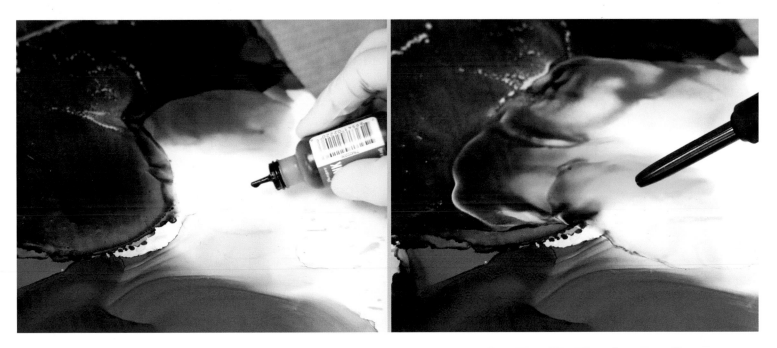

9 **FILL IN SMALL EMPTY AREAS.** Fill in any empty areas with a non-metallic ink color blended with alcohol. If an empty area is small, you will only need a drop or less of ink to fill the space. Here, I've added a drop of blue and pushed it forward and up into the large black area.

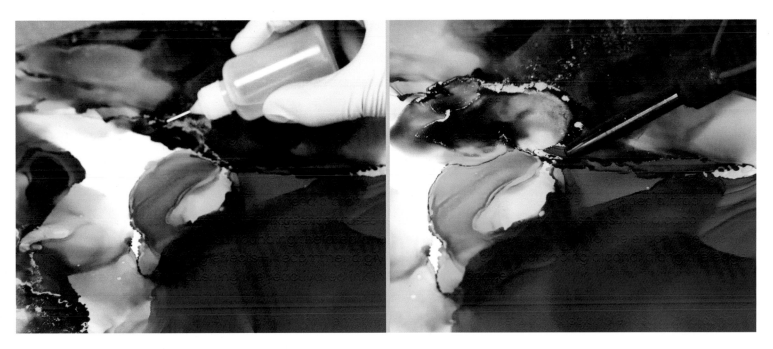

10 **FILL IN TINY EMPTY AREAS.** If an empty area is extremely small, you can also just use alcohol to reactivate the dried ink surrounding the area and then blend those colors out into the empty area to fill it. This can create interesting effects—I recommend giving it a try. Here, I am dropping alcohol along the edge of a black area and then pushing the reactivated ink into the white space.

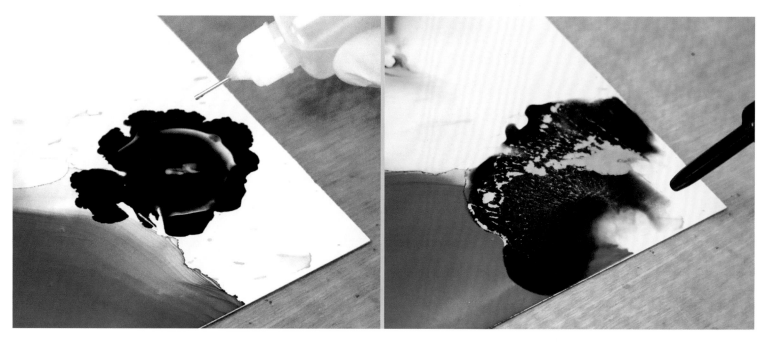

11 ADD BLACK AND SILVER TOGETHER. Add in small spots of black and silver ink for any areas on the piece that need more contrast and depth. Since you do not want the black ink to spread too much and impact the rest of the composition, at this point, if you add black, put down the metallic ink with the black ink and blend them together so that you don't have to add alcohol twice. There is no worse feeling than ruining your favorite spot in a composition by oversaturating another spot. This is the point in the piece that requires restraint if you are going to continue adding ink.

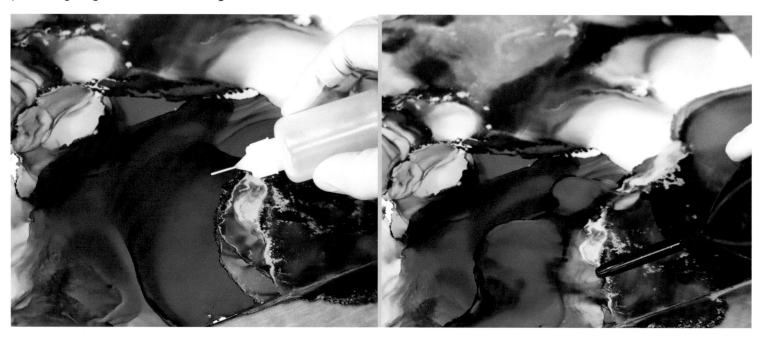

12 ASSESS AND ADJUST THE PIECE. At this point, you should have filled the page with your composition. Take a minute to look at the piece in front of you. This is the time to notice if there are any spots you do not like about the piece. Here, for example, I didn't like how harsh the demarcation in this purple area was. Use alcohol to lighten up areas that might be too dark or saturated. You can even use a paper towel or an alcohol wipe to wipe away specific areas where you want to start over.

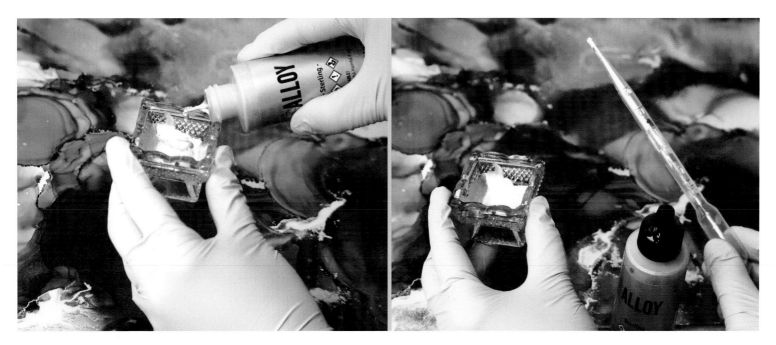

13 PREP THE INK FOR THE STARS. Once your piece is fully dry and you're completely satisfied with your composition, it's time to add the metallic "stars." Take the silver metallic ink, shake the bottle well, and drop several drops into a glass dish. Use a pipette to gather up some of the alcohol from the glass dish and then push the ink out of the pipette and back into the glass. You want it basically empty, with just a tiny bit of ink left over inside.

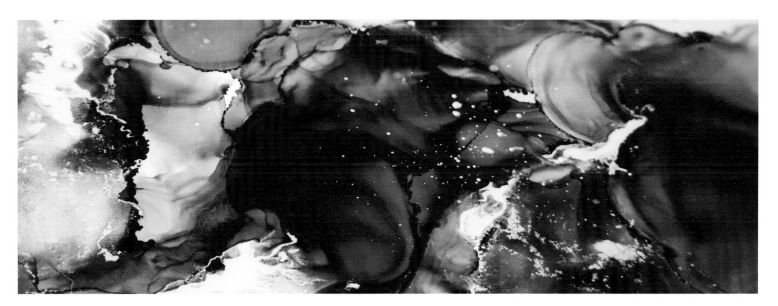

14 SPLATTER ON STARS. Holding the pipette a few inches away from the paper, sharply push air and ink out of the pipette onto the paper. The more metallic ink is left in the pipette, the larger the drops will look and the more likely it will be that you will get blobs of ink rather than speckles. Practice on a scrap piece of paper so you can decide how to approach the type of stars and splatter you want to create. The closer you hold the pipette to the paper, the larger the drops will be; the farther away, the smaller they will be. Stars look more concentrated farther away and less concentrated closer up, so practice creating depth by adding concentrated splatters on parts of the piece you want to appear farther away, and also including areas with spread-out splatters so that the stars appear closer.

REFLECTION

How did that feel? How was this project in comparison to the previous project? Did you notice a difference in how you engaged with your process? What were you telling yourself before, during, and after your creative process? Were you able to tap into a creative flow? What made it easy or what got in the way?

I am repeating some of the same reflection questions from the previous project because repetition leads to remembering. When we repeat something, such as an affirmation or a question, it becomes second nature to use similar language in the future. If you get in the habit of asking yourself how something made you feel, you will more consistently check in with yourself and your needs. If you consistently engage in thoughtful reflection about the art you create and the process of creating it, you will more naturally reflect on your process and value it more than just trying to create something beautiful.

Repetition also equates to safety and comfort, and, if something feels safe and comfortable, we come back to it. Your creative process is sacred; the more you treat it as such, the more deeply you will connect with a flow that results in artwork you love and connect to and that others love and connect to too.

Are you able to tap into a witness mentality? What makes it difficult?

What is it like to witness your process without engaging with the inner critic?

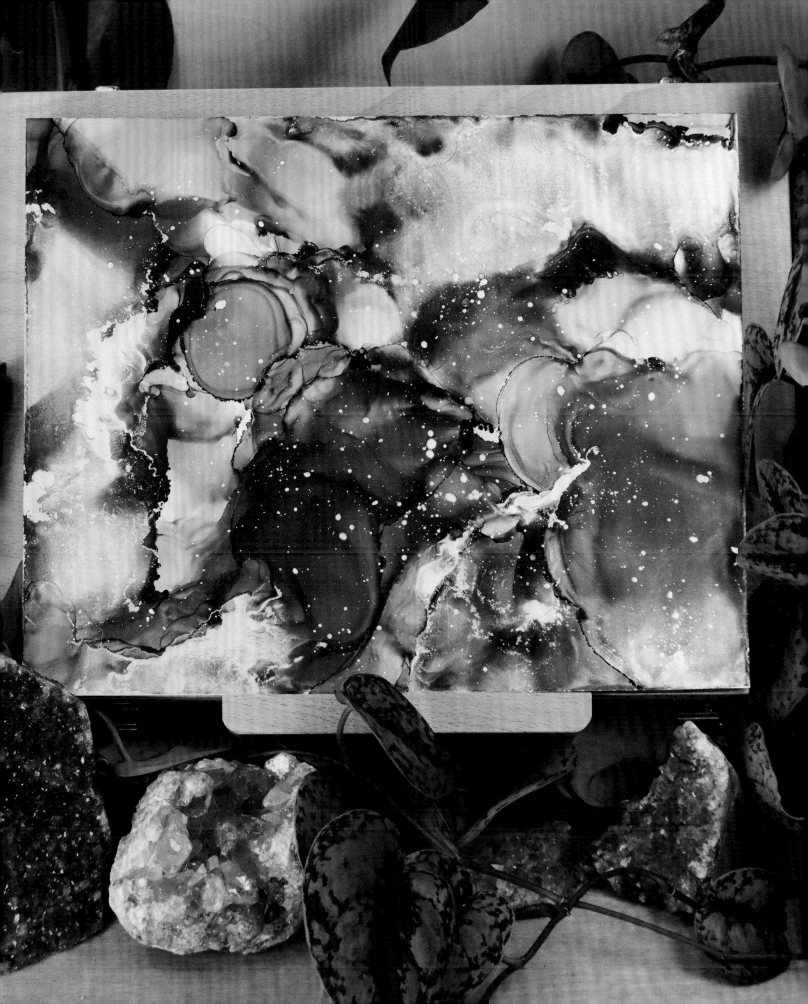

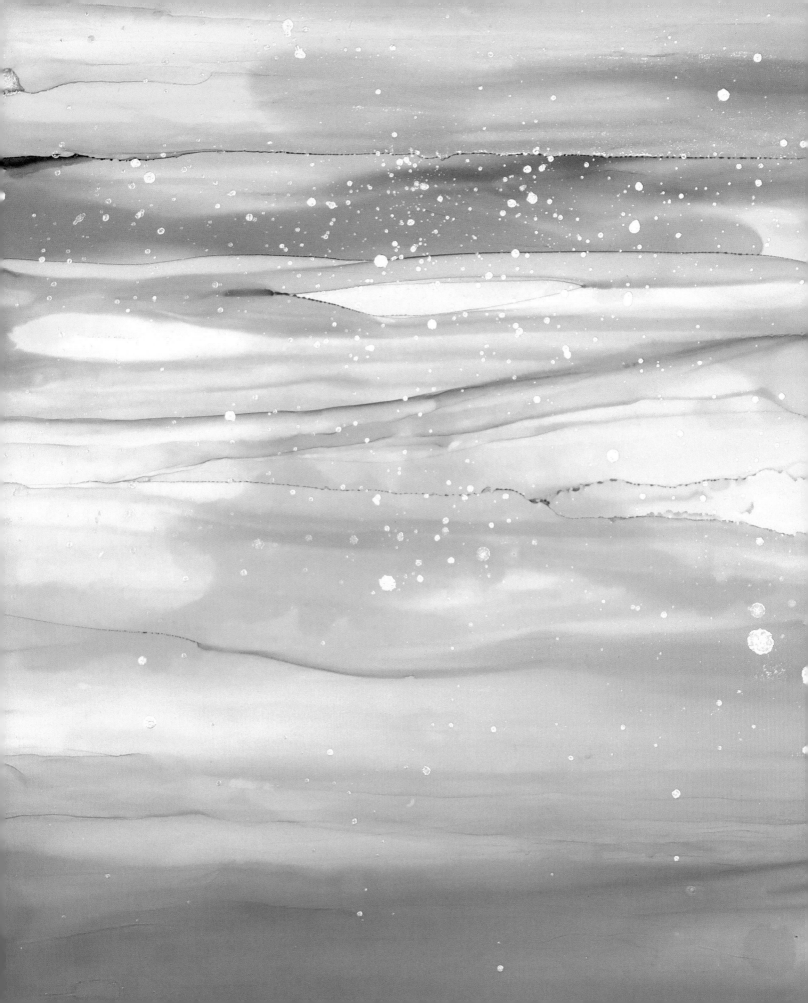

ALCOHOL INK SUNRISE LANDSCAPE

For this project we are going to bring some light into our project portfolio and transition into a daytime landscape using alcohol inks. The composition for this project is more controlled than our previous projects and requires you to tap into your imagination a bit more deeply. What type of image are you trying to create? A sunset, a sunrise? Is your foreground earth or water? Get as creative as you'd like here. This is a great project to incorporate the plastic wrap technique from Chapter 2, as well as any other technique you've wanted to try to create different texture as the ink dries. If you'd like to, you can find a photo of a favorite sunrise or sunset and challenge yourself to create an abstract expression of that reference image.

I am patient with myself as I learn to be present with my process

find your flow

SEEK QUIET AND STILLNESS, NOT SILENCE

It can be difficult to tap into a flow state with the noise of our inner thoughts distracting us. For some lucky people, it is relatively quiet in their mind when they begin a project and engage in the creative process. For others, it can feel daunting to try to get to a space where we feel focused enough to create a project from start to finish.

The projects I chose for this book were designed, in a way, to make focused presence and flow as accessible as possible. It is okay if you are having a hard time quieting down the mind. The goal is not to have a completely quiet mind; in fact, having a completely quiet mind is technically impossible. Even the goal of meditation is not to stop the thoughts completely, but, rather, to notice them and observe them nonjudgmentally instead of engaging with them.

There are always going to be thoughts and observations flickering around in your mind. The trick is whether or not you engage with the thoughts that are fed into your thought stream. Be gentle with yourself as you work through each project, and do your best to practice

present moment awareness not just in your creative process, but in all aspects of your life. The more aware of the present moment you are in your day-to-day life, the more present you will naturally become for your creative process.

For this project, we are going to be painting an intuitive fluid landscape with alcohol inks. This project was designed to be a meditative experience that helps quiet the mind. The goal here is to invite in the senses while you paint and focus as much as you can on the present moment. Creating a multisensory experience can be grounding and allows you to relax while focusing on the painting. We are attempting to create a fluid abstract landscape, not an exact replica of a landscape, so let go of

There are always going to be thoughts flickering around in your mind. The trick is whether or not you engage with them.

assumptions about how your painting "should" look. Intuitive fluid painting encourages you to freely express your emotions without any restrictions; instead of focusing on the outcome, explore the feelings instead.

By allowing yourself to show up to your process in this way, you encourage yourself to embrace creativity, which encourages you to let go of habitual thoughts. When you immerse yourself in this meditative painting process, you take a break from the outside world and enter a peaceful, self-reflective state of consciousness where you are free to express yourself and create a work of art that is unique and gratifying.

If you notice yourself having a hard time settling into a meditative or relaxing painting process, do your best to become curious about this rather than frustrated. If you do become frustrated, let that guide the composition of the piece rather than lead you to walk away. Maybe instead of a light, airy piece, your emotions are guiding you to a dark, rocky ledge; let your emotions and your imagination guide you.

If you are having trouble staying present, you can bring yourself into the moment by inviting in the five senses (six if you count your emotions). What are you seeing? What are you hearing? What are you touching? What are you tasting? What are you smelling? What are you feeling? Asking yourself these questions when you are having trouble grounding into the present moment and staying focused can help snap you back into the here and now.

LET'S GET STARTED!

Since we will be tilting and dropping ink off the paper in this project, I recommend having a layer or two of paper towels underneath your paper to catch the ink, even if you have a protected work surface. The amount of ink that we are going to drip off the paper will create a messy surface that is difficult to clean, so it's better to have the paper towel catch the mess and save you the time and energy.

TOOLS & MATERIALS

- Yupo paper: 11" x 14" (28 x 35.5 cm)
- Alcohol ink: 4 colors of your choice in sunrise shades, plus 1 foreground color
- Metallic alcohol ink: brass or gold
- 91% isopropyl alcohol or blending solution
- Fine-tip squeeze bottle

- Drying tool
- Paintbrush
- Small glass dish
- Pipette
- Paper towels
- Varnish
- Gloves
- Protective face mask

COLOR KEY

- Cloudy Blue (Ranger)
- Purple Twilight (Ranger)
- Sandal (Ranger)
- Salmon (Ranger)
- Monsoon (Ranger)
- Brass (Jacquard)

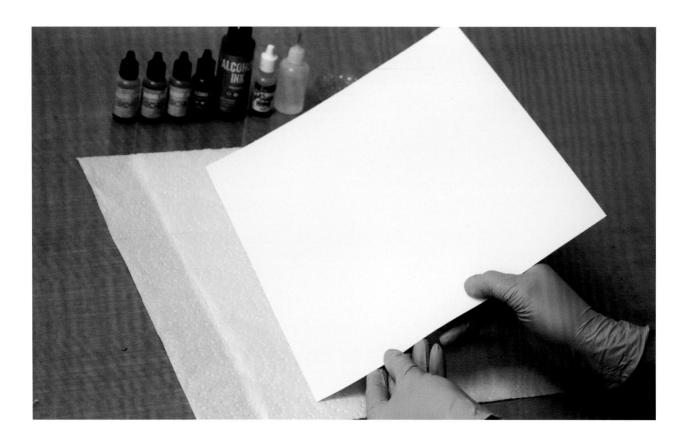

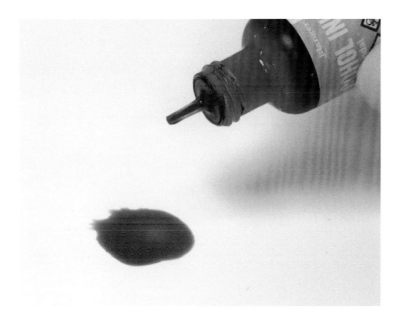

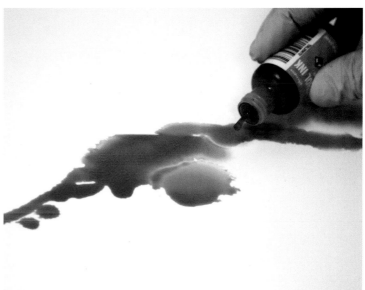

1 START WITH A SUN. Start with your alcohol ink color that most closely resembles the sun—preferably an orangey red. I am using the Sandal ink color for this step. Add a drop of ink to the upper middle portion of the page. This is the location in the sky where the sun has "risen" to for your composition.

2 ADD A SECOND COLOR. Add a redder sky color—in my case, Salmon—in a line above and around the first color. This adds warmth to the sun and the illusion of a fiery sky.

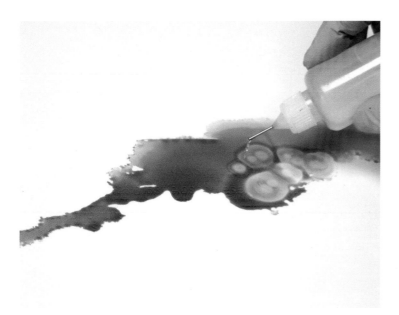

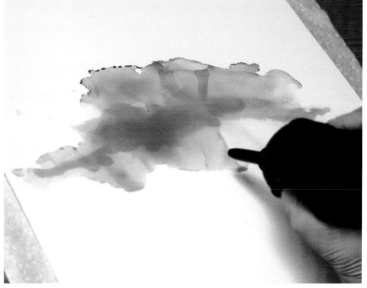

3 ADD ALCOHOL. Dilute the wet ink colors with alcohol; the ratio here depends on how pigmented you'd like your piece to be. I added about 10 drops of alcohol before using the air tool to begin to blend it in with the ink colors.

4 BLEND. Blend the area with the drying tool using 3–5 gentle bursts of air to create a soft billow in the center of the page. Do not let the ink dry completely. Be careful when blending with a hand air tool not to use bursts of air that are too vigorous or too short, or the ink will splatter. The more you practice with this tool, the better you will understand how to manipulate it.

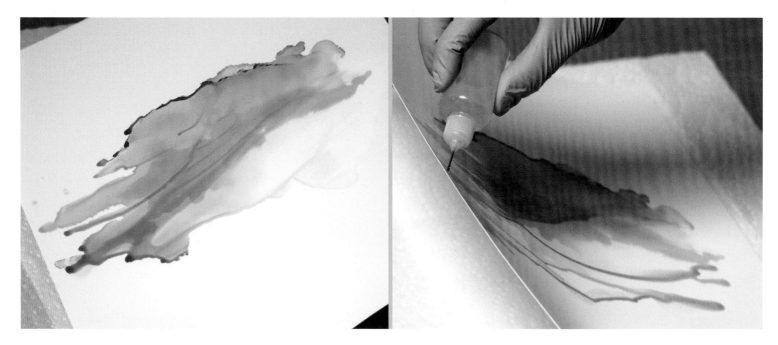

5 TILT AND BLEND. Take the paper in your hands and gently tilt the bottom of the paper slightly upward and to one side. To increase how the color spreads, add alcohol to the paper on the lifted side and allow the alcohol to spread horizontally across the page. Tilt the paper back and forth so that the ink blends and spreads. Some of the color should drip off the paper onto the paper towels. Add more alcohol as you go if needed for further blending.

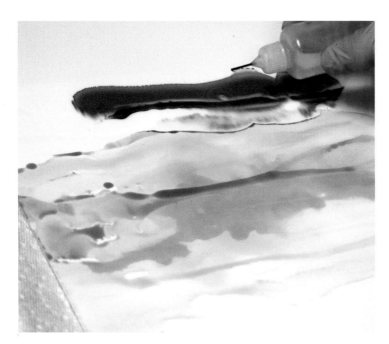

6 ADD A THIRD COLOR. Take a new color—in my case, Purple Twilight—and add a line of the ink across the top of the drying existing ink. Dilute with alcohol.

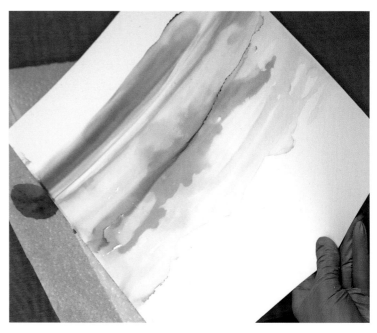

7 TILT AND DRY. Lift the paper and tilt to only one side this time, letting the ink run off the page. Hold the paper this way until the ink dries and is blended into the top of the pinkish-orange area. Use the drying tool to fully dry the section.

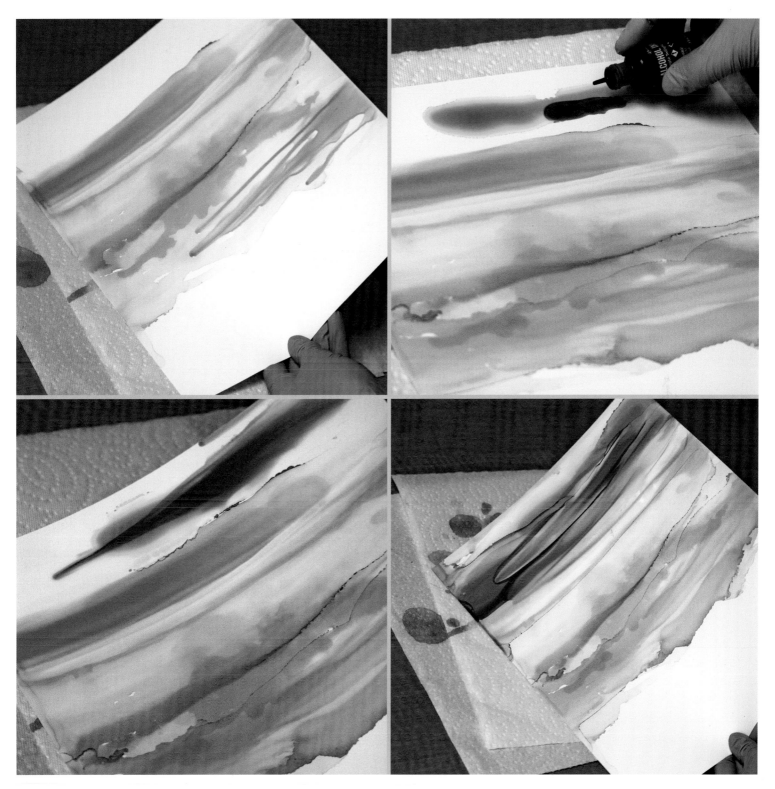

8 COMPLETE THE SKY. Leaving the bottom third of the page untouched for the ocean foreground later, keep building the composition of the sky by repeating the previous steps using different colors. I added a bit more orange near the bottom of the sky, and then I focused on the top area: I added a line of Cloudy Blue ink in the center of the page above the dried purple ink, then added a new drop of Purple Twilight ink there too before adding alcohol and proceeding to lift and tilt to blend the new area of color. Continue adding in more lines of the same blue to fill in the empty spots until you are happy with your sky.

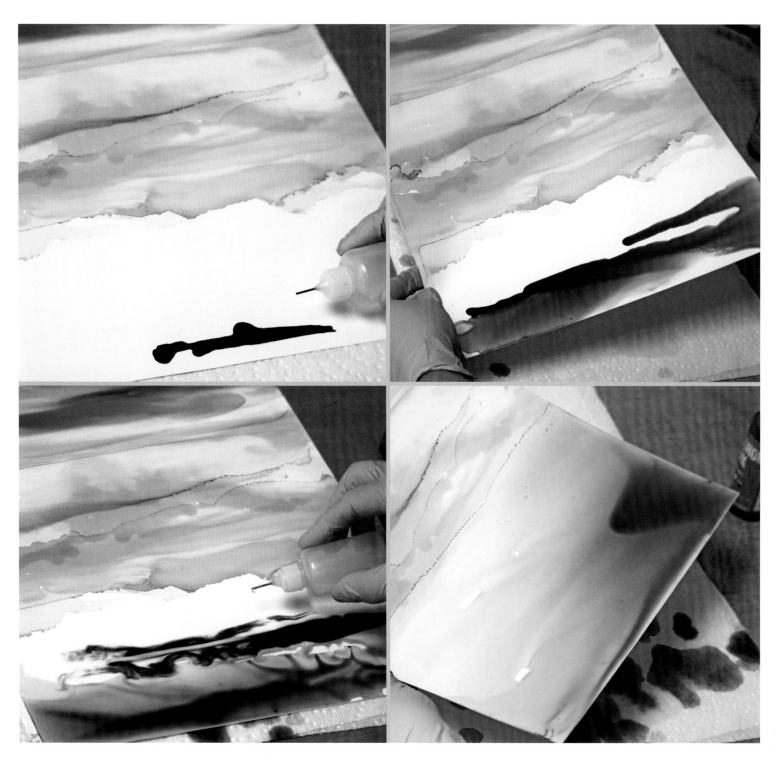

9 CREATE THE OCEAN FOREGROUND. Take your unused ocean ink color—in my case, Monsoon—and add a line of it along the very bottom of the page, diluting it with alcohol and blending with the drying tool. You want this section of the piece to really spread and fill the area. Once you've blended the alcohol and ink, use the lift-and-tilt technique to spread the blue, continuing to add more blue ink and alcohol as needed until you just barely touch the sky portion of the piece. Continue to allow the dark blue to spread and blend just slightly into the sky. The darkest part of the water should be the farthest away from the sky; the lightest part of the water should be closest to the sky.

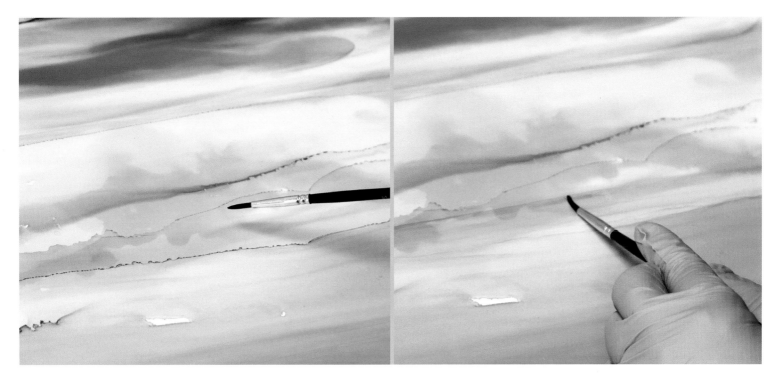

10 MAKE ADJUSTMENTS USING A PAINTBRUSH. Put some alcohol in a dish and wet your paintbrush. Use the damp paintbrush to soften any harsh lines you see within and between layers of color. This will give the sky a more realistic, ethereal effect.

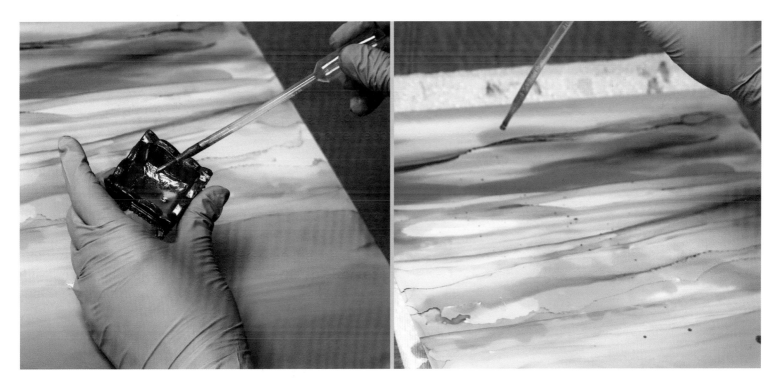

11 ADD SUNSET SPARKLE. Prepare the metallic ink using a glass dish and a pipette as instructed in the previous project (page 93). Utilize the splatter technique described in that project to create golden dots in the sky for an extra touch of magic.

REFLECTION

By now you can probably guess what I am going to ask you. How did working on that project feel? What were you telling yourself before, during, and after your creative process? Were you able to tap into a creative flow? What made it easy or what got in the way?

I truly want you to ask yourself these questions after every project in this book. You will discover something different about your process and how you show up to it every single time. Sometimes you might not realize what you've learned until you look back at the reflections you record in your studio journal and realize from hindsight how far you've come. Growth isn't always obvious when we are in the midst of it. Allow these moments of reflection to give you an outside view into your creative world.

What have you learned about your creative process so far that you didn't know before?

Describe the emotions you feel when you are painting. Consider how you can use your emotions to fuel your creativity or overcome creative blocks.

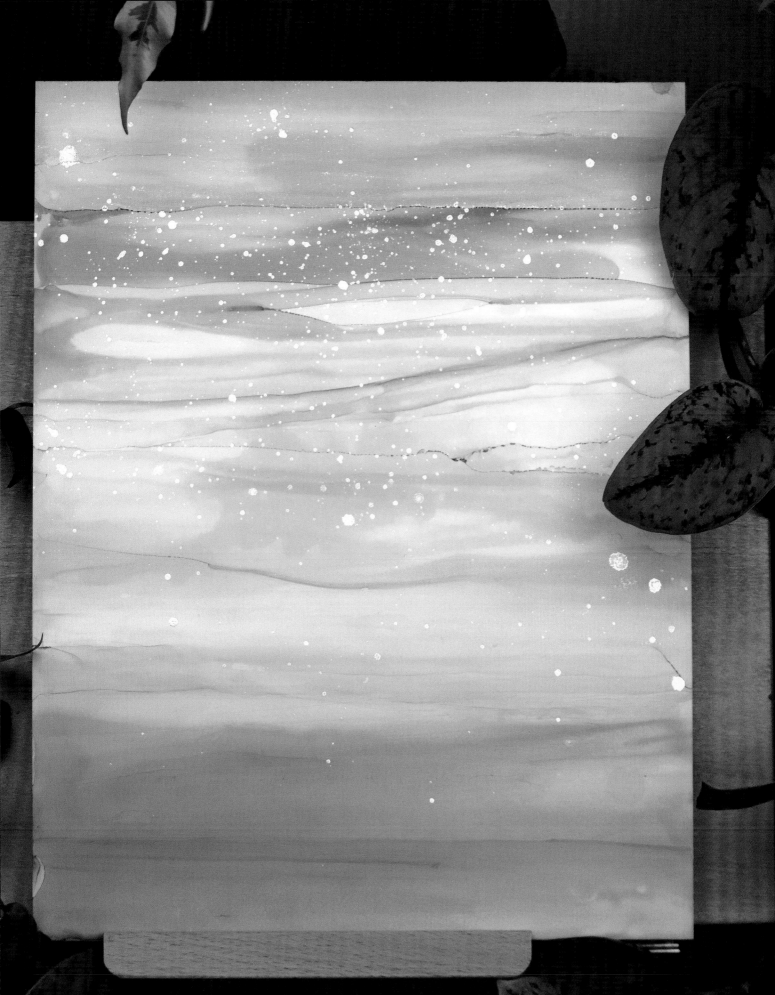

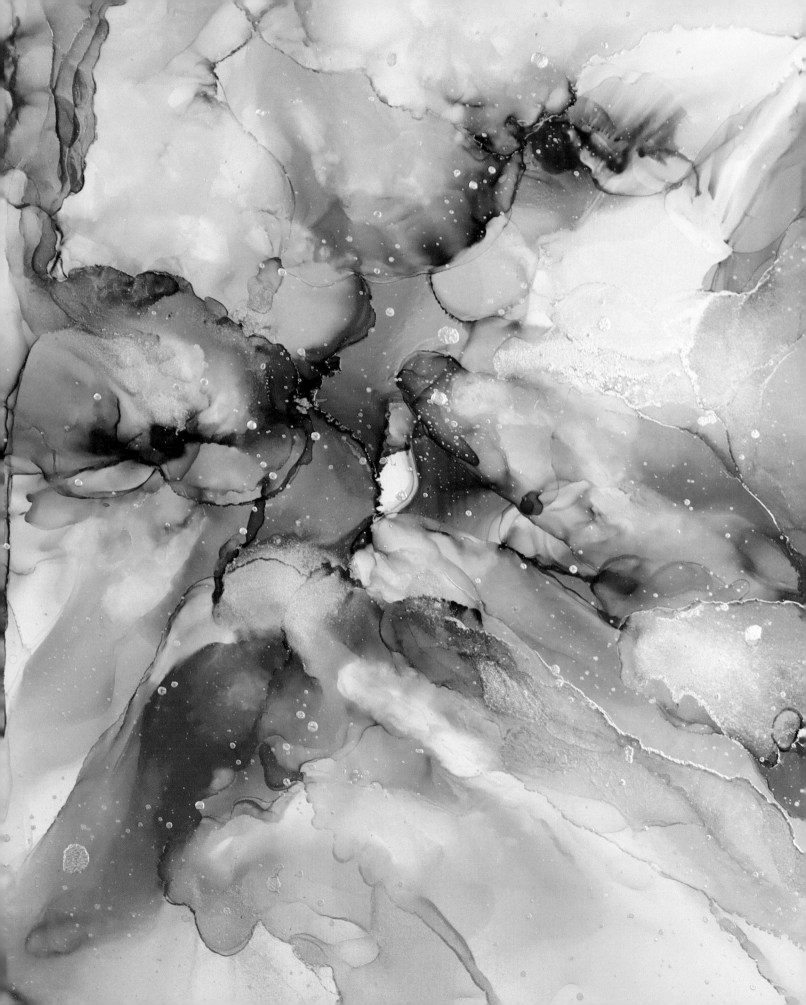

ALCOHOL INK CLOUDSCAPE

This project, while simple, combines many of the skills we've learned so far and adds in a unique component: white alcohol ink. White alcohol ink can be a tricky medium to work with because it has a different consistency and viscosity than other inks. The white pigment is much heavier, almost like an acrylic paint, and requires a bit of finesse to be spread just right. This project will give you an idea of how to create a loose but intentional abstract expression that also challenges you with a medium (the white ink) that might bring up a bit of frustration and confront your inner critic.

I trust in my innate ability to create

LET THE PROCESS TELL A STORY

The idea behind this project is to quiet down your mind enough to hear what your process wants from you, to let the art and the process tell a story of its own.

Abstract art is a form of storytelling and a way to communicate what words often fail to convey. It is a language that is unique to its creator. To be able to confidently communicate through your creative flow, you need to trust that what you are doing means something, which involves taking your process seriously.

Taking your process seriously doesn't mean being rigid and not having fun with it; rather, it means that you stop calling yourself silly for being passionate about creating and for wanting to pursue this hobby seriously. I often hear aspiring artists say that they "paint just for fun," and I see them shrug off anything creative they've explored as just a silly side thing. You do not have to make a big deal out of your art, but if you just chalk it up as being "silly," how will you ever trust yourself to move beyond that?

At this point in the book, my hope is to instill even just a tiny amount of trust and confidence in your ability to create a completely abstract piece that also tells a story. This is a much-harder task than you might think. Everyone thinks they can easily create abstract art until they actually try to do it. Creating abstract art with meaning takes intention and—you guessed it—trust.

In abstract expression, there is no wrong way to create except to not create at all.

It takes time, commitment, and practice to begin to trust yourself to create consistent results with fluid mediums and abstract compositions. The lack of control over the process and outcome makes it a great challenge to any perfectionist. Once again, we are asked to confront how our inner critic shows up and notice when it plants seeds of distrust between ourselves and our creative process. I want you to understand that there is no special talent required to create art, and you can trust that in abstract expression, there is no wrong way to create except to not create at all.

While engaging in the special challenges of using white alcohol ink, practice your mindfulness skills you've gathered from the previous exercises and projects in this book to observe your inner critic and engage it in a way that helps it to relax and let you create in peace. It can be helpful to make your creation process a sensory experience: light a candle or incense, create a cozy space, turn on some music, and allow yourself to get lost in the moment of creating. Also remember to check in with your breathing during the creation process, especially with alcohol ink. When working with a bulky mask on, we can forget to engage in mindful breathing. Make sure you are not holding your breath; take a few seconds every so often to relax your muscles and release any tension you might be holding in your body as you paint.

As often as you can, take a moment, even when you are not creating, to check in with yourself. Ask yourself: How am I feeling? What am I telling myself about how I am feeling? What would be the most nurturing thing I could do for myself based on how I am feeling?

LET'S GET STARTED!

For this project, I recommend creating a small color study of the ink colors and the white ink so that you can practice using the white first and see what techniques you'd like to incorporate into your final composition. You can also test out different metallic alcohol inks to see which metallic shade you think works best with your chosen colors. I went with a warm brass here.

TOOLS & MATERIALS

- Yupo paper: 11" x 14" (28 x 35.5 cm)
- Alcohol ink: 4 colors of your choice, plus white
- Metallic alcohol ink: brass or gold
- 91% isopropyl alcohol or blending solution
- Fine-tip squeeze bottle
- Drying tool

- Pipette
- Small glass dish
- Paper towels
- Varnish
- Gloves
- Protective face mask

COLOR KEY

- ● Wild Plum (Ranger)
- ● Stream (Ranger)
- ● Sandal (Ranger)
- ● Salmon (Ranger)
- ○ Snow Cap (Ranger)
- ● Brass (Jacquard)

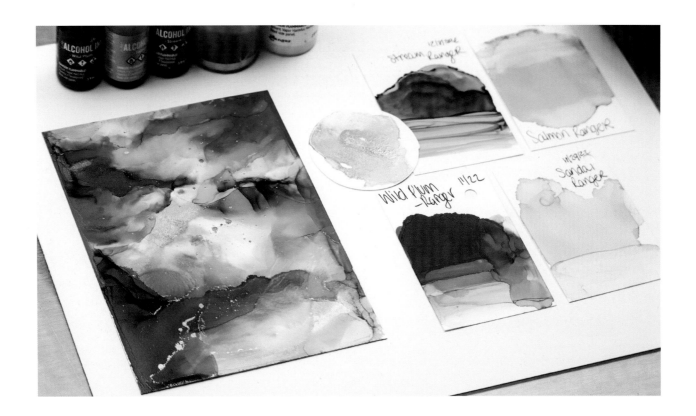

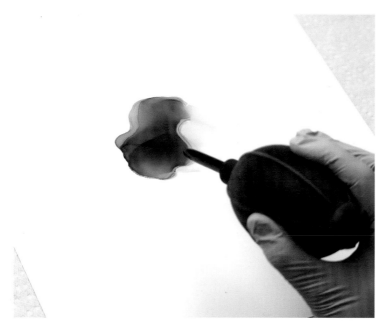

1 START WITH A COLOR. Choose your focal point and add 1–2 drops of any ink color, followed by alcohol, and blend with your drying tool. For a more ethereal effect, add the alcohol down first; for a more concentrated effect, add the ink down first. Let this layer of ink dry.

2 BLEND IN A SECOND COLOR. Choose a second color to put down next to the first dried color. Add 1–2 drops of ink and dilute with alcohol, blending the ink and the alcohol with your drying tool. Allow the two colors to blend into one another. If you feel like the color is too light and want to darken an area to build depth and dimension, add more ink to some areas as you go. Let this layer of ink dry completely.

3 ADD METALLIC INK. Shake your bottle of metallic ink well. Add 1–2 drops of the metallic ink between the first two dried colors, dilute it immediately with alcohol, and blend. Before this dries, go in and add a third color to the wet metallic ink and blend until dry. Use your gloved finger to blend dry areas that aren't lifting properly.

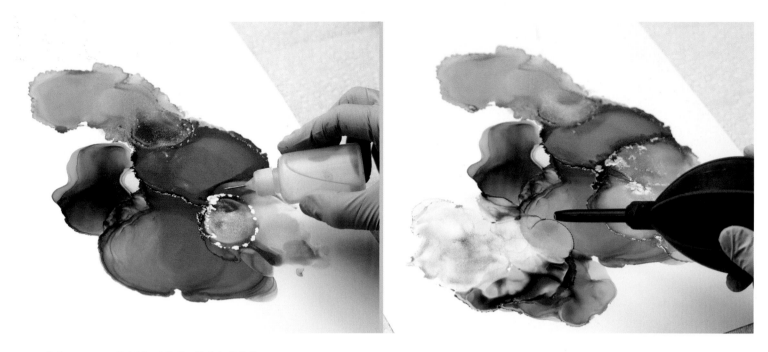

4 **CONTINUE TO ADD COLORS.** Continue to build the composition by alternating between different colors of ink and the metallic ink, working from the middle outward and leaving the edges for last. Do not add metallic to every single color layer; this builds depth and interest in the piece and prevents the piece from appearing flat.

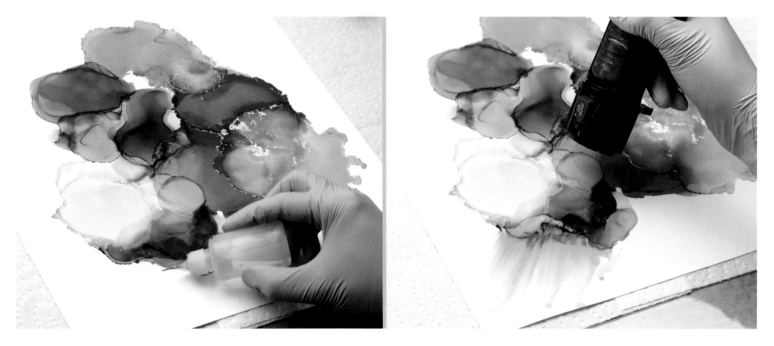

5 **PUSH INK TO THE PAGE EDGES.** When you've decided to fill the page to an edge, you can create a bloom-like effect by adding alcohol alongside a section of dried, saturated ink and then using your drying tool to blast the ink and alcohol away from the dried area and off the page in one direction.

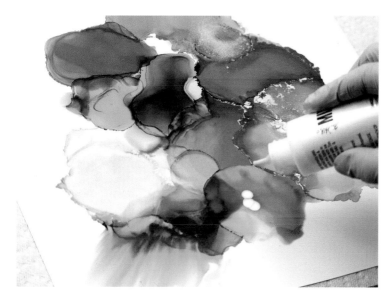

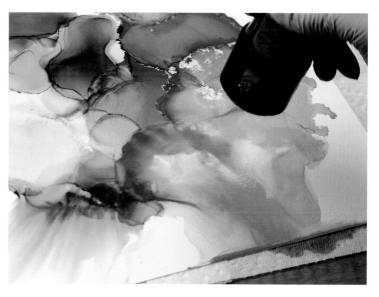

6 START WORKING WITH WHITE. Shake the white ink bottle well. Add 1–2 drops of white ink. A little goes a long way with the white ink—start with less and see how you like the outcome. Dilute the white ink with alcohol in a 2:3 ratio (2 parts ink to 3 parts alcohol); you may want to increase the ratio to 2:4, depending on how the white ink is behaving.

7 MANIPULATE AND BLEND THE WHITE. When working with white, you want to work quickly so that the white pigment does not settle onto the paper and begin to dry before you have a chance to move and blend it. The white ink will need more manipulation than other ink colors, but, just like the metallic ink, be careful not to overwork it, or you will end up creating mud.

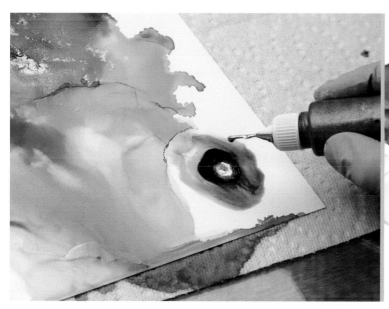

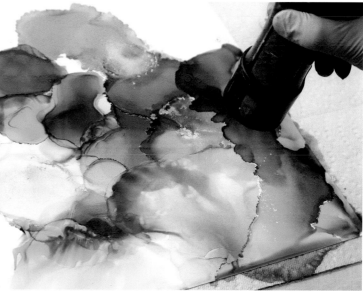

8 CONTINUE BUILDING. Continue to build your composition by alternating between different colors of ink, the metallic ink, and the white ink. Feel free to improvise and experiment here and incorporate any techniques or skills you'd like to use bring your story to life. What is this piece trying to say? What feeling is it trying to convey?

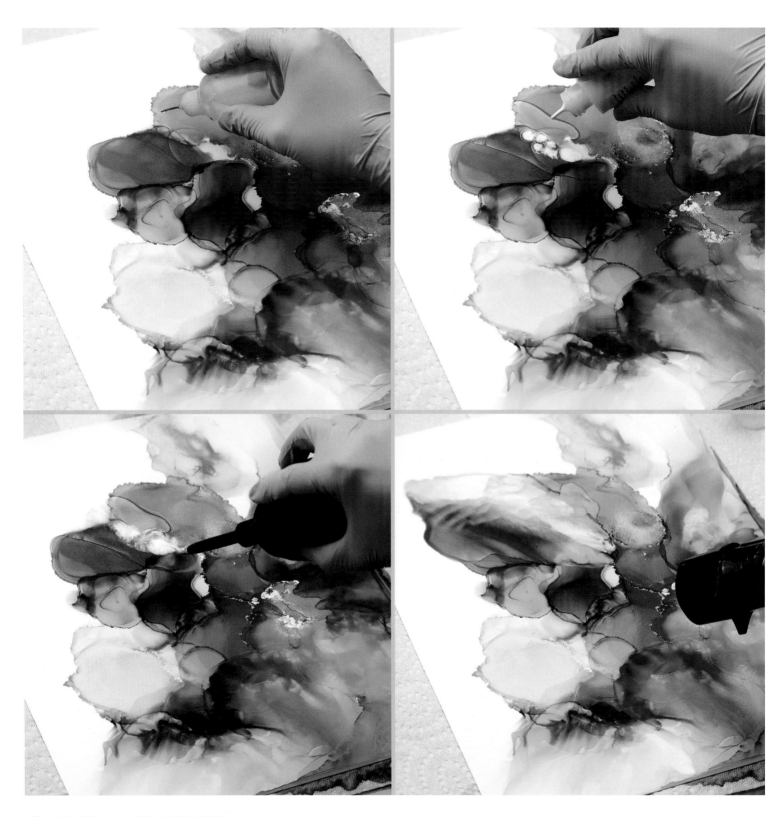

9 FINISH ALL THE EDGES. Using the bloom effect along the edges is a quick and beautiful way to fill the remainder of the composition without overdoing it. In this particular spot, I added white to the alcohol before spreading it with my drying tool.

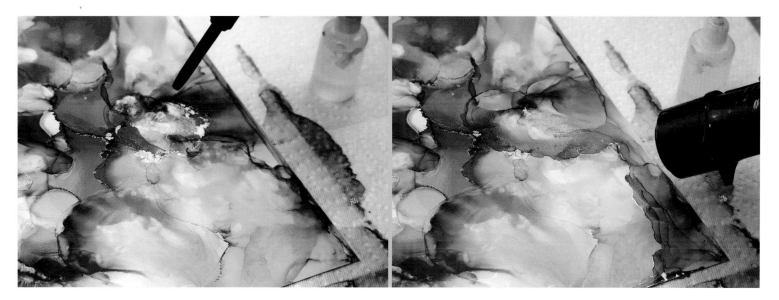

10 **REWORK DESIRED AREAS.** When you've filled the page or composition, go back in and rework any areas you do not like by diluting the area with alcohol and blending it out or wiping it away with an alcohol-dampened paper towel and starting again. That is the beauty of alcohol inks: they can be quite forgiving if you are patient with your process. For example, I added a new area of gold and white (left), and I reworked one corner to create a darker layer of blue on top of the existing blue (right).

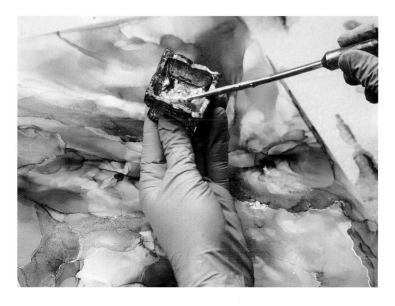

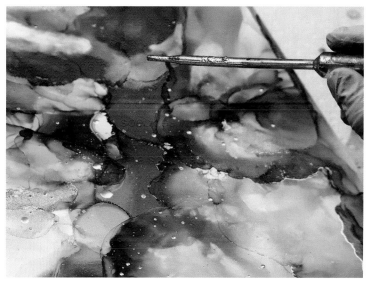

11 **PREPARE A PIPETTE OF METALLIC.** Shake the metallic ink well and add several drops to a glass container. Using a pipette, pick up some of the ink, then squeeze most of it back into the glass. You only want a little ink in the pipette for the next step.

12 **SPLATTER METALLIC.** Push any remaining droplets of metallic ink from the pipette in a fast burst onto the paper to create a splatter of metallic ink that resembles stars and specks of light. The closer to the paper you hold the pipette, the larger and more concentrated the speckles will be; the farther away from the paper you hold the pipette, the smaller and less concentrated the speckles will be. If you are getting blobs instead of speckles, you are starting with too much ink in the pipette. Practice this technique a few times to get it right.

REFLECTION

How did that feel? What were you telling yourself before, during, and after your creative process? Were you able to tap into a creative flow? What made it easy or what got in the way? Answering these questions with each new project gives you a checkpoint to refer back to when you are curious about how you are showing up to your creative practice. Reflection is helpful because it helps us build a road map for how we function at our best (and even at our worst) when we are active in our creative pursuits. How do your answers to these questions change when you are creating on a bad day versus a good day? How does the reflection process change when you've created something you love versus something you don't? When do you find yourself most likely to skip the reflection process altogether?

The more you get to know the inner workings of your mind and thought processes, the more equipped you are to confront your inner critic and perfectionist. The inner critic likes to convince you that it knows you better than you know yourself, and that might even seem true at first, because the inner critic is literally a part of you—but it is not all of you. The inner critic is jaded by a lens of fear and protection that tries to keep you safe by keeping you small. You deserve to be seen and understood, and so does your art, even if it's only by you. If you're skipping these reflections, at the very least, ask yourself why. What are you avoiding about your process?

dig deeper

How often do you check in with yourself and how you are feeling?

How does it feel to prioritize your own needs?

How does prioritizing your own needs and feelings impact your creative process?

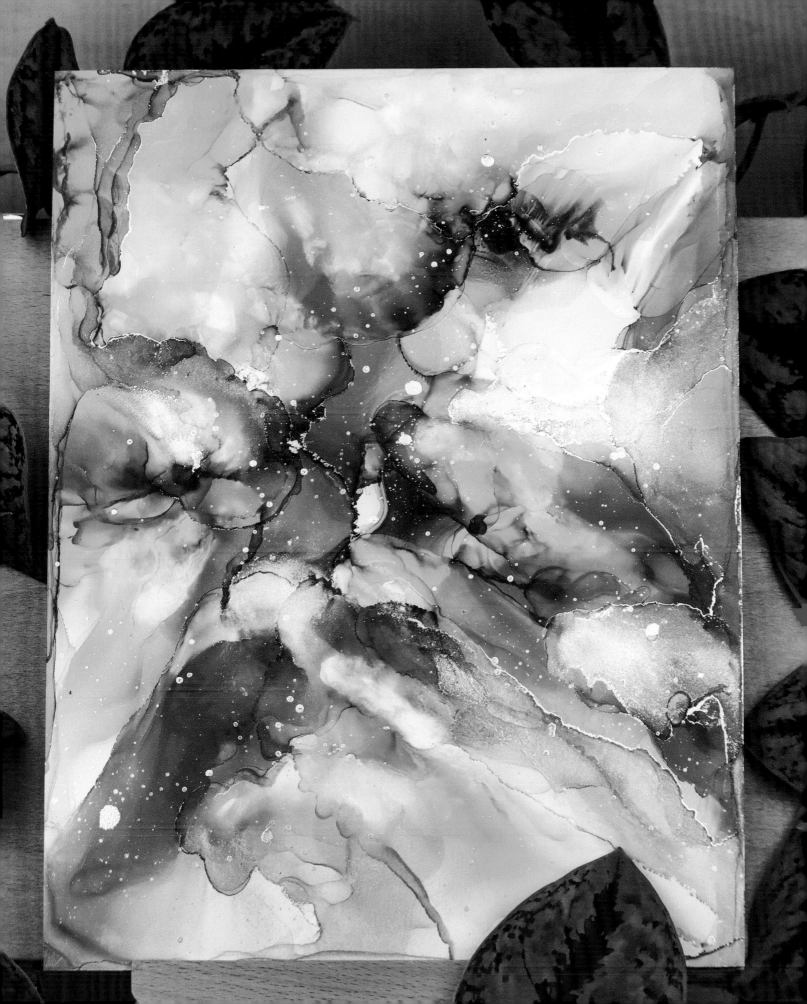

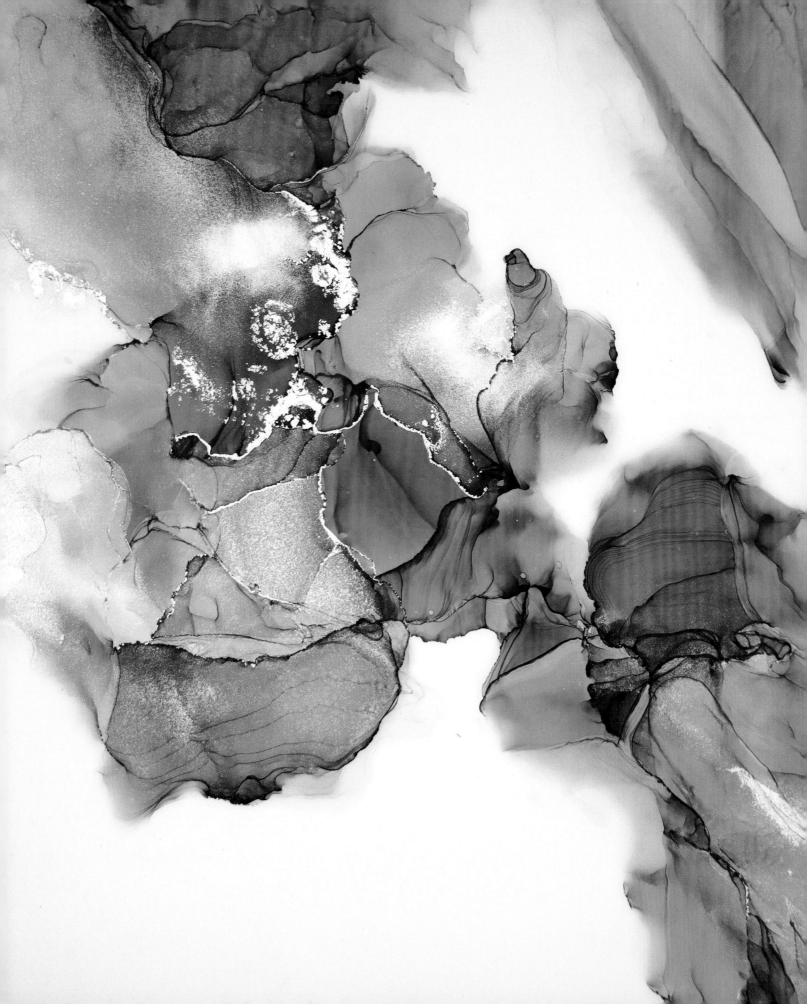

WISPY ALCOHOL INK DIPTYCH

I chose this next project because I wanted to challenge you to elevate your work in a way that gives you the feeling of creating professional-quality alcohol ink paintings. This project will require a bit more focused finesse, and you will benefit from tapping into more restraint and patience than the previous projects. We will be working with maintaining white space (or negative space) in our composition, which means not filling the whole paper with color. It can be difficult to control and manipulate the inks in a way that does not lead to a full-page composition. Creating this ethereal, wispy effect can take a lot of practice and technical skill with the inks. It is okay if it takes you a few tries to get it right.

I am the most important tool for my craft

find your flow

CREATE FROM A PLACE OF NOURISHMENT AND DISCIPLINE

As we move deeper into the projects in this book, I want you to focus on not only implementing all the skills we've touched on for art making, but also for self-care and nourishment.

As an artist or maker, *you* are the tool by which *your* art is created. Yes, you use a paintbrush and paints, but without you, your touch, your soul, it would simply be a work of artificial intelligence. Make sure you are nourishing and caring for yourself before beginning your creative process. Discipline in your art practice also means discipline in taking care of your tools, and you are your most important tool. Do not move on to any of the projects in this book unless you've been able to feed yourself, hydrate yourself, and take care of any basic needs. It is a great privilege to be able to provide for oneself in such a way.

When you have fulfilled your basic needs, you have the capacity to engage in more discipline and restraint, which you will need for this project. If the word "restraint" makes you feel rebellious, me too. It's always so tempting to let it all out by pouring as much ink and alcohol as you can and having a ball, but there is a different kind of reward when you can sit with a piece and slowly allow the composition to reveal itself to you. This project requires trusting yourself and your ability to build layers slowly, rather than rushing through the piece in one pour of color. Take your time working through each layer of ink and use this as an opportunity to consider what you've

As an artist or maker, you are the tool by which your art is created. Make sure you are nourishing and caring for yourself.

learned about creating successful abstract compositions.

To create a controlled composition like this, it is helpful to remember that less truly is more. You do not need a lot of ink to create this outcome. In fact, the more you saturate the page with ink, the harder it will be to achieve that ethereal look we are going for. If it takes you a few "ugly" outcomes to get to one you love, that is okay! You will go through several ugly stages with this piece before you get to a place where you are happy with it, so don't give up halfway through, and certainly don't give up after the first try. Just at the point where you want to give up is the point where your creativity most benefits from you pushing through and continuing. The biggest growth comes at the end of your comfort zone. That is the sharp curve where transformation happens and the piece has the biggest shot at turning around into something you are proud of.

This project has a high propensity for setting off your inner critic. Be aware of and observe how that part might show up here, and remember to send it off somewhere where it can rest. Engaging with the inner critic in an inflammatory way just inflames you. Reframing your inner dialogue to reflect the soft gentleness of the flow you are trying to create will invite ease into your process and soothe the heat. Have fun and remember to take deep breaths.

LET'S GET STARTED!

I created a small 5" x 7" (12.7 x 17.8 cm) study for this piece to explore the colors and techniques I wanted to use to bring this composition to life. Creating such a small study with white space is a huge challenge and a great way to warm you up for working larger. If you can maintain white space successfully for your smaller study, you will have greater ease maintaining white space for your larger composition. Use your color swatch ring to help guide your color choices if you're planning to work with different colors than I am working with here.

TOOLS & MATERIALS

- Yupo paper: 2 sheets of 11" x 14" (28 x 35.5 cm)
- Alcohol ink: 3 colors of your choice
- Metallic alcohol ink: brass or gold
- 91% isopropyl alcohol or blending solution
- Fine-tip squeeze bottle
- Drying tool

- Heat tool
- Paintbrush
- Small glass dish
- Pipette
- Paper towels
- Varnish
- Gloves
- Protective face mask

COLOR KEY

 Cloudy Blue (Ranger)

 Slate (Ranger)

Pebble (Ranger)

Brass (Jacquard)

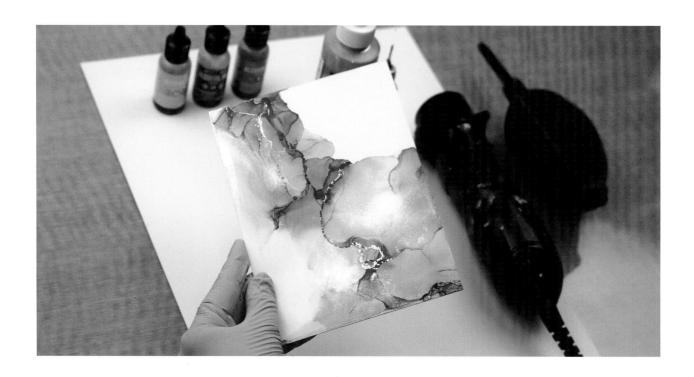

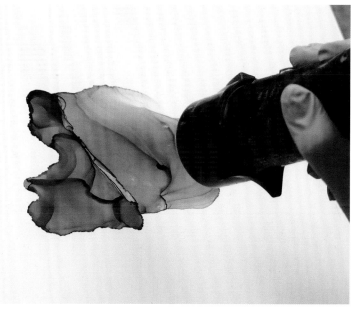

1 **ADD AND BLEND ONE COLOR.** Drop 1–2 drops of the first color of ink in the center of your paper. Choose any ink color you'd like to start your composition. Dilute the ink with alcohol and blend using the heat tool. Do not push the ink too far out—you want each layer of color to be relatively small and saturated, because we will be coming back to rework the color later.

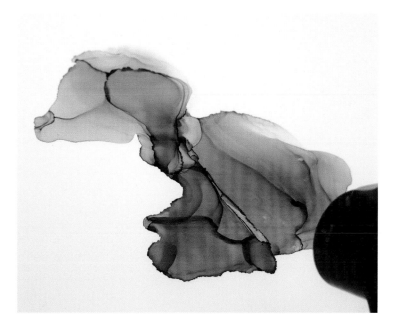

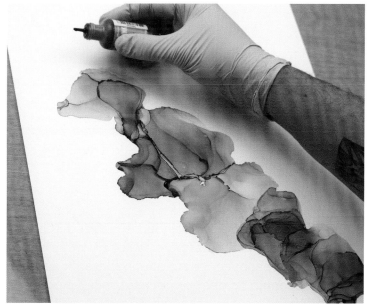

2 **ADD A SECOND COLOR.** Anchor a second color to the edge of the dried first layer. Anchoring is when you add a new color just barely touching the dried color you put down previously. Use the heat tool to dry this layer.

3 **CONTINUE ADDING COLORS.** Continue to anchor colors in a balanced pattern until your composition is touching two sides or corners of your paper. I like to use a pattern for my colors—i.e., repeating them in a fixed order—because it is the easiest way, in my opinion, to keep a balanced color composition. But this is up to you, your style, and the effect you are going for.

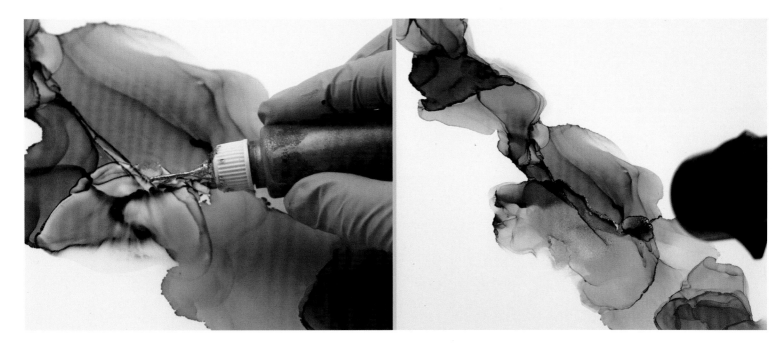

4 ADD METALLIC INK. It's time to add some metallic ink! To keep the gold ink flowing, put the alcohol down first and then the metallic ink. Immediately move the gold ink with an air or heat tool so that it does not sink into the paper, pushing the ink into and out of the alcohol until it dries.

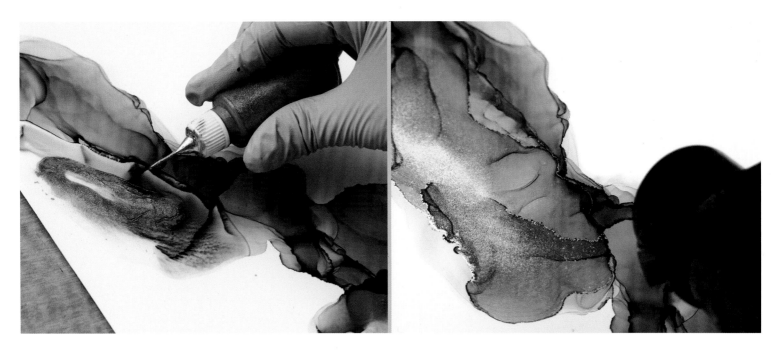

5 CONTINUE ADDING METALLIC INK. Continue adding alcohol and metallic ink to different areas of the dried layers to build your composition. I alternate between using a heat tool and an air tool at times when I want to differentiate my control over the blending.

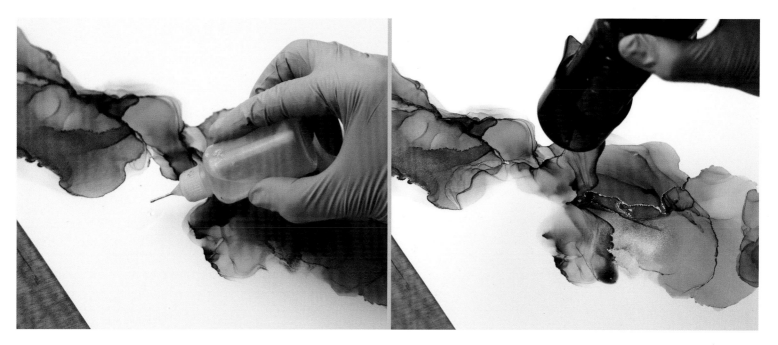

6 MAKE ADJUSTMENTS USING ALCOHOL. Look at the current composition and choose a few spots to add some interest by reactivating areas of dry ink and using heat and air tools to manipulate them in different ways. Here I am adding alcohol next to dried ink and using the heat tool to blow the ink and alcohol around, lightening the area and creating a bloom effect. This is a nice way to rework areas you do not like.

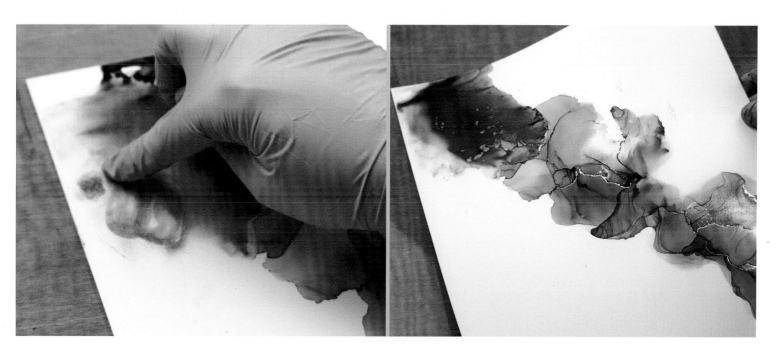

7 BLEND METALLIC INK BY TOUCHING AND TILTING. You can make changes by adding a bit of metallic ink and blending it in with your finger, then lifting the paper and tilting it in one direction away from the dried ink and off the paper until it slows to a stop or mostly runs off. Alternate between this method and using the heat tool to soften up some of the edges. Do not overdo it. Just choose a few spots for interest and then move on—you can come back later if you still feel like something is missing.

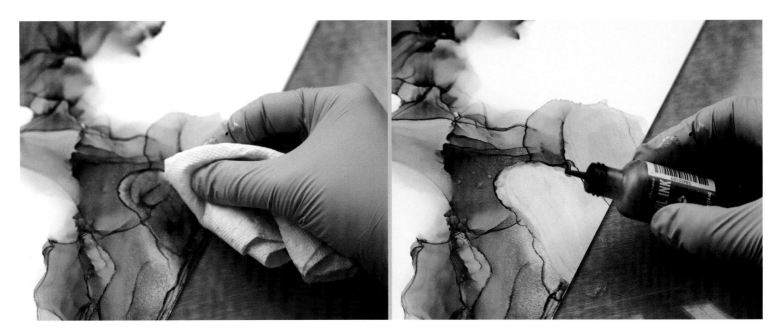

8 **CONTINUE BUILDING, ERASING IF NEEDED.** If your composition feels lacking, go ahead and add a bit more ink to the composition. Balance the colors by thinking in patterns. Do not overdo it with the metallic ink. I added only a few small additional areas of metallic ink, which was enough to bring a beautiful glow to the piece. If you end up with muddy areas or areas you do not like, you can saturate a paper towel with alcohol or use an alcohol wipe to wipe away that area and start again.

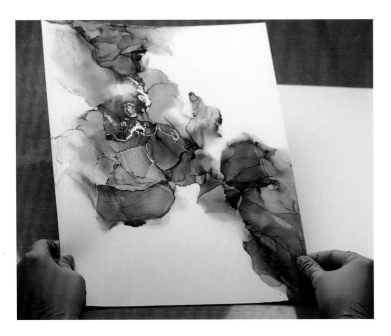

9 **PREPARE FOR THE SECOND PIECE.** Once you are happy with your total composition, let this piece fully dry. (As you can see, I added quite a few new areas of color and blending.) Then grab a second, matching-size sheet of paper. It is time to create the "partner" to make this project into a diptych!

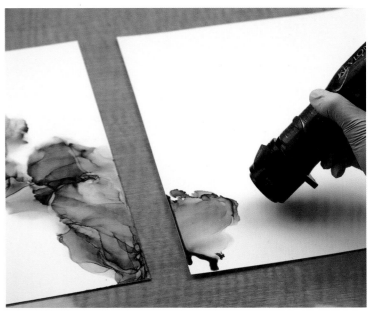

10 **BEGIN ALONG ONE EDGE.** Start this new composition where the first sheet left off, as though one piece flows into the other. Keeping the first piece close by but not so close that you get ink on it will help you keep the flow flowing. It's okay if the edges do not perfectly match—you just want the set to give the appearance of flowing as one.

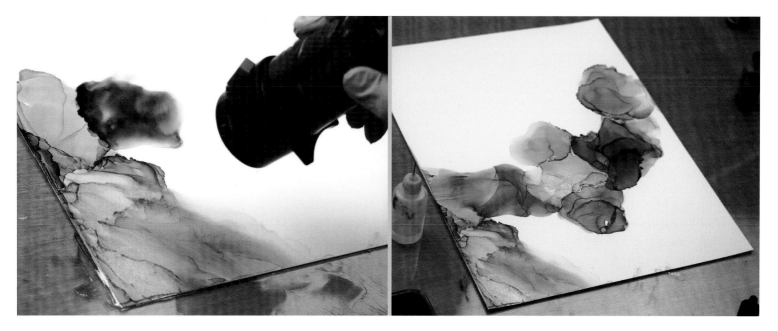

11 CONTINUE BUILDING THE SECOND PIECE. As you work, consider how the flow of the first piece will flow into the new piece. You want it to look like the pieces were created as one. If you have larger sheets of paper, you could create one large composition and just cut it in half, but you will learn less about building compositions this way.

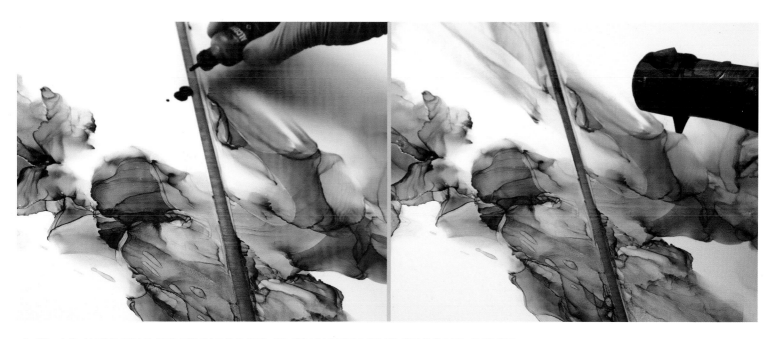

12 ADJUST THE FIRST PIECE TO FLOW WITH THE SECOND PIECE. If your new piece begins to look unbalanced with the first piece, feel free to go back in and add to the first piece to help balance it out, like I did here.

REFLECTION

How did completing that project feel? What were you telling yourself before, during, and after your creative process? Were you able to tap into a creative flow? What made it easy or what got in the way? Pay attention to if you are trying to create from an empty vessel (the vessel being *you*). If you are tired, burned out, or forcing yourself to create when you do not want to be creating, you may find it harder to access your creative flow. This is not a sign of failure or regression but rather a sign that you might just need to rest. Rest is an artist's biggest secret weapon and greatest rejuvenator. If you are finding it difficult to tap into a creative flow and you're implementing all the suggestions we've discussed, try taking a break, a nap, a walk—whatever you need to do to reset your energy—and come back to creating later. Nothing ever needs to be created right now. If you are getting indications from your body and mind that you would benefit from rest or other forms of nourishment outside of creating, honor that voice. It is part of the creation process.

How often do you try to create from an empty cup? How often do you create on an empty stomach, without drinking water, or when you would much rather be napping?

How does this impact your process? Do you even notice an impact?

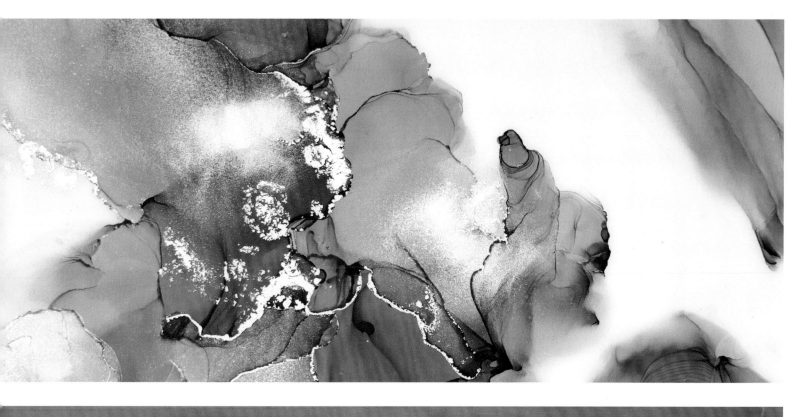

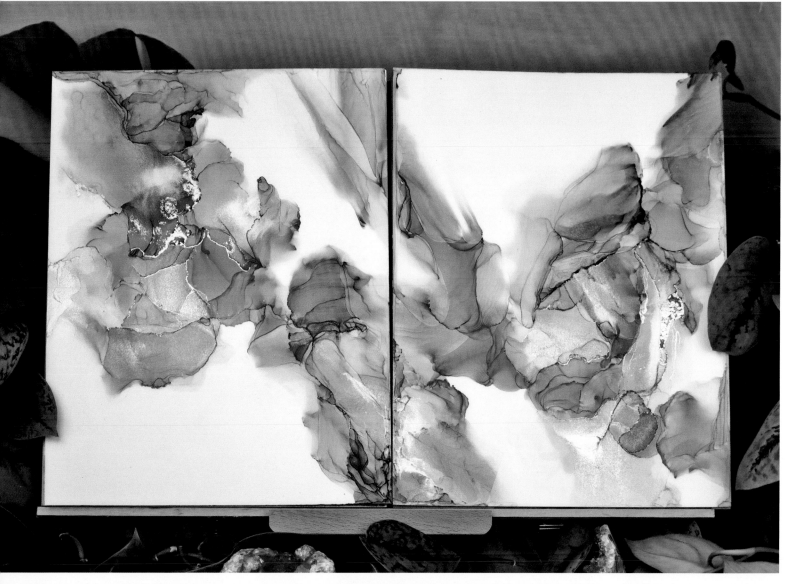

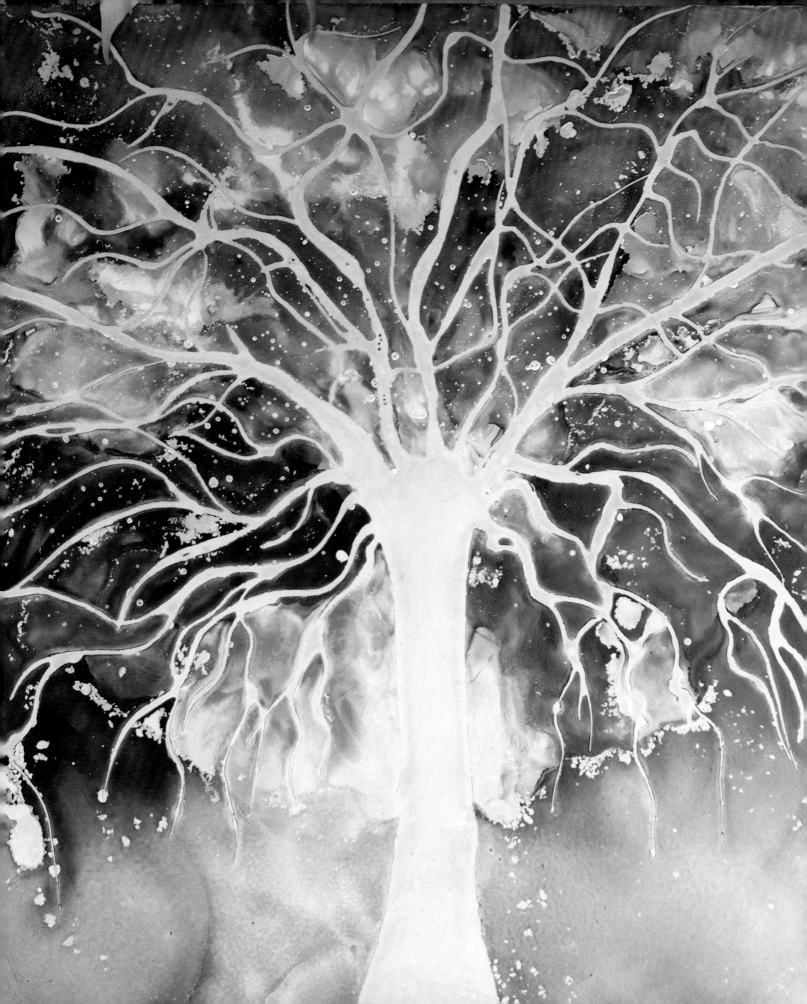

ALCOHOL INK MOSAIC

For this project, we are going to get our toes wet in creating mixed media fluid art. The idea is to create a mosaic or stained-glass style of expression using alcohol ink as our primary medium but with additional elements like spray paint and masking fluid incorporated to create the mosaic effect. You'll notice that for this project I take a looser approach to how I apply the inks. As always, feel free to work on any variation of this project you'd like. You can use a paintbrush to fill in areas outlined in masking fluid; you can work with lots of colors or only one or two colors; all of this is up to you and your intuition. Use the steps outlined here simply as a guide.

I will surprise myself with what I can do if I try

find your flow

GET OUT OF YOUR COMFORT ZONE

This fluid art project allows us to challenge the parts of ourselves that keep us creatively stuck while also leaving room for freedom of expression.

Many people think the presence of the inner critic motivates them, but often it's the opposite. The parts of ourselves that fight to keep us from stepping outside of our comfort zone look a lot like our authentic self, so it can be confusing at first to parse out the difference. Engaging in projects like this while utilizing the tools offered throughout this book will help you tell the difference so that it is easier to show up and create.

Creative people often get caught up in the inner critic's version of who it wants them to think they are: "I am not an artist; I can't draw/paint/write." What if those narratives weren't true but rather were things that part of you wants you to believe to keep you from failing and making bad art? What if, most of the time, the inner critic was wrong and bad art was actually part of the process? All the self-imposed limitations set upon you by the inner critic can be broken by boldly pursuing your creative process in a way that fills you up rather than drains you. This mixed media project challenges the parts of ourselves that believe there are limits to what we can create.

Working with multiple mediums and techniques is a true test of your creative process and flow. It can be intimidating to apply multiple techniques to create

It is always okay to work within your comfort zone when you are just starting out in a new process. The trick is to not get stuck there.

a cohesive outcome. At first glance, it might look like you need to be able to draw to be successful at this project. But this is not true. You do not even have to draw a tree—you can create abstract shapes, lines, or whatever you feel comfortable exploring. Try to think outside the box and work within your comfort zone before pushing past it. It is always okay to work within your comfort zone when you are just starting out in a new process. The trick is to not get stuck

there. Getting stuck in your comfort zone looks a lot like a creative block, but it's easier to miss. It can take the form of not being willing to try new techniques, explore new concepts, or add in new mediums to your repertoire. It can take the form of sticking with the safe route and sticking to only what you know because it is comfortable. But I know you can get past all this and push your comfort limits!

If you are here reading and learning about fluid art and creative flow for the first time, and you usually practice another style of art making, I want to express how proud I am of you for being here with me creating this portfolio of intentional fluid art projects. If this is your first time pursuing any artistic endeavor, I am just as proud of you for showing up and continuing to create by using one of the trickier styles of abstract work available to you. You've successfully stepped past your comfort zone. Give yourself a round of applause, and welcome!

LET'S GET STARTED!

To create an interesting color under the masked lines, spray-paint your paper before starting. The gold pigment of the spray paint does begin to lift as you work, but it looks seamless with the alcohol ink because it so closely resembles the gold ink. If you do not want the spray paint to lift while you work with the alcohol inks, seal it with varnish before applying the inks. Allow the paper to dry for 12 or more hours before working with the inks. Wear a respirator mask and/or work outdoors when working with spray paint.

TOOLS & MATERIALS

- Yupo paper: 11" x 14" (28 x 35.5 cm)
- Alcohol ink: 6 colors of your choice
- Gold spray paint
- Masking fluid (I am using a 20-gauge/0.5 mm bottle tip)
- 91% isopropyl alcohol or blending solution
- Fine-tip squeeze bottle

- Drying tool
- Paintbrush
- Small glass dish
- Pipette
- Paper towels
- Varnish
- Gloves
- Protective face mask

COLOR KEY

- Dandelion (Ranger)
- Sunset Orange (Ranger)
- Wild Plum (Ranger)
- Purple Twilight (Ranger)
- Snow Cap (Ranger)
- Stream (Ranger)

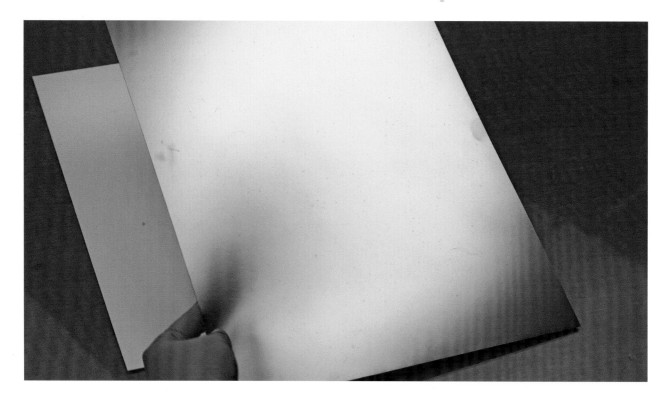

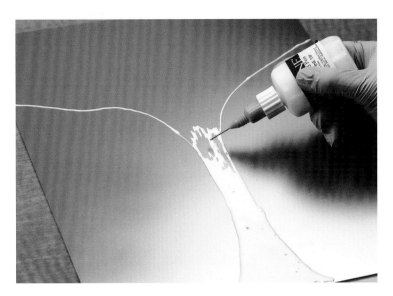

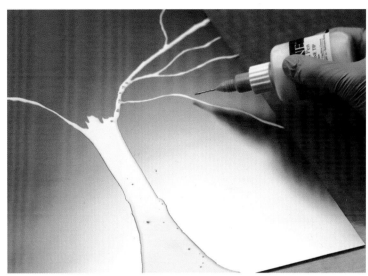

1 **START DRAWING THE TREE.** First you must draw a tree on your spray-painted paper using masking fluid. I'll walk you through my drawing technique here, but you can also freehand your own tree or other shape or use an online template. Start by creating a tree trunk with the masking fluid by drawing two concave curved lines. Fill up the trunk to the point where the lowest arms curve out.

2 **DRAW LARGER BRANCHES.** On each side, extend the curved lines into large branches that extend off to the left, the top, and the right. Make sure there is at least one large branch that tapers from the trunk. By the time you are done, you will want to take up a good two-thirds of the paper with your tree and its branches—it is meant to be a true focal point of the work.

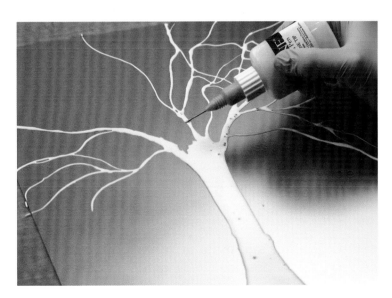

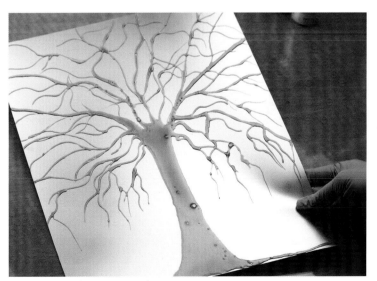

3 **DRAW SMALLER BRANCHES.** Draw multiple smaller branches extending off the larger branches and even-smaller branches extending off those. The branches should get thinner as they get farther away from the trunk. Make sure some of the branches extend all the way off the edges of the paper. Varying the sizes of the branches gives the tree a realistic feel.

4 **ALLOW TO DRY.** Double-check that the trunk and branches are solidly filled with masking fluid. Then allow the masking fluid to dry completely, following the directions on your bottle for drying time. Do not attempt to continue to the next step if you even suspect the masking fluid is still wet. I recommend waiting 24 hours to be safe.

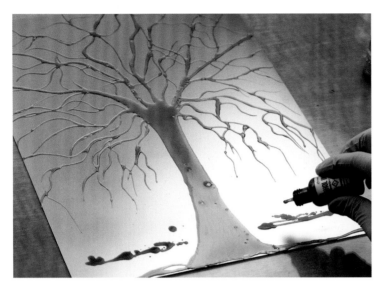

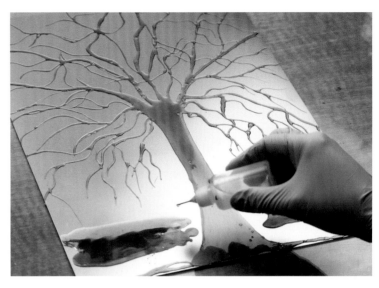

5 ADD THE FIRST COLOR. Once the masking fluid is fully dry, add your first ink color along the bottom edge of the paper in a horizontal line. I am creating a sunset-inspired composition for the background of my tree, so I am starting with a yellow (Dandelion). Dilute the ink with alcohol and blend lightly with the drying tool, but do not dry completely—move on to the next color.

6 ADD THE SECOND COLOR. Add a line of the next ink color just above the first diluted color. Dilute this new color with alcohol. I worked with Sunset Orange here, fading it into the yellow base to build on the sunset composition.

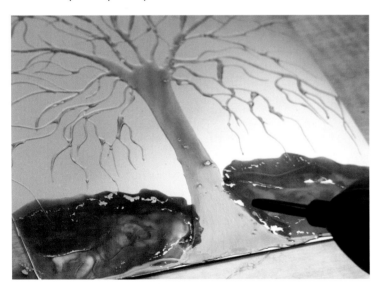

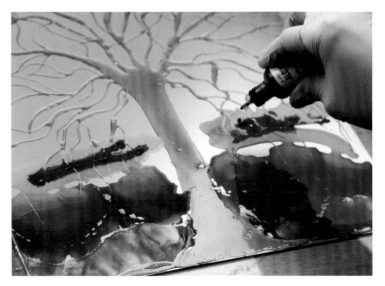

7 BLEND WITHOUT DRYING. Blend the two colors using the drying tool, but, again, do not let this layer dry completely—we will be working with the wet-on-wet technique for the remainder of the piece. To blend two colors without having them totally blend together to create a new color, gently push the new color you've added just slightly into the first color. Continue to blend gently into and away from the first color without pushing all the way into that color.

8 ADD MORE OF THE FIRST TWO COLORS. Add another layer of orange and yellow. Remember, we are using the wet-on-wet technique here, so do not let any of the layers dry before moving on to the next layer.

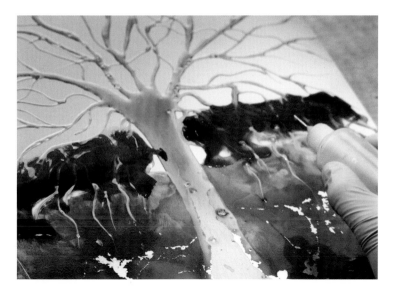

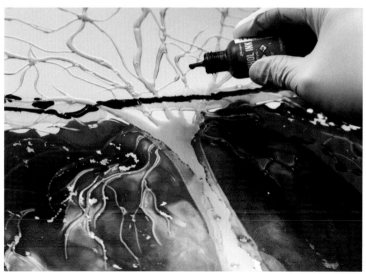

9 ADD THE THIRD COLOR. Continue to your third color—in my case, Wild Plum. Add this color above the orange and yellow. To ensure a seamless blend here, add alcohol down first for the next layer, right along the edge of the previous layer. Then add only a few drops the purple ink before blending into the alcohol.

10 ADD THE FOURTH COLOR. Continue to build the composition about two-thirds of the way up the paper by adding wet layers of alcohol followed by ink. I added another color, Purple Twilight, in this layer before moving on to the final sky color.

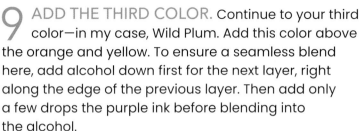

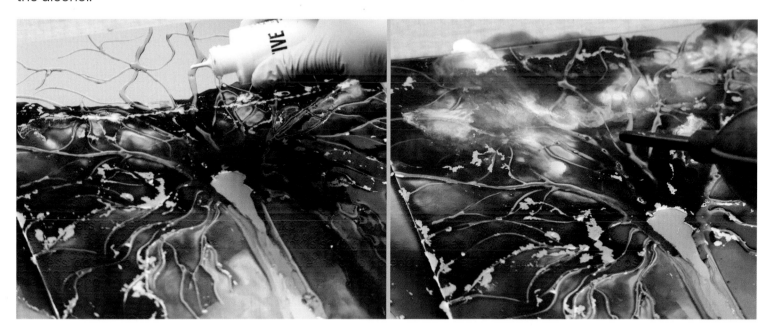

11 START BUILDING THE CLOUDY SKY. To add a cloud-like effect, blend in white alcohol ink with the blue layers of the sky. Remember to shake the bottle of white ink very well every time you pick it up for best results. You must work quickly because the white ink is so pigmented and heavy. When working with white ink, follow this process: add alcohol down first, add your blue ink color, blend with the drying tool, add 2–3 drops of white ink into the blue, and immediately blend with the drying tool again.

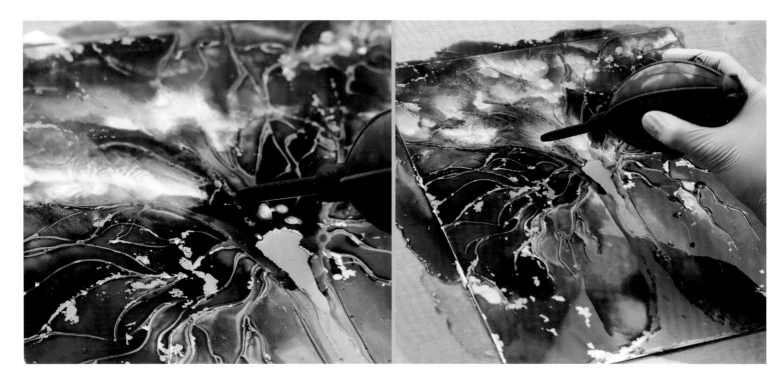

12 CONTINUE WORKING WITH THE WHITE INK. If the white ink settles onto the paper and is not moving, add more alcohol or use the drying tool close to the paper when pushing the air onto the color to loosen it up. Because the white ink is so heavy, you may need to use a larger burst of air closer to the paper to get it to move.

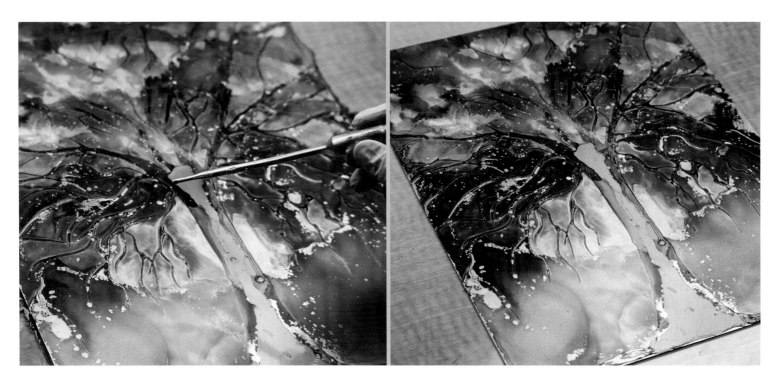

13 ADD GOLD SPARKLES. Once you are happy with your background colors, add gold splatter using the splatter technique taught in previous projects (see pages 93 and 117). Let the piece dry for at least 12 hours before varnishing the entire thing. Waiting to varnish allows the ink to fully set.

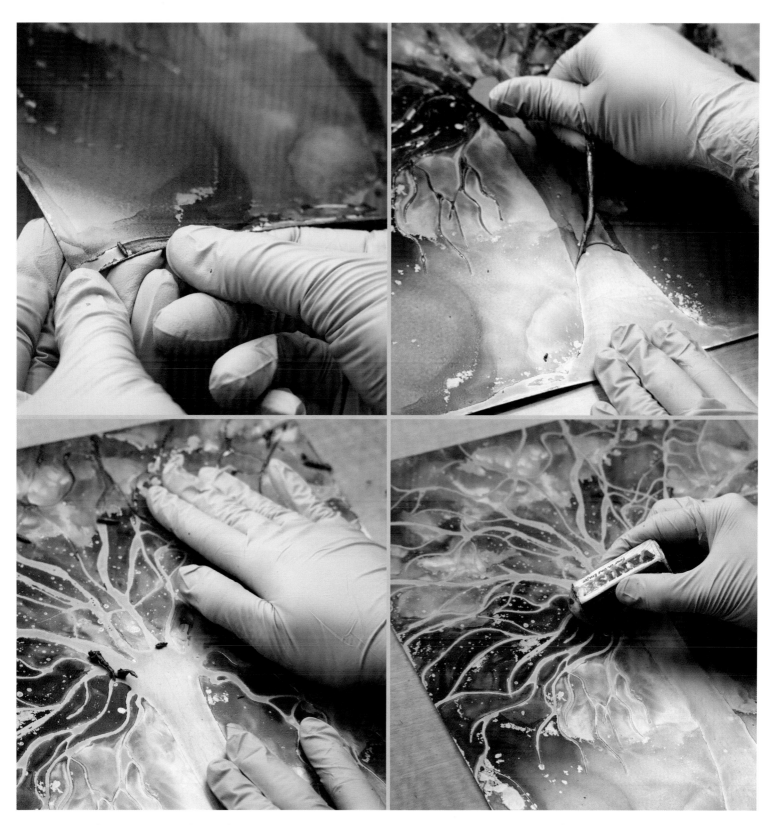

14 REMOVE THE MASKING FLUID. After varnishing, wait patiently for another 24 hours. Then peel off the masking fluid using gloved fingers. It may take some finagling to get started, but typically, once you get it started, it shouldn't be too difficult to remove. You can also use a rubber eraser to remove any remaining shreds of masking fluid.

REFLECTION

Remember to ask yourself those four questions I have been asking at the close of each project: How did that feel? What were you telling yourself before, during, and after your creative process? Were you able to tap into a creative flow? What made it easy or what got in the way? Another benefit of reflecting on these types of questions for each new project is that they help you better parse out the difference between your authentic self and your inner critic. It is like taking your temperature after each project and using the data as a tool to measure how you show up to your process each time and how it leaves you feeling each time. Asking these questions instead of always just focusing on how you feel about the artwork itself helps you engage more deeply in your personal process. The more intimately you come to understand your process, the more you trust yourself, which in turn leads to creating work not only that you like to look at, but that makes you feel something.

dig deeper

How do you know when the inner critic is taking up space in your creative process?

What does the inner critic tell you about yourself and your abilities as an artist or creative?

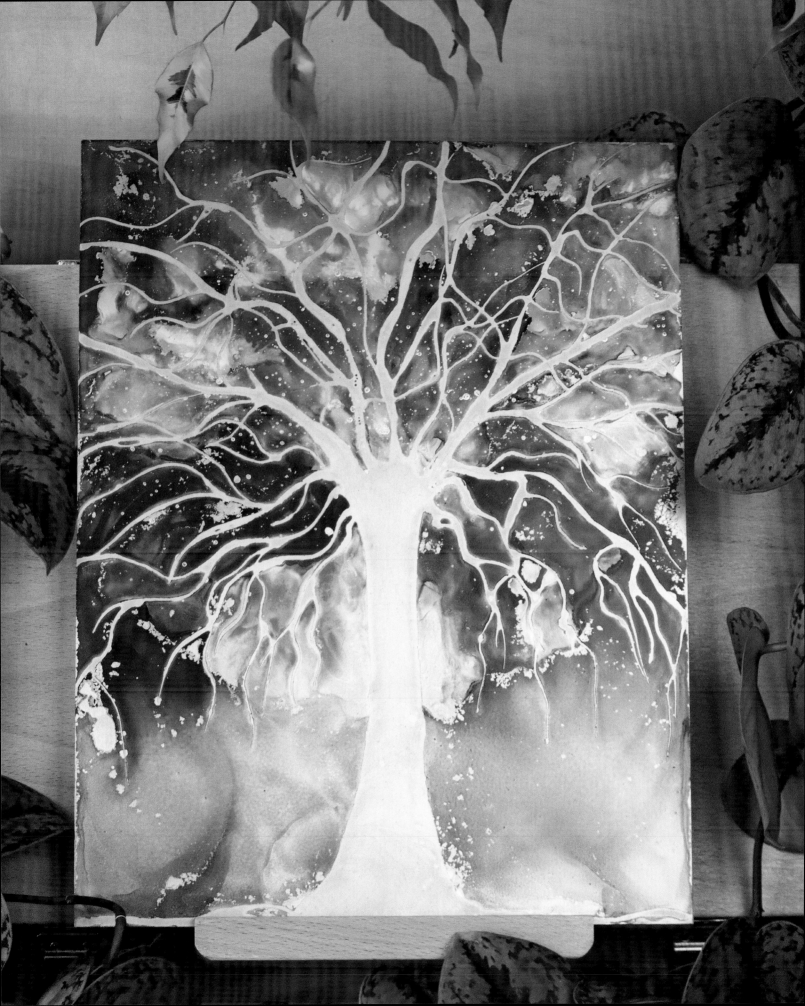

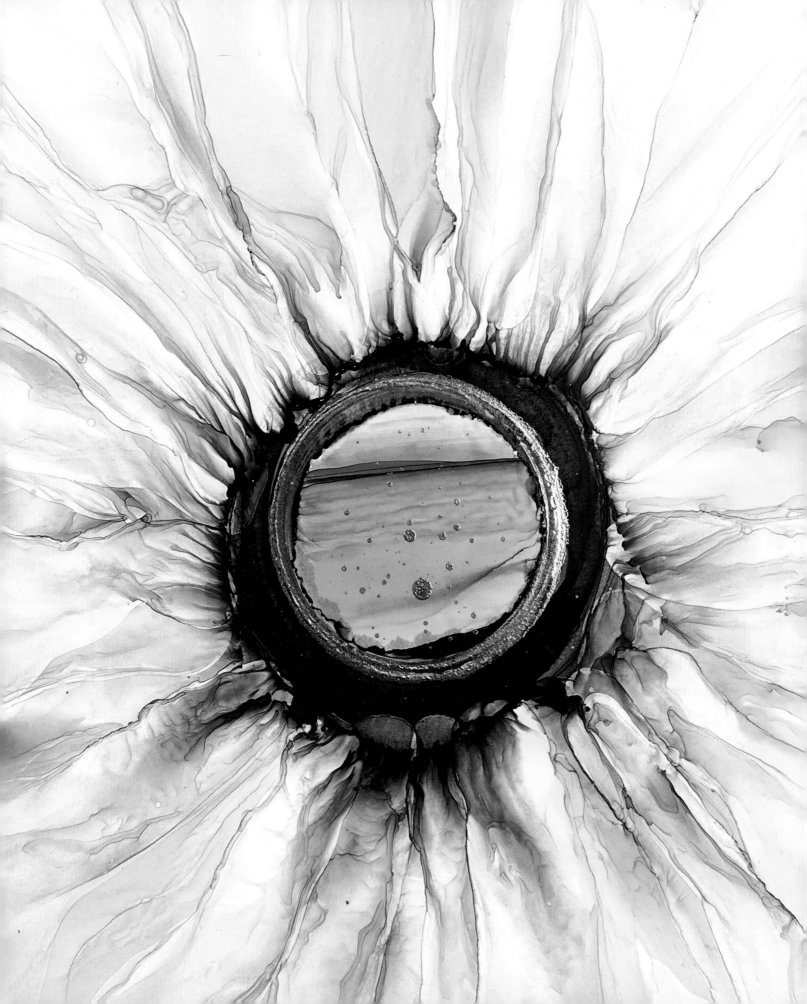

ALCOHOL INK BLOOM

This project, the last of our purely alcohol ink projects in this book, is a culmination of several techniques and mediums we've used so far. It combines the classic alcohol ink ingredients with some very intentional composition, a mix of abstract and realistic visuals, and fun techniques like creating ink rings. It's the perfect project to teach you how to push through "ugly" stages in your work with confidence.

I trust myself to push past the ugly stages of my artwork

find your flow

PUSH THROUGH UGLINESS

It's time to explore how much trust we have in ourselves and our ability to create even through the "ugly" stages of making art.

This last of our alcohol ink projects is one that came out of my own creative frustration trying to figure out how to finish the projects for this book. As a first-time author, I had many moments of self-doubt and insecurity when developing the content for this book. This ink bloom project was an idea I had that I'd never seen done before. While I was bringing the concept to life, it went through so many ugly stages that I wasn't sure I could confidently do it while also teaching others. But I told myself that if I was going to write a book on conquering the inner critic in the creative process, I needed to practice what I was preaching, so I persisted— and it is now one of my absolute favorite projects of the entire book. The fact that this project exists at all is a

perfect example of stepping outside your comfort zone, trusting yourself, and reaping the benefits of the trust it took to get you there. It also shows that confidence can sometimes be secondary to trusting yourself; once you start trusting yourself, the confidence will eventually flow.

Not many artists talk about or share the "ugly" stages of a painting or project. If you've ever written an essay, you know that it often takes several rough drafts before you have your final paper. Painting is a lot like writing a paper; the layers of the painting can be considered parts of your rough drafts. There are often errors that need to be worked out in the next layer, and possibly the one after that. It's easy to be deceived into

Painting is a lot like writing a paper; the layers of the painting can be considered parts of your rough drafts.

believing that the most-talented artists never created anything unattractive. But this is a massive myth that will cause many artists to quit before they understand how great they can be. Your favorite works of art likely went through at least one, if not several, ugly stages before becoming the masterpieces you perceive them to be.

How many times have you given up on a started project because you were convinced it was not turning out how you envisioned and never would? Would you believe me if I told you that this is the threshold at which most aspiring artists remain cemented as just that: aspiring? If you find yourself confronted with the ugly stage of an art piece, that is an indication of two things: a need to walk away and come back, and a need to push yourself further outside of your comfort zone with as much trust as possible when you come back.

Always feel free to walk away and take breaks from any project. Sometimes the inner critic tells us that if we walk away from a piece, we will never come back to it. Make it a commitment to come back to your project in a certain amount of time, and trust in yourself that you will push through the frustration. This project will require you to trust yourself and push through the ugly "I can't do this; I give up; I ruined it" stages. Allow yourself a few ugly versions before deciding the outcome you want isn't within your grasp.

LET'S GET STARTED!

Choose a cup that is large enough to create a round frame for a landscape scene. Since we will be painting inside the circle, you don't want it to be too small. It may be helpful to tape your paper down to make it easier to work around the glass, but I like to be able to turn the paper as I work; see what works best for you. Prepare your alcohol ink paint palette with the colors you will be using to paint inside the center of your bloom.

TOOLS & MATERIALS

- Yupo paper: 11" x 14" (28 x 35.5 cm)
- Alcohol ink: 6 colors of your choice
- Metallic alcohol ink: brass or gold
- 91% isopropyl alcohol or blending solution
- 2 fine-tip squeeze bottles
- Drying tool
- Paintbrush
- Small glass dish
- Alcohol ink paint palette
- Paper towels
- Varnish
- Gloves
- Protective face mask

COLOR KEY

- Dandelion (Ranger)
- Teakwood (Ranger)
- Butterscotch (Ranger)
- Cloudy Blue (Ranger)
- Sandal (Ranger)
- Salmon (Ranger)
- Brass (Jacquard)

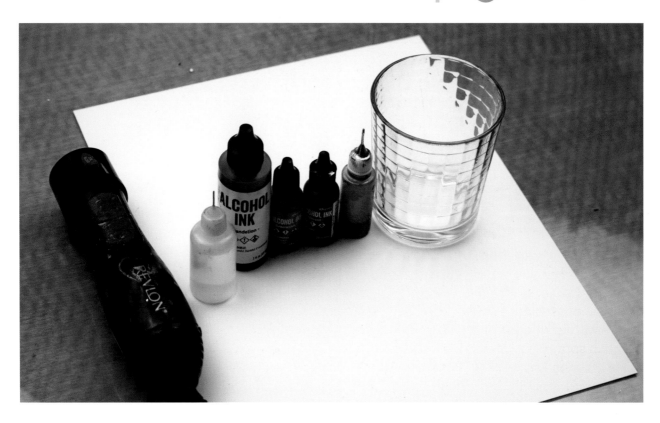

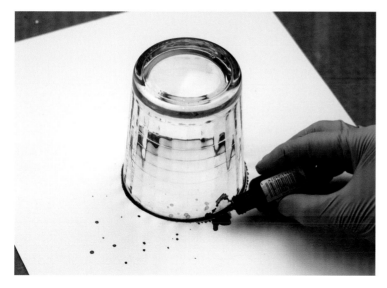

1 ADD THE FIRST COLOR AROUND THE GLASS. Place your chosen cup in the center of your paper and begin to add brown ink along the rim of the glass. This will become the center of your flower bloom. Since I am creating a sunflower-inspired bloom, I chose Teakwood as my brown shade.

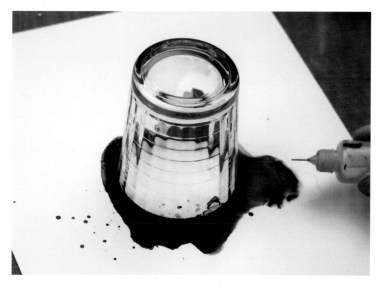

2 ADD ALCOHOL AND BLEND. Add alcohol along the edge of where you added the ink, and use a heat tool on a low setting to gently blend the ink into and away from the glass, blending until dry. I prefer the more controlled look of the heat tool for this project.

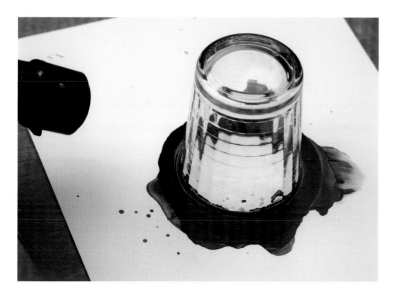

3 CLEAN UP SPLATTERS. Be mindful of how close you put the heat tool to the glass, as it may cause splattering. If the ink does splatter, don't worry—you can either leave the splattering or wipe it away with some alcohol, and we will work over any staining later. The quicker you clean spots of ink you do not want off your paper, the less time the ink has to actually stain—but more-pigmented, darker colors will stain pretty quickly.

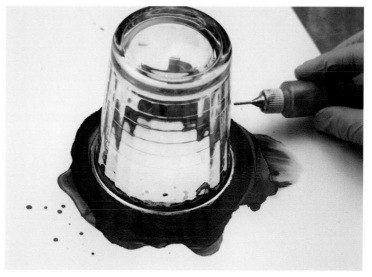

4 ADD A RING OF METALLIC INK. Add brass metallic ink from a fine-tip squeeze bottle. Do not dilute this with alcohol, because, unlike in other projects, here we want a controlled and highly pigmented solid gold ring for the center. Simply draw around the entire rim of the glass with the metallic ink and dry the gold pigment with the heat tool. Make sure the metallic ink is completely dry before attempting to move the glass. You can continue with a few more steps in the meantime.

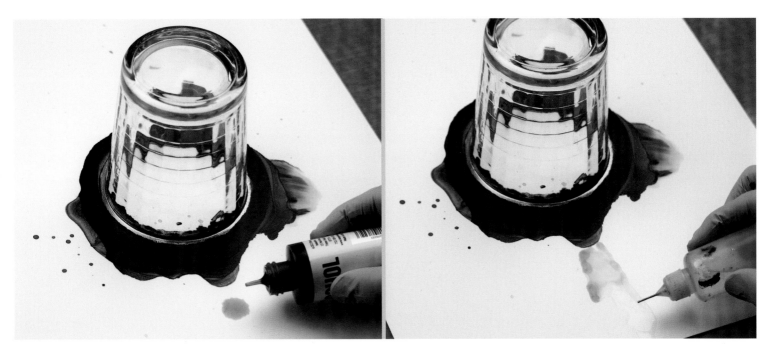

5 START THE FIRST PETAL. To begin creating the petals of the flower, start by adding a drop of yellow—I used Dandelion—slightly outside the dried brown center. I do not have the colors touching yet, but I do blend them slightly together when using the heat tool in the next step. Because yellow is less pigmented than other colors, put the ink down first, then a little alcohol. Here I am applying the alcohol in the shape of the petal I am about to create with the heat tool to help guide the ink in the direction I ultimately want it to go.

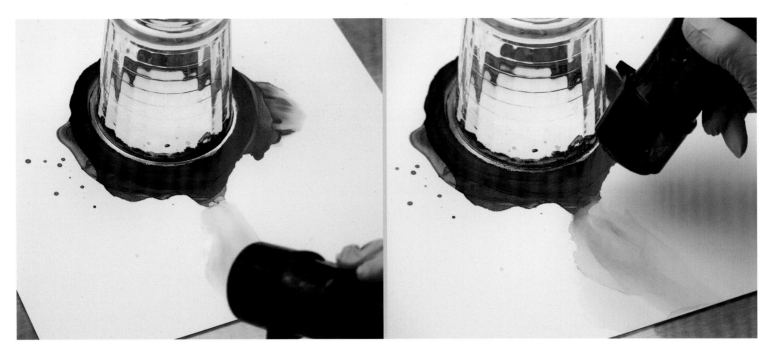

6 BLEND AND SHAPE THE FIRST PETAL. Using the heat tool, blend the ink and alcohol, pushing the edge of the yellow slightly into the edge of the dried brown. Once the yellow is just touching the dried brown, turn up the heat setting on the heat tool and push the ink that is touching the brown away from the center and off the page, holding the heat tool in one consistent direction. You can use the heat tool to manipulate the direction of the drying ink into the shape of a petal as you go.

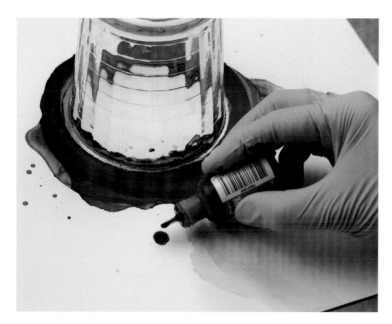

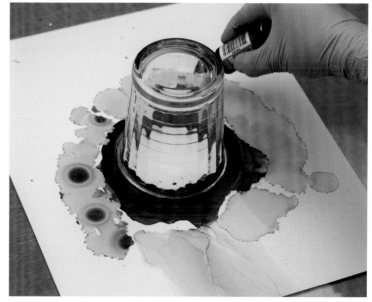

7 CREATE A SECOND PETAL. To add dimension to the yellow petals, work a different yellow—in my case, Butterscotch—in with the first yellow. Here, I have dropped the darker yellow next to the existing yellow petal and will blend it partially into that petal.

8 BUILD THE BASE OF THE REST OF THE PETALS. Add the rest of the petals around the center of the flower, working in layers. You can either work each petal one at a time, dropping ink and blowing, or you can add yellow dots all around the brown ring to mark where your petals will be and then blow them all at once. I added a drop of Dandelion with a drop of Butterscotch on top for each remaining petal, then went in and blew the ink out all around to get the final petal effect.

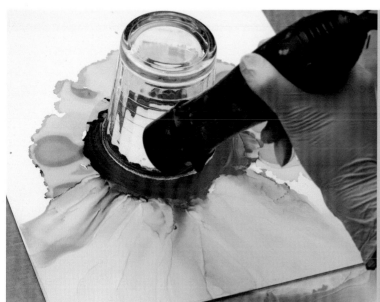

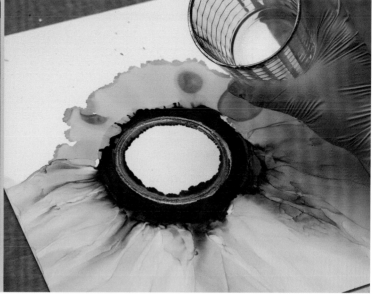

9 FINISH BLENDING ALL THE PETALS. Once it starts to get tricky to work around the glass and you are sure the gold center has dried, you can remove the glass from the center of the paper. Continue the bloom effect technique around the entire center of the flower until you are happy with your petals and ink coverage.

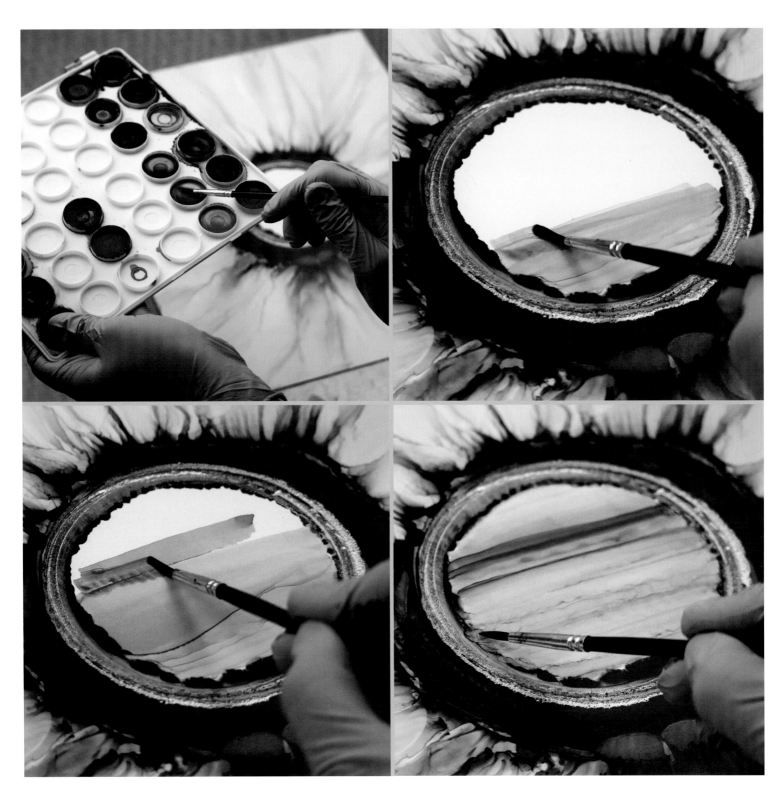

10 PAINT THE CENTER. Grab your prepared alcohol ink paint palette. Use a paintbrush to paint an abstract fade that resembles a landscape in the blank white center of the bloom. If the ink in your palette is dry, use just a bit of alcohol to reactivate it—you do not want the ink to spread too much, since you are working in such a small area. The gold ring acts as a barrier, but avoid getting the middle too saturated with ink or alcohol so that it doesn't bleed into the flower. I also grabbed a little of the dried brown ink around the inside of the gold ring to pull into the abstract fade.

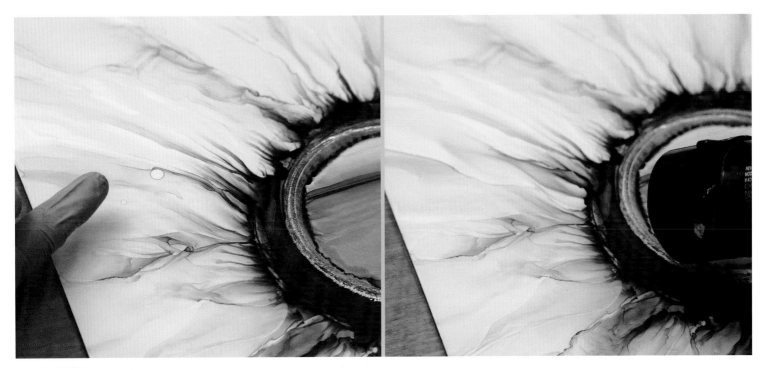

11 MAKE ADJUSTMENTS. If you accidentally drip or splatter on your piece, as shown here, use alcohol and your heat tool to rework the ink back to the way it was before, or close to it.

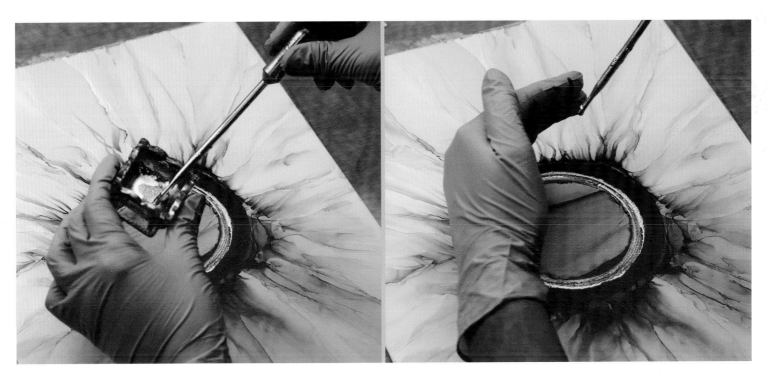

12 ADD SPARKLES TO THE CENTER. Now it's time to add metallic sprinkles to the center of the bloom. Mask off the rest of the bloom by cutting a hole as large as the center of the bloom out of a scrap piece of paper, or just use your hand to block the petals as you work. Prepare some metallic ink in a glass dish and a pipette as taught in previous projects (see pages 93 and 117), then add your splatters to the space as densely as you wish.

REFLECTION

Did you make it through without any ugly stages? If your piece came out looking nothing like mine and you feel defeated, you probably already know by now what I am about to say: keep going and try again. If you've come up with your own version of the project, I am proud of you for pushing through and creating a work you are, I hope, proud of. If you are even slightly happy with the outcome of this project, it means you are on your way to a more confident creative flow, especially with alcohol ink. A lot of people think that alcohol ink looks easy, but once you've attempted to create enough outcomes, you know it takes quite a bit of finesse and skill to manipulate. Sometimes, though, you can have all the right skills, instructions, and tools and still end up creating from a place that doesn't quite flow.

For the next project, we will dive into what happens when our mood impacts the space we create from. For now, though, I want you to look back at whatever you created today and remember the steps it took to get you to this point. Keep going!

dig deeper

What is your relationship to the ugly stage
when it comes to the artwork you create?

Do you usually quit when you reach an ugly stage,
or do you push past it?

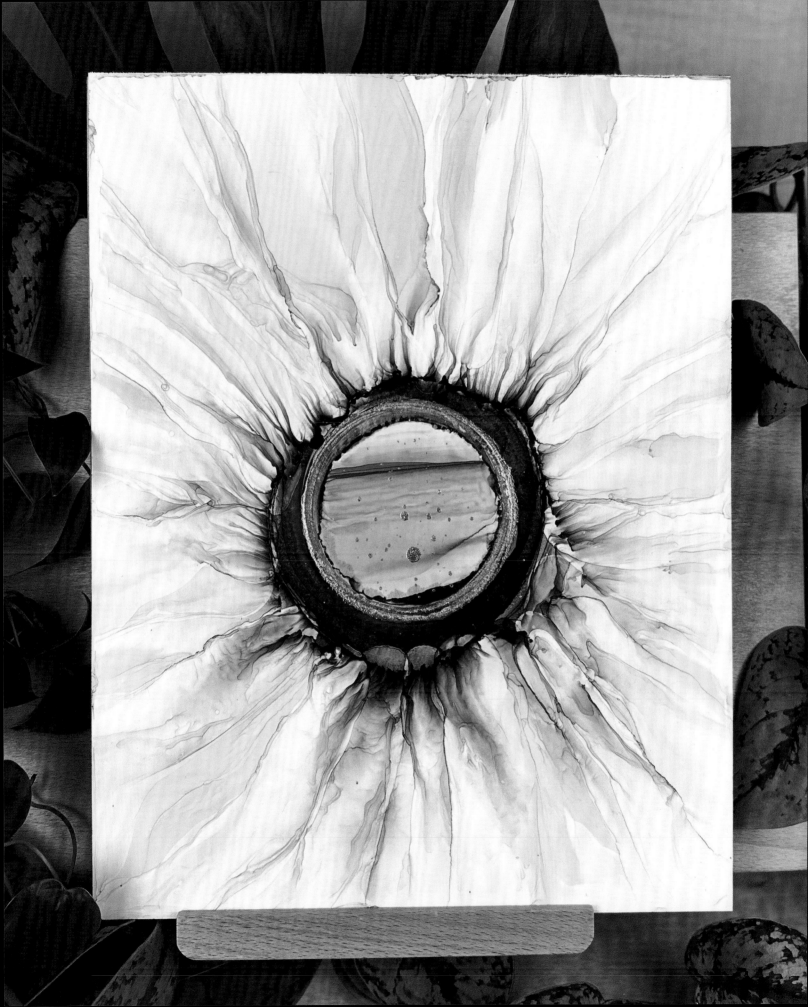

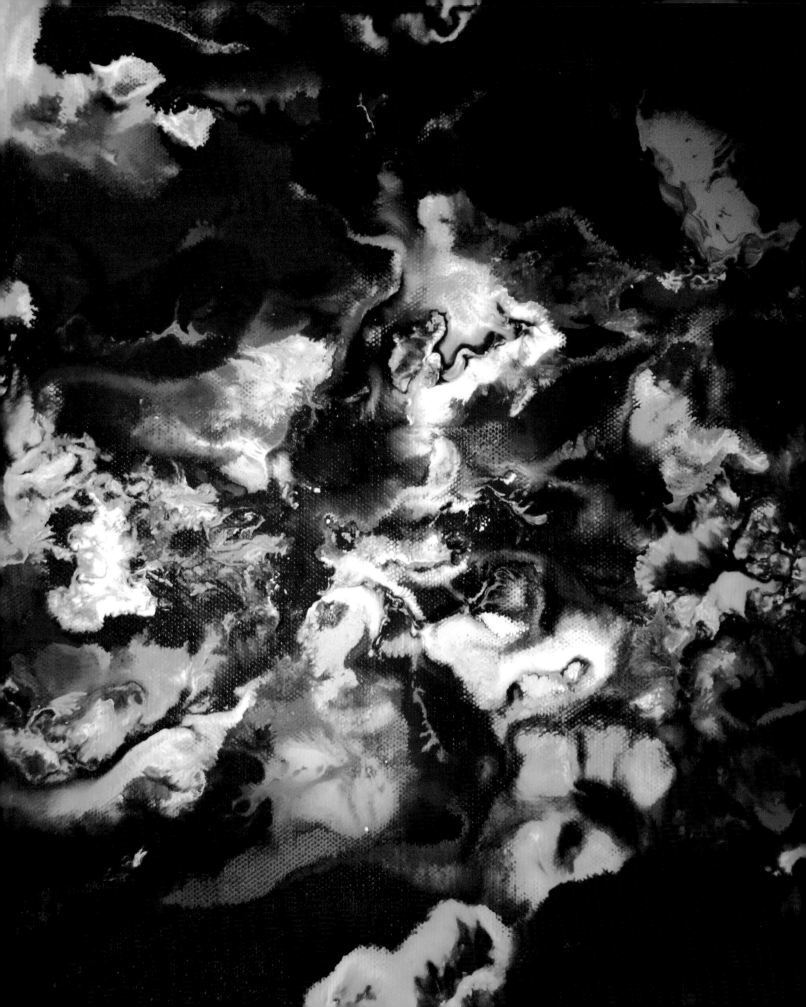

HIGH-FLOW UV DREAMSCAPE

Our next project is a loose, fluid painting that allows you to let go of rigid rules and guidelines and let the color and movement of the paint speak for you. It is a meditative project that can be utilized on days when your inspiration is low but your motivation to create is there. Allow this project to be a meditation. Do your best not to overthink the outcome. Get lost in the swirling textures and colors. Allow the project to be a light on a dark day. The great thing about UV-friendly art is that it can still be viewed even when being in the bright light feels like too much. Here, I am simply using fluorescent high-flow acrylics incorporated with regular high-flow acrylics to give the piece the ability to flow under UV light.

It is okay to create for the sake of creating and nothing more

find your flow

WORK THROUGH BAD MOODS AND LOW MOTIVATION

Some days, weeks, months, and even years, you might find yourself with little desire to create.

A bad mood, a loss, a transition, a busy phase—these are just some of the reasons why you might not find yourself in the mood to create. If creating is your profession or your "can't live without" hobby, not creating because of a bad day, mood, or situation can really feed the guilt meter and leave you feeling like you're not doing enough. Creating in a bad mood, a distracted state of mind, or a dark place can feel impossible.

I want to remind you that it is okay if you do not want to push through those moments when you do not feel like creating. Creative blocks are normal, and a consistent creative flow isn't always easy to access, depending on what is going on in your life or in the world around you. It is okay to take breaks and long pauses from your creative practice; your flow will not suffer from it unless you continue to feed the narrative that tells you that you aren't a worthy artist if you aren't producing. There are times when the most productivity and inspiration come from doing anything other than painting. Maybe that's a walk in the fresh air, or maybe it's a cuddle with your pet or a nice, cozy nap.

Sometimes, though, finding the motivation to make art can be more about getting started than anything else. Sometimes, we just have to go for it, simply for the sake of creating and without much thought. That's where abstract expression can serve a higher purpose, and that's where this project comes in.

You do not have to be creating masterpieces for art to boost your mood.

My hope is that you can use this project, and many other projects in this book, to inspire you to create even on bad days—and maybe even especially on bad days! Art and art making have a major proven impact on mood. Viewing and creating art can help your nervous system relax and rewire for a more positive upswing in mood and quality of life. You do not have to be creating masterpieces for art to boost your mood, and you do not need to sell your art or share your art and have it validated by others for it to boost your mood. You just need to create. Something. Anything.

Find a comfortable place to sit in the dark so that you can focus and let your mind ease into a relaxed state. Take a deep breath, then turn on the UV black light, illuminating the finished painting in front of you. The picture in front of you, painted with UV-activated glow paint, is slowly revealed, illuminating what wasn't seen in the dark. As you gaze at the painting, everything around begins to disappear, leaving only the bright neon colors and designs within the picture. Watch the paints come to life in the darkness, creating a multidimensional piece full of wonder and excitement. As you focus on the painting, let it draw in all your attention and continue to breathe in and out. Allow yourself to embrace this calming moment, feeling at peace and content.

LET'S GET STARTED!

Prepare your canvas for high-flow acrylic application by following the step-by-step instructions on page 27. Choose three high-flow acrylic paint colors to create the background. Add these three colors to individual cups, one color per cup, and add some high-flow medium to each cup. Swirl the cups around to mix the paint with the medium. Adding this medium will allow the paint to work better for filling the background in the first few steps. I also added a bit of Mars Black to the Phthalo Green paint to darken it, which is completely optional.

TOOLS & MATERIALS

- High-flow acrylic paint: 12 colors of your choice, including some fluorescent UV colors
- High-flow medium
- Stretched canvas: 11" x 14" x 2" (28 x 35.5 x 5 cm)
- Fine-mist spray bottle
- Palette knife
- Paper towels
- UV flashlight or lightbulb
- Small cups for paint
- Gloves
- Varnish

COLOR KEY

- Phthalo Green (Golden High Flow)
- Mars Black (Golden High Flow)
- Turquoise (Golden High Flow)
- Sap Green Hue (Golden High Flow)
- Fluorescent Blue (Golden High Flow)
- India Yellow Hue (Golden High Flow)
- Permanent Violet Dark (Golden High Flow)
- Fluorescent Violet (Golden High Flow)
- Titanium White (Golden High Flow)
- Fluorescent Magenta (Golden High Flow)
- Fluorescent Chartreuse (Golden High Flow)
- Pyrrole Orange (Golden High Flow)

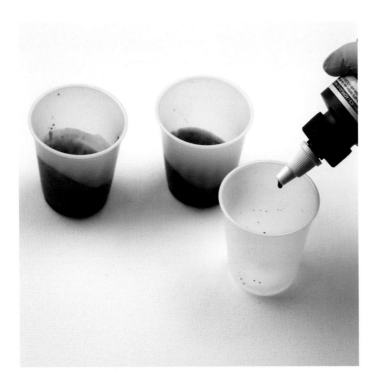

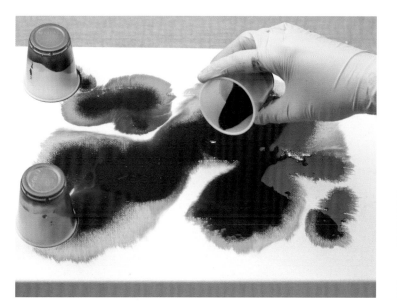

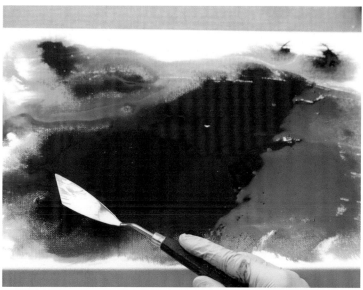

1 POUR YOUR BACKGROUND COLORS. The first part of the process is to create a colored wash for the background of your piece using your chosen background colors mixed with high-flow medium as described on the facing page. I used Turquoise, Phthalo Green, and Sap Green Hue. Use a fine-mist spray bottle to help the colors bleed together and spread effectively without needing to add more paint.

2 SPREAD AND MIX THE COLORS. You can also use a palette knife to move the color around. Keep using the mister bottle as needed to help blend the colors and create a more fluid effect.

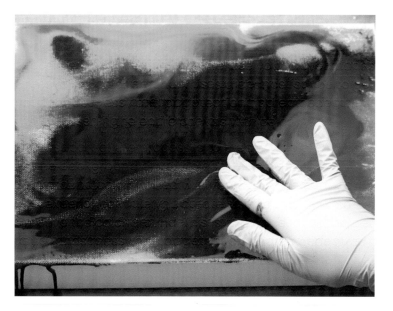

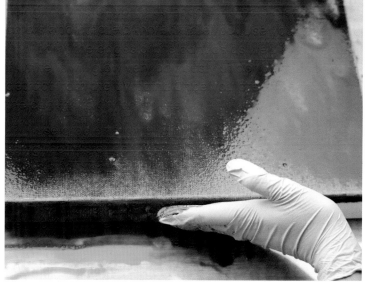

3 USE YOUR FINGERS. If you want a sensory experience while you create, use your gloved hands to move the color around. This is a chance for you to get your hands messy and put intention and emotion into the process. Fill the entire canvas with color.

4 PAINT THE CANVAS EDGES. Use your fingers to paint the edges of the canvas as well. If you leave if white, it will glow very obviously under UV light and detract from the UV paint. Once you are finished, allow the canvas to dry completely.

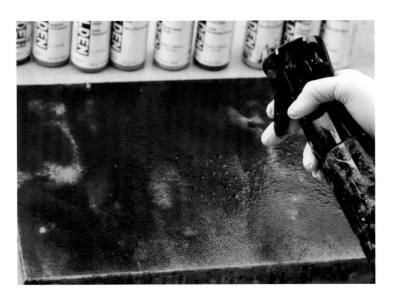

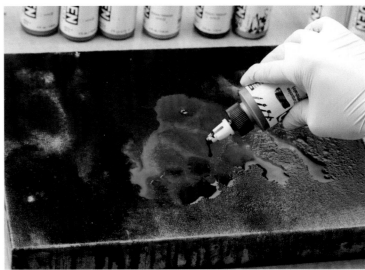

5 MIST THE DRIED CANVAS. Once the canvas background color is completely dry, you are ready to create your UV dreamscape. Before you start, mist the dry canvas with water. You needed the background colors to dry so that the new paint layers will build upon them rather than blending with them, but wetting the background again will help the new paint layers spread.

6 ADD A FEW COLORS. Drop 1–3 drops of your first few high-flow colors directly from the bottles onto the canvas to start building your composition. I am using Turquoise and Sap Green Hue again to start so that the new layer has some visual consistency with the existing background.

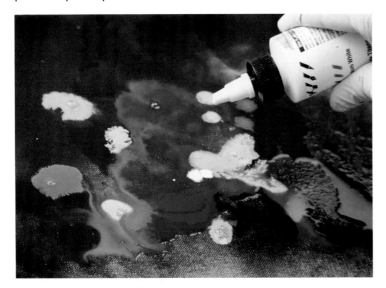

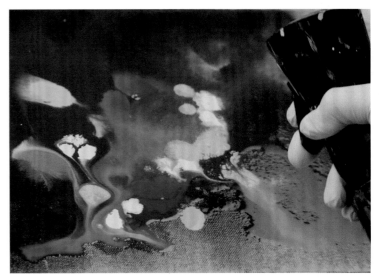

7 ADD MORE DIVERSE COLORS. Then add additional colors, but not necessarily every single color you plan to use. I am adding Fluorescent Blue, India Yellow Hue, Permanent Violet Dark, Fluorescent Violet, and a few drops of white at this stage. Do not fill the entire canvas—just begin to add areas of color that will eventually run together to create the fluid composition.

8 MIST THE COLORS TO BLEND THEM. Mist the paint colors with the fine-mist bottle to help them begin to blend and bleed together. Use your own discretion and creative eye to decide how much water to add, but start by adding just a little; you can always add more as you go.

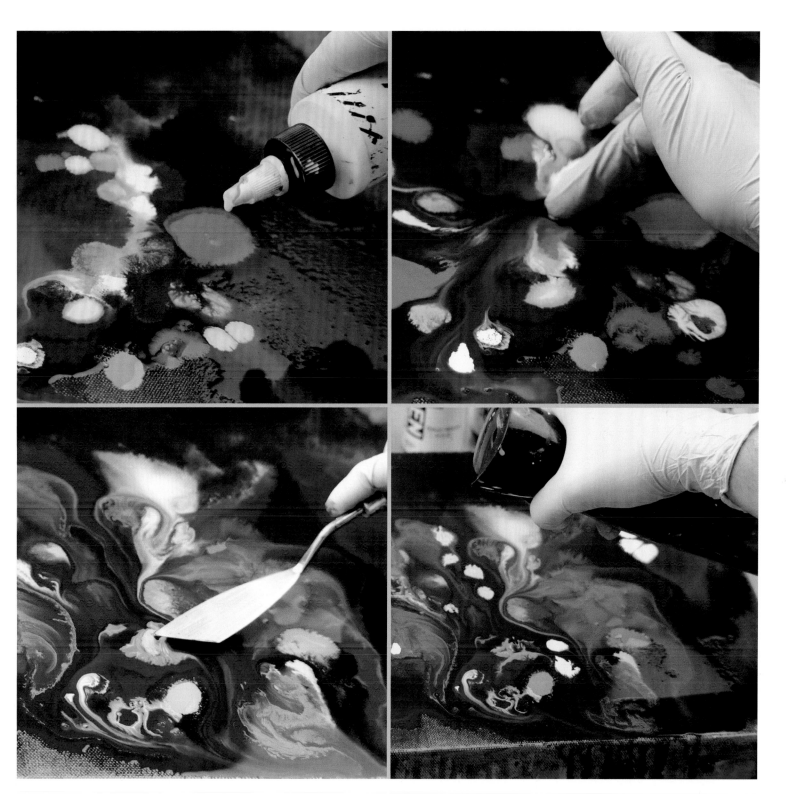

9 BLEND IN EARNEST USING DIFFERENT TOOLS. Add more colors and alternate between misting the colors to get them to blend and using your fingers and/or a palette knife to manipulate them. Do not over-mist—the paint will become too watery, and the colors will run together too much. If this happens, let the layer dry and come back again with less water in a new layer. No layer of paint is wasted in this process. Remember to push through the ugly stages and the mess-ups. The beauty of acrylic paintings is that they can always be painted over again and again.

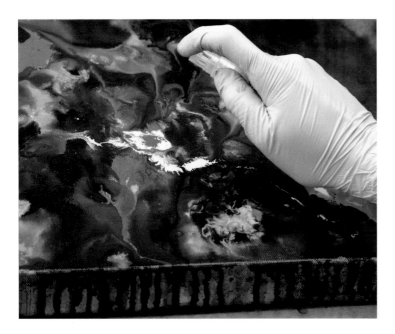

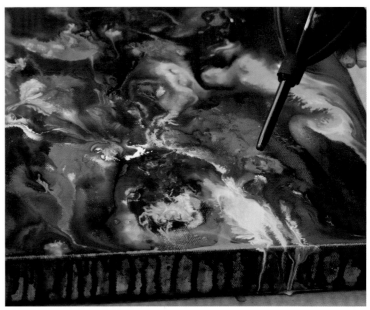

10 TRY A MINI MISTER. Use a mini water mister for more control over smaller areas of the painting. For example, here, I wanted to focus on the blob of orange and white.

11 TRY AN AIR TOOL. Use an air tool to blow around a few spots and manipulate the paint with forced bursts of air to create interesting effects. This is a fun way to push paint in dripping lines onto the edges of the canvas, as shown here.

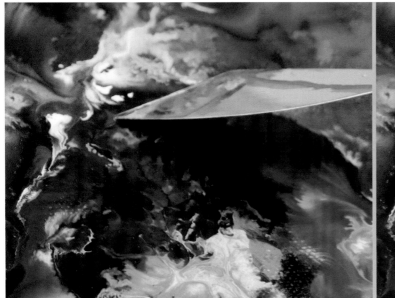

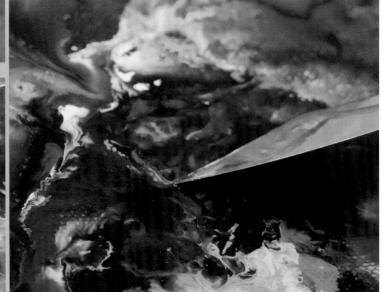

12 TRY A PALETTE KNIFE. Use a palette knife to pick out and highlight details within the paint. For example, here, I dragged a bit of the fluorescent purple out of its puddle to extend it. You can also let some layers dry if you really love how a particular area is looking. If you notice a certain spot looks amazing and you do not want to risk it getting blended away as you continue to work, this is a great opportunity to practice taking a break. If you leave that area alone to let it dry, you can then either mask it off to protect it from the next layer or simply work around it.

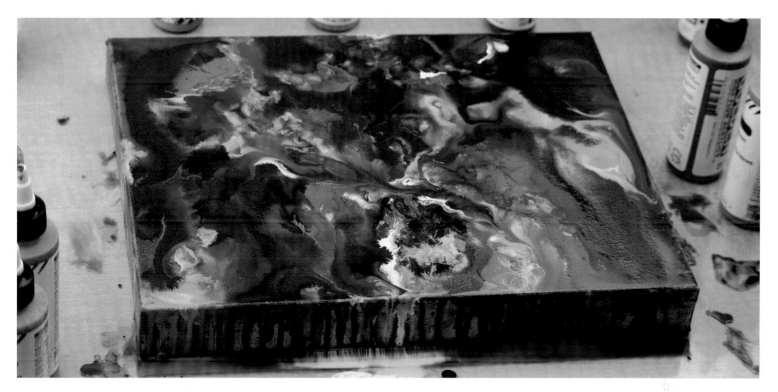

13 FINISH YOUR COMPOSITION. Keep working until you are happy with how the composition looks. Then leave the piece completely alone to dry—walk away from it. I recommend leaving the room where the drying art is if you are afraid you'll be tempted to mess with it further.

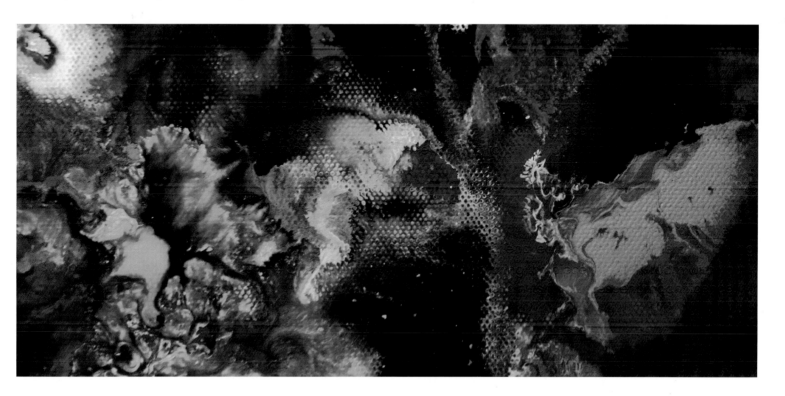

14 VARNISH AND FINISH. After the piece has dried, varnish it. Then bring the piece to a dark room with your UV light. Turn out the lights and turn on the UV light to see your artwork in its full fluorescent magnificence!

REFLECTION

This project is intended to help you create pieces that are connected to something deeper, whether that's processing a bad day, engaging in a certain feeling, or just taking a moment to tap out and tap into something meditative. Unlike many of the other projects in this book, it is not meant to challenge the inner critic. It actually invites the inner critic to get involved and get messy. What would happen if the parts of ourselves that are so afraid of failing and making a mess were given ultimate permission to do so? If we let ourselves tap into our inner child's mindset more often during the creation process, how much would we be able to let go of? Come back to this project when you need a reminder of why you create in the first place. You will always get a different result, and you will always learn something new about yourself and your process every time you show up to create and express yourself.

Do you tend to avoid your creative practice when you're not in the mood? What happens when you push through and create anyway?

What is your relationship to taking breaks during your creative process?

Do you feel guilty when you rest instead of creating?

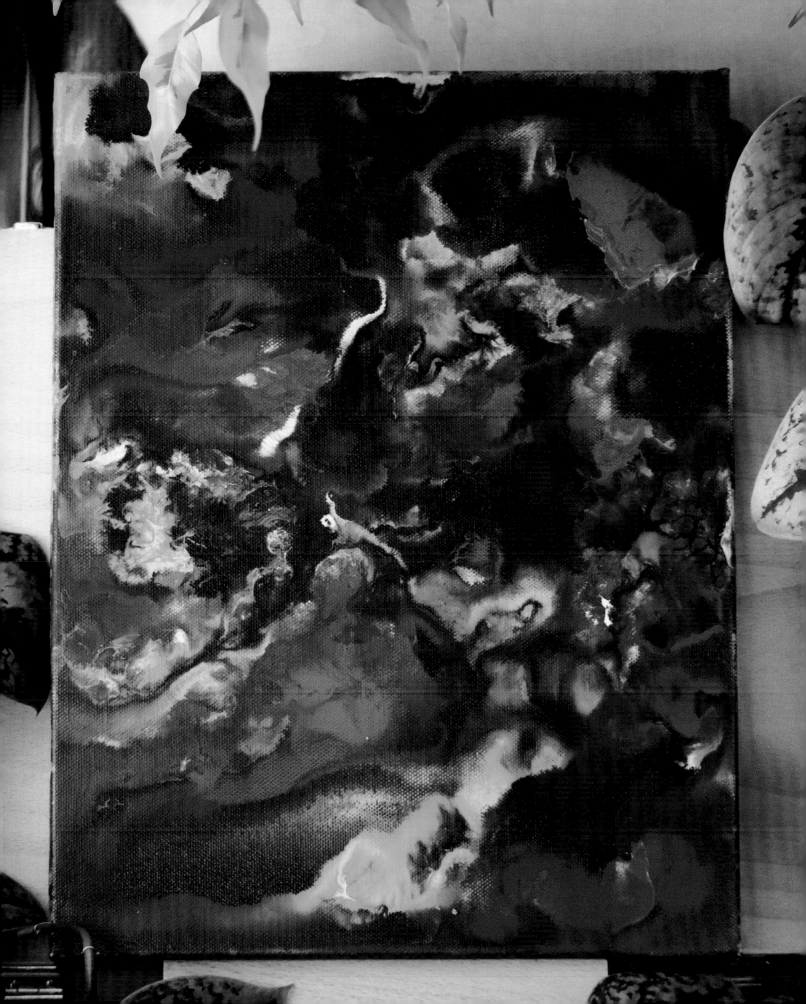

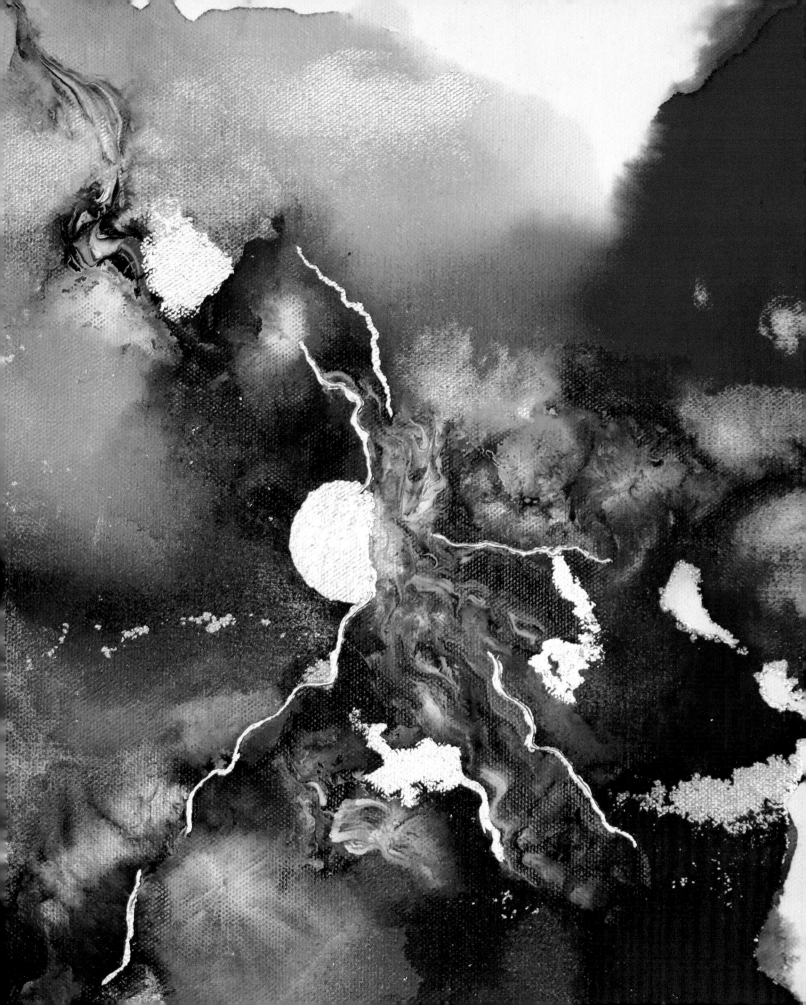

MIXED MEDIA ABSTRACT

For this project, we are going to create a mixed media painting on canvas utilizing both alcohol inks and high-flow acrylics. You do not need to carve out a large chunk of time to create it. There is no concept involved, no studies or planning. This project has endless possible outcomes, and there is no right or wrong way to go about it. You can do this project on a limited time schedule and with very few tools and still create a stunning work of art. I want you to go into this project with an open mind and all the trust and confidence I've instilled in you up until this point.

I am aware of the mindset

I am in as I create

find your flow

LET CREATIVITY FLOW IN THE SPACE AND TIME AVAILABLE

As much as we might want to be creative, making time for art can be difficult in the hustle and bustle of modern life.

I hear many artists complain about the lack of time in their schedule to carve out a moment for creating. One of the reasons I love fluid abstract expression is the efficiency at which you can create a beautiful and engaging work of art.

It is a myth that a masterpiece requires thousands of hours. It is also a myth that a masterpiece is a piece that is loved and admired by you and everyone else who views it. In my controversial opinion, a masterpiece is any piece that gets you out of your head and into your heart, any piece that teaches you something about yourself and the experience of art making. A work does not have to be beautiful to be a masterpiece, but it does have to make you feel something. If you've never fallen love with a piece

you didn't love initially after the artist told you the story of how they created it and why, then you are missing out.

One of my favorite parts of creating intuitive abstract fluid art is the magic of not having to have a plan when I start a piece. It can provide a ton of confidence to plan out a concept for your projects ahead of time—as we've seen in many projects so far in this book—but, for the intuitive process, sometimes trying to plan a project can hinder how your intuition flows. You should strive to leave plenty of room in your creative practice for random art making that has no desired outcome. This allows you to keep your process loose and not get too caught up in trying to perfect a concept.

When we spend less time in creative blocks, we can focus on creating intentional work, which in turn takes less of our precious time.

Another way to expedite your art making while still tapping into a creative flow is by becoming keenly aware of how you are showing up to your creative space. How are you feeling? Are you trying to force it and rush? Noticing your mindset when you show up to the creative process can cut down the amount of time you spend creating because you are spending less time frustrated and stuck in negative thought patterns that feed creative blocks. When we spend less time in creative blocks, we can focus on creating intentional work, which in turn takes less of our precious time. Being creatively blocked or in a negative headspace doesn't mean you should quit trying to create—it just means you will benefit from going into the project aware of being in that headspace so you can give yourself grace if the project doesn't go your way.

If you're juggling a busy life, a full-time job, being a parent, or any of the things that fill up our cups, creating can still be accessible and possible. Make a commitment to making it happen and to developing the skills necessary to have a creative process and flow that you can easily tap into and out of as needed to suit your lifestyle.

This project is truly about letting your confident, creative flow guide you. Grab a glass of water, have a snack, light a candle, and turn on some music—it is time to tap into your flow, uninhibited, and have fun.

LET'S GET STARTED!

Prepare your canvas for high-flow acrylic application by following the step-by-step instructions on page 27. Some people like to prep their canvas with Kilz latex primer before working with inks on canvas, but I skip this step—I prefer the way the ink looks soaked into the raw canvas rather than risking the brush marks that can be caused by priming it with latex primer first. But follow whatever method works best for you!

TOOLS & MATERIALS

- High-flow acrylic paint: 6 colors of your choice
- Alcohol ink: 3 colors of your choice
- Metallic alcohol ink: brass or gold
- Stretched canvas: 11" x 14" x 1 ½" (28 x 35.5 x 3.8 cm)
- Fine-mist spray bottle
- Palette knife
- 91% isopropyl alcohol or blending solution
- Fine-tip squeeze bottle
- Drying tool
- Paper towels
- Gold foil sheets
- Gold leaf adhesive
- Soft mop paintbrush
- Gloves
- Protective face mask
- Varnish

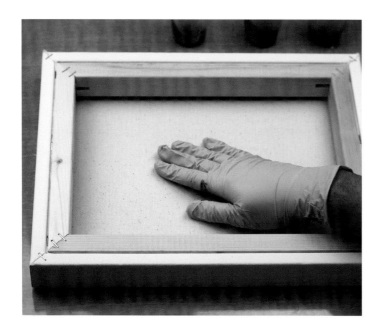

COLOR KEY

ALCOHOL INKS

- Butterscotch (Ranger)
- Wild Plum (Ranger)
- Stream (Ranger)
- Brass (Jacquard)

ACRYLICS

- Iridescent Gold (Fine) (Golden High Flow)
- Naples Yellow Hue (Golden Fluid)
- Titanium White (Golden High Flow)
- Quinacridone Magenta (Golden Fluid)
- Cobalt Turquoise (Golden Fluid)
- Anthraquinone Blue (Golden Fluid)

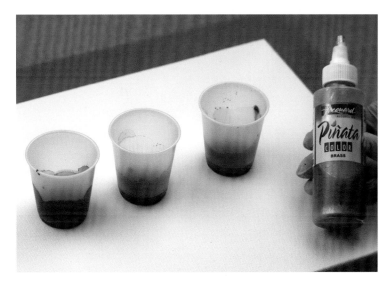

1 MIX ALCOHOL INK WITH ALCOHOL. Premix your chosen colors of alcohol ink with isopropyl alcohol in a 2:4 ratio of ink to alcohol in small cups. You will be pouring these diluted alcohol inks directly onto the canvas. Since you are working on a porous surface, the ink is more prone to sinking into the canvas before you can move it around. Premixing and pouring this way helps the ink move more freely.

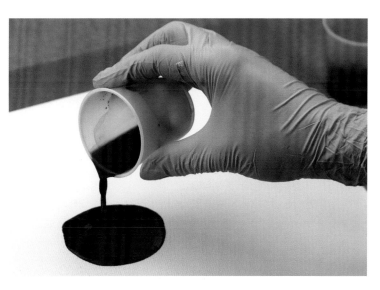

2 POUR THE FIRST COLOR. Make sure the surface of your canvas is completely free of any hair or debris. Then pour one of the prediluted alcohol ink colors onto the canvas.

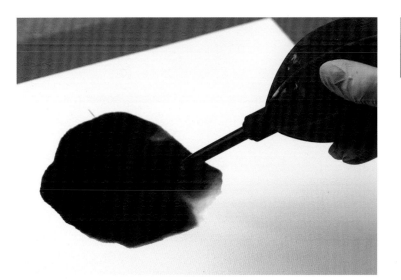

3 START TO MOVE THE COLOR AROUND. The ink may still be rather pigmented, so feel free to dilute with more alcohol; the more you practice, the more you will become familiar with the ratio of ink to alcohol that you prefer. Begin to move and blend the ink immediately with an air tool so that it does not sink into the canvas. You want to keep the ink moving almost constantly when working with canvas, because the canvas will absorb the ink quickly.

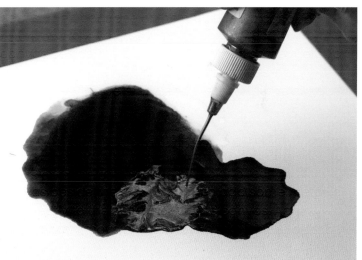

4 ADD A SECOND COLOR AND METALLIC INK. Pour your second ink color directly onto the canvas beside the first color. Then add some metallic ink directly to the new color on the canvas. Again, immediately move and blend the ink with the air tool.

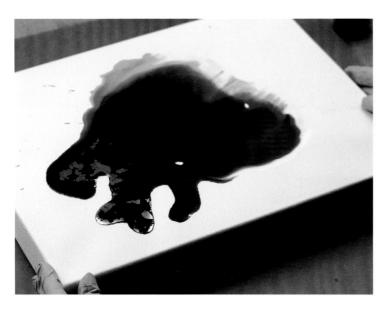

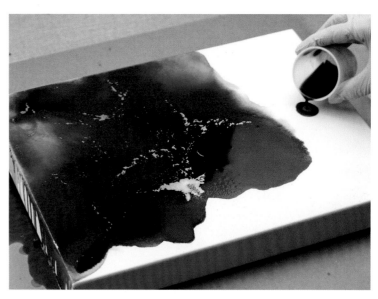

5 KEEP MOVING THE INKS AROUND. You can also pick up and tilt the canvas to get the inks moving. Try different methods at different moments during this whole project.

6 CONTINUE ADDING COLOR AND ALCOHOL. Keep building the composition by using the prediluted ink colors, adding extra alcohol as needed and moving the ink around constantly. It is up to you what type of composition you want to create. This will be the background of your piece; we will be adding midground and foreground elements later.

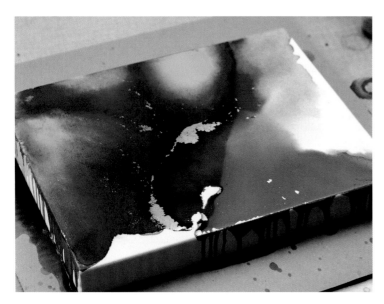

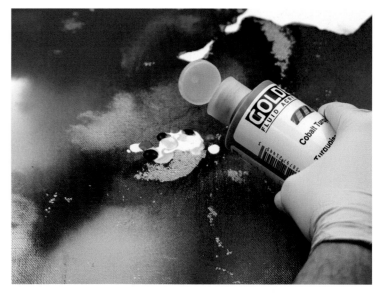

7 FINISH THE INK COMPOSITION. Once you are happy with your ink background, allow the ink to dry completely before moving on to the next step. You also have the option to varnish this dried alcohol ink layer now to prevent the ink from bleeding through to your acrylic colors, but it is completely up to you.

8 START WORKING WITH ACRYLICS. Using drops of high-flow acrylics directly from the bottles, begin to add interest to the midground of your piece. Use the composition of the first layer to guide where you go with this new layer. I started with gold acrylic over an area of gold alcohol ink to create consistency. Then I added drops of multiple other colors, all in this one concentrated area.

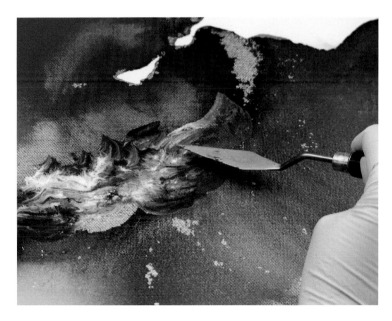

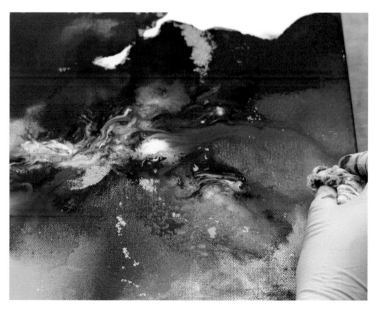

9 **WORK THE ACRYLICS WITH A PALETTE KNIFE.** Using a palette knife, gently manipulate the wet paint, spreading it and scraping it with the edges of the knife to create different textures and swirls. For more control over the application of paint, you can apply the paint directly to the palette knife, especially if you only want to add tiny details of paint.

10 **USE WATER TO MANIPULATE AND BLEND.** You can mist some areas of the wet paint with water to achieve a seamless blend with the layer below and to create translucent knife strokes. I like to focus on the edges of the wet acrylic where the acrylic meets the alcohol ink to mist with water—the paint will spread, following the water, and create an ethereal, cloud-like effect. Use a paper towel to soak up excess water or overly pigmented areas.

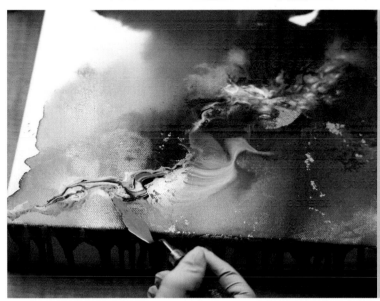

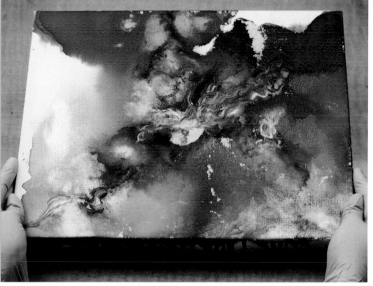

11 **FINISH YOUR ACRYLIC COMPOSITION.** Continue adding just a few drops of acrylic paint at a time and blending and shaping with your palette knife and mister. Use your own discretion, creative vision, and knowledge about abstract compositions to guide you. Work slowly and intentionally. Once you are satisfied with your composition, let the piece dry completely.

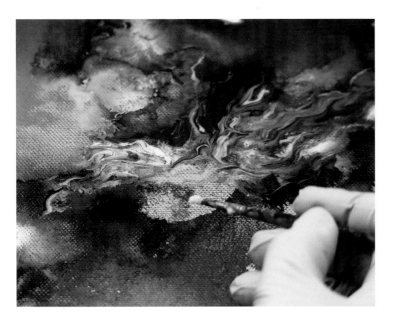 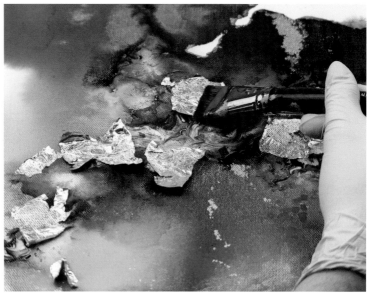

12 APPLY GOLD LEAF ADHESIVE. It's time to add gold leaf accents to the foreground! Use your imagination here. You can highlight areas that are already gold or add contrast with bright pops of gold foil where there is no gold. To start, apply gold leaf adhesive using a paintbrush to areas you want to foil. Follow the directions on your specific brand of adhesive.

13 APPLY GOLD FOIL. Wait 15 minutes or longer, depending on the brand, to allow the adhesive to dry to optimum tackiness. If you try to apply the foil too soon, the adhesive will be wet instead of tacky. When it's ready, apply foil to the tacky adhesive and gently brush it with a soft, dry mop brush to ensure the foil is securely applied to the canvas.

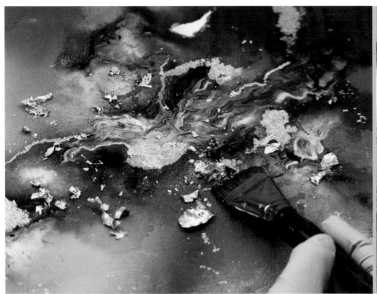

14 BRUSH THE FOIL OFF TO REVEAL THE DESIGN. Use the same brush to immediately wipe away any excess foil. Save the excess foil in a container for later.

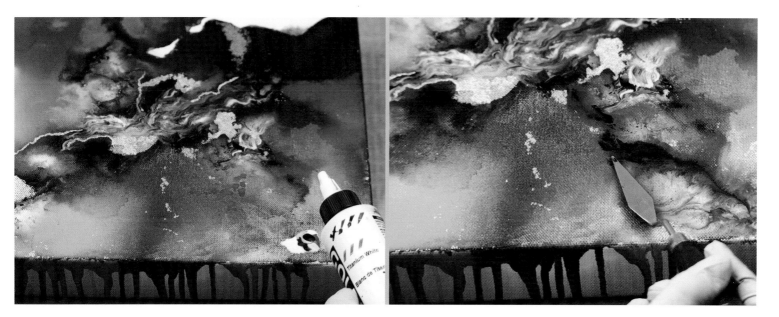

15 GO BACK IN WITH MORE ACRYLIC PAINT. Add final acrylic details to tie in the gold leaf to the rest of the piece. I like to hide some of the gold leaf behind a few spots of acrylic to build dimensionality in the layers and to give the effect that each layer bleeds into the next. You can add and adjust with acrylics as much or as little as you'd like.

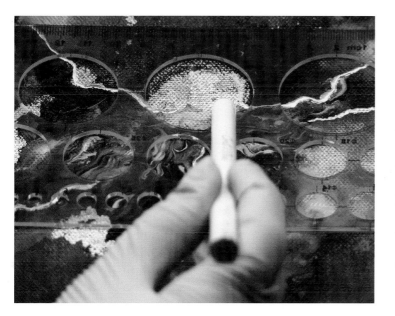

16 ADD MORE FOIL IF DESIRED. Don't be afraid to go back in and add more foil if you want! You don't want to overthink a piece or overwork it, but if you are inspired, run with it. In this case, I wanted to create a sun or planet effect with the central blob of gold, so I used a stencil to draw a half circle in gold leaf adhesive and also added more thin strips of foil radiating out from it.

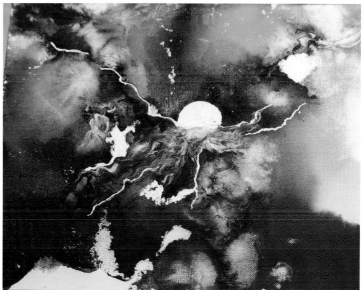

17 VARNISH IN STAGES. Let any final layers of paint dry completely before varnishing. Varnish the piece with an alcohol ink–friendly spray varnish first if you have not yet varnished the alcohol ink layer. After that varnish has dried, use a brush-on varnish to seal and protect the acrylic paint and gold foil. Paint the edges of your canvas once this varnish is completely dry. Otherwise, the ink will bleed through the paint.

REFLECTION

How was that for you? Did that feel like a true abstract expression of your intuition? If not, what got in the way? A flow that you can easily tap into and out of is one built on a foundation of creative confidence. It is taking the time to master the skills necessary to show up as your full artistic self when pursuing a creative project. No time spent creating is time wasted, and you will realize this more and more as you create and push through creative blocks and doubt. Confident artists are not immune to creative blocks; confident artists tense up in their process at times and forget their foundation too. It is a normal part of the process to feel stuck and inadequate. The challenge is to keep pushing through those moments of discomfort and stagnation and create anyway.

How does not having a plan before starting a painting change your process?

Do you feel more or less confident when you start a painting
with a concept in mind?

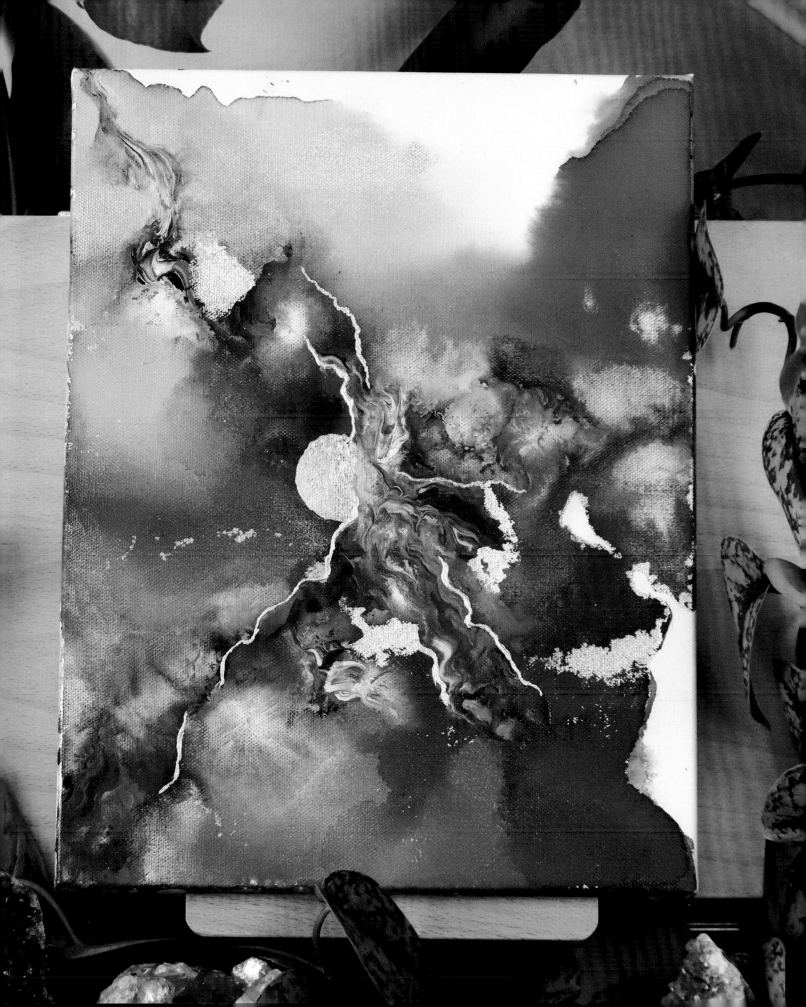

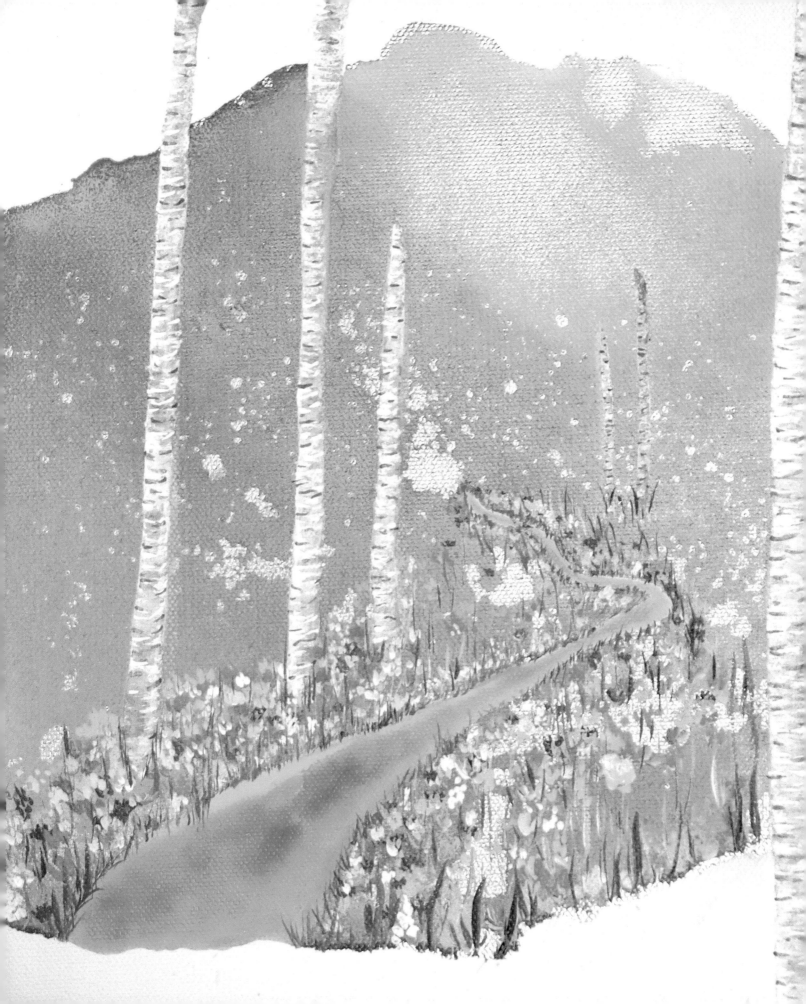

MIXED MEDIA NATURE SCENE

It is time for the final project in our fluid art portfolio. This project was chosen for last to help solidify your abilities and potential as an emerging fluid artist. This project combines elements of everything we have learned thus far and may feel extra intimidating. You may be looking at the end result thinking, "Yeah, right—I can't do that." Well, I want to give you one final push through any impostor syndrome that might be lingering and help you bring this representational abstract concept to life. I promise you have all the tools and tricks you need to work through it while also connecting to your own authentic flow. Some components of this project are preplanned, while others will need the guidance of your own imagination and intuition. I encourage you to bring to life a vision that is uniquely your own.

I can conquer impostor syndrome and create my own masterpiece

find your flow

OWN YOUR CONFIDENCE AND ABILITIES

Do you feel yourself beginning to embody the role of an artist, or are you still in a place of self-doubt and apprehension about your ability to create confidently?

Wherever you are in your journey, that is okay. Growth is not always obvious right away. Sometimes when we feel the most stuck or even when we feel like we are going backward, we are evolving the most. Progress is not always visible when you're in the middle of it. If you made it this far into the book, if you've worked through all the exercises and projects, you have a complete portfolio of fluid abstract work to reflect on as you continue down the creative path, and there is no denying you have grown as an artist.

You do not have to sell your art or even share your art to embody the role of an artist when creating. You do not need to create for anyone but yourself. This process and creative journey are for you

and you alone. Social media has put so much pressure on us to share every bit of our process and capitalize on every hobby we pursue. You do not have to want to quit your day job to want to create. You do not have to be rich to create. You barely need art supplies to create. The goal of this book is to show you how creating can be just for the process alone, with the end result being a bonus that you can rework over and over again. As you move through this final project, compare how you show up to the creative flow and process *now* versus how you showed up when you started the first exercise.

The journey is yours *now*, and I am so excited for you to take the next steps.

Take a moment to reflect on the outcome of this final project; if possible, grab each project you've completed from this book and view them together. Take a few deep breaths, inhaling deeply through your nose and exhaling slowly through your mouth. As you continue to breathe in this way, feel your body relax more deeply with each exhale, and gaze upon your paintings. The colors and compositions of your paintings are truly one of a kind and speak to the essence of your unique creative touch. Remind yourself of all the hard work it took to get to this point. Allow yourself to feel proud and accomplished in what you have created.

As you examine the details of the paintings, notice any feelings of discomfort or fear arising. You may feel like an impostor, thinking that your talent and hard work aren't enough. Acknowledge these feelings and then imagine taking a deep breath and letting the negative thoughts fade away.

Take another deep breath and visualize yourself stepping into your painting. Immerse yourself in the colors and design of your art and imagine yourself becoming one with your creativity. Allow these positive feelings to fill you with a sense of purpose and pride.

As you step out of your painting, take these feelings with you; let them resonate for a moment. Remember that your art is uniquely yours and that the emotions it stirs cannot be replicated.

Take a deep breath in and exhale slowly. When you feel refreshed and returned to the present moment, open your eyes and take in your surroundings with a renewed sense of confidence and pride in your abilities and accomplishments.

LET'S GET STARTED!

Prepare your canvas for high-flow acrylic application by following the step-by-step instructions on page 27. Some people like to prep their canvas with Kilz latex primer before working with inks on canvas, but I skip this step—I prefer the way the ink looks soaked into the raw canvas rather than risking the brush marks that can be caused by priming it with latex primer first. But follow whatever method works best for you!

TOOLS & MATERIALS

- High-flow acrylic paint: 4 colors of your choice, plus white and black
- Alcohol ink: 2 colors of your choice
- Metallic alcohol ink: brass or gold
- Stretched canvas: 11" x 14" x 2" (28 x 35.5 x 5 cm)
- Fine-mist spray bottle
- Paint palette
- White chalk pastel pencil
- Paintbrushes: round-tip and fine liner
- 91% isopropyl alcohol or blending solution
- Fine-tip squeeze bottle
- Drying tool
- Small glass dish
- Pipette
- Paper towels
- Gloves
- Protective face mask
- Varnish

COLOR KEY

ALCOHOL INKS

- Peach Bellini (Ranger)
- Salmon (Ranger)
- Brass (Jacquard)

ACRYLICS

- Titanium White (Golden Fluid)
- Carbon Black (Golden Fluid)
- Turquoise (Phthalo) (Golden Fluid)
- Quinacridone Magenta (Golden Fluid)
- Naples Yellow Hue (Golden Fluid)
- Sap Green Hue (Golden Fluid)

1 **START WITH A LAYER OF ALCOHOL.** Drop alcohol down onto the canvas and spread it with an air tool to block out the area you'd like the ink to cover on the canvas. For this project, we are not filling the entire canvas with ink or paint. When working with canvas, I recommend putting alcohol down onto the canvas first or prediluting your alcohol ink colors so that the ink does not quickly absorb into the canvas and become difficult to move. See more info about this in the previous project (page 173).

2 **ADD INK TO CREATE A COLOR WASH.** Create a controlled wash of color within your designated zone using the wet-on-wet blending technique and your air tool. Include some metallic ink with your colors. Make sure to leave some negative space around your ink wash; this will create a frame of white around the dried ink. If any of the ink sinks into the canvas and isn't spreading, use a finger to rub and blend it out. Allow this layer of ink to dry.

3 **CREATE A MOCKUP OR SKETCH.** If you have a tablet, take a photo of your existing piece now to use as a starting point to create a digital mockup of the artwork you're going to create on the canvas. You can also use a smartphone and an editing app for a quick and simple mockup. The idea is to give yourself some structure and specify where you'd like foreground elements to go. Try an app such as Procreate, or use tracing paper to do a sketch by hand, or just go for it without a mockup!

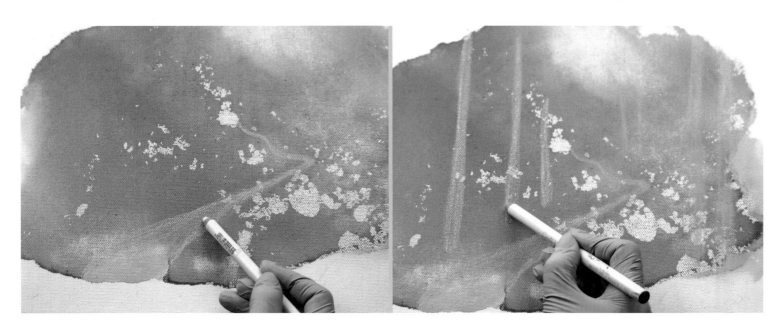

4 SKETCH THE TREES AND RIVER. Using a white chalk pastel pencil, roughly sketch where you'd like the birch trees to go. Birch trees have long, thin trunks. You want the larger, taller trees to be in front and the smaller, shorter trees to be in the back. See if you can find an area where a water source or path might wind through your composition. If the path is coming toward you and you want the impression that you are walking into the canvas, make the path wider at the front and have it taper off as you move up the canvas. You can use where you place your trees to determine this, or you can place the water source or path first to help you determine where the trees go. Either way is fine!

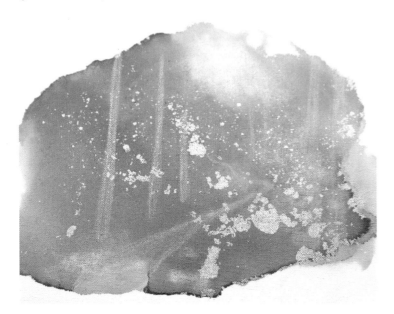

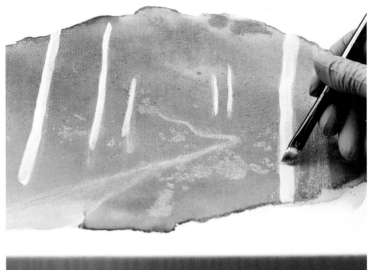

5 ADD METALLIC SPATTER. Using metallic alcohol ink, a small glass dish, and a pipette, add golden sprinkles to the tree and "sky" area (not along the bottom waterway or path). Follow the technique outlined in previous projects (see pages 93 and 117).

6 START PAINTING THE TREES. Put some white fluid acrylic paint in a paint palette and paint over the sketched trees. If you are nervous about painting the trees freehand, try using painter's tape to demarcate the trunk first. The first layer of paint will be a bit translucent, but don't worry—we will build up the paint through the next few layers.

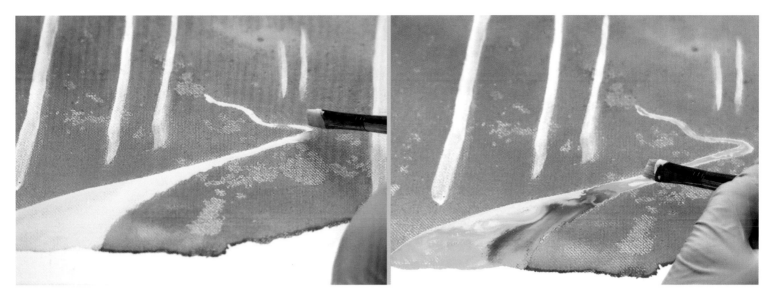

7 PAINT THE RIVER. While the first paint layer on your trees dries, mix the colors for your waterway or path. I mixed turquoise and white to create a stream; you could use brown or green to create a path. Adding white to your paint will brighten the colors and create dimension in your objects, especially if you are using darker base colors. To create the stream, start with a mixed blue and a little water for the first layer, then go in with pure turquoise and water on top of that, while the previous layer is still drying—a wet-on-wet technique. A little paint goes a long way here.

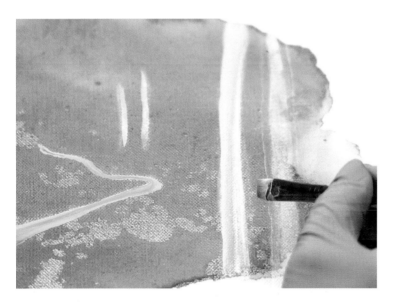

8 ADD A GRAY LAYER TO THE TREES.
Completing the painting of the trees will take multiple steps and layers. First, go in with another layer of white until the trees are no longer translucent. Then, using white mixed with the tiniest touch of black in your palette, paint a light gray stripe down each tree.

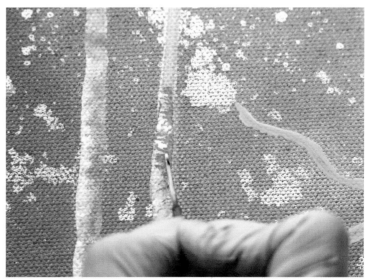

9 PAINT DETAILS ON THE TREES. Go back in with white and/or light gray to add a second, more detailed layer to the trees. Paint short horizontal lines and blocks that blend with the existing trunk to create textured striations like in real birch trees. Think about where your light source is coming into your painting— wherever the light is hitting the trees is where the lighter areas should be, and wherever is shadier should be darker.

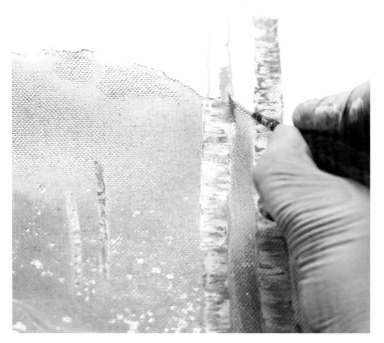

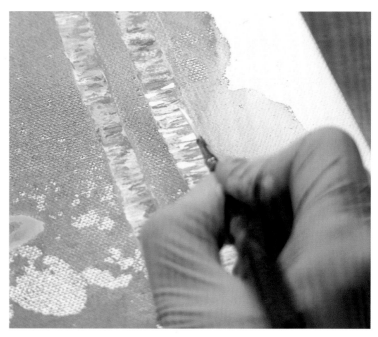

10 EXTEND SOME OF THE TREES. If desired, you can extend some of the foreground birch trees past the edge of the painted background and all the way off the edge of the canvas. This creates a strong dimensional effect that invites the viewer into the scene. I chose to extend the foremost trees not only at the top but also at the bottom (see photo at bottom right).

11 ADD MORE WHITE TO THE FOREGROUND TREES. To emphasize the difference between the foreground and background even more strongly, go back in one final time with white to add highlights to the foremost trees.

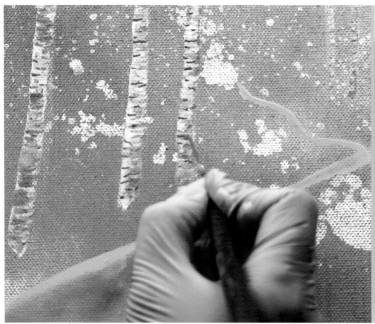

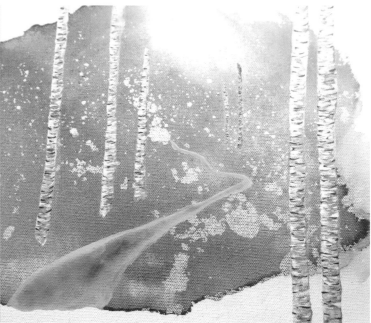

12 FINISH DETAILING THE TREES. Once all previous paint layers have dried, mix a slightly darker gray and create more-defined horizontal hash marks on all the trees. Refer to photos of real birch trees for guidance.

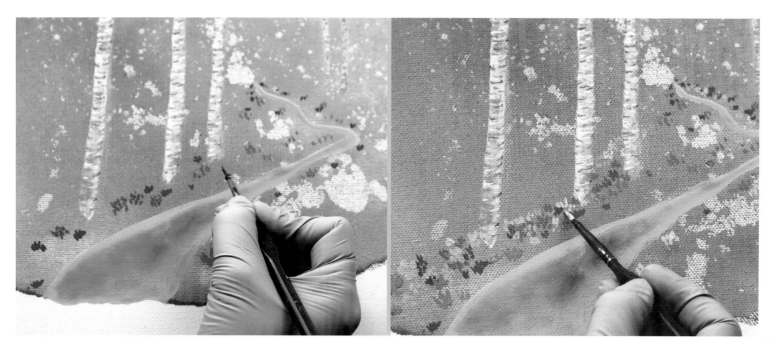

13 PAINT THE FLOWERS. Now it's time to add in the flowers! Add your flower colors to your paint palette. I am using yellow, magenta, and white. I always have a little water in my palette too to help the paint blend more smoothly. Mix the magenta and white to make pink. To create impressionistic flowers, paint clusters of abstract petal marks throughout the trees. Remember: the more in the foreground the flowers are, the larger they should be. Use different brushstrokes and floral shapes. Mix a few different shades of lighter and darker pink as you go, continuing to add flowers until it starts to look like a lush field of blooms. Add some yellow flowers too.

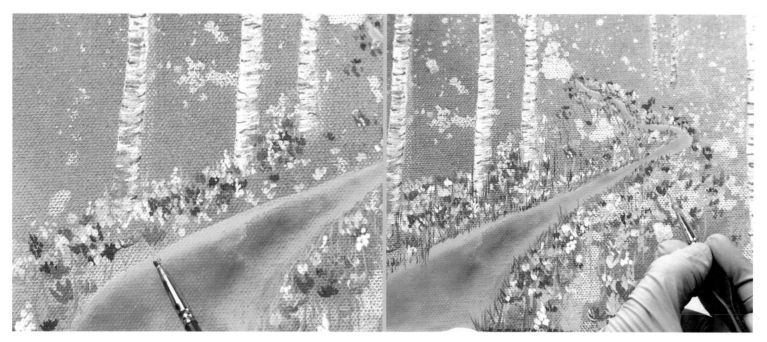

14 PAINT THE GREENERY. Mix green and white, then add in impressionistic strokes that resemble greenery scattered among your flowers. Flowers have stems and leaves, and grasses exist along the banks of streams and paths. Mix and use several shades of lighter and darker green. Use your imagination to add green strokes throughout to create the illusion of a forest floor. And don't be afraid to let some greenery spill over into the water and path!

FINAL REFLECTION

You've completed the final project of the book.
You may be thinking, now what?

Now it is time for you to spread your creative wings and begin the journey of integrating everything you've learned into your own regular creative practice. All the projects we've done in this book were meant to be repeated and practiced over and over, each time giving you a different flow and result. Come back to the text and tutorials for reminders when you're feeling overwhelmed, blocked, or intimated by the process. No one is expected to learn and integrate everything the first time. As I've said many times, it takes practice and consistency for something to flow naturally. If you feel called to, flip back through your studio journal to see how far you've come. Give yourself a huge pat on the back, because choosing to follow a creative path is a major act of bravery and self-love in a world that tries hard to grind us down and burn us out.

Keep going on this journey. You are an artist. I am so proud of you.

What do you notice when you compare your mindset going into the last project versus the first exercise? What is the same? What is different?

What excites you most about the future of your creative journey?

What are your wildest dreams when it comes to creating?

INDEX

Note: Page numbers in **bold** indicate exercises. Page numbers in *italics* indicate projects.

Jessica Young, M.Ed, LMHC, is a multidisciplinary contemporary artist working with a focus in intuitive abstract expression using fluid mediums and epoxy resin. Entirely self-taught, Jessica began painting professionally in 2017 as a way to balance her own mental wellness. Since then, her work and process have captivated millions on social media. Outside of art, Jessica is a passionate healing practitioner and licensed psychotherapist. She carries two degrees in clinical psychology, currently runs her own psychotherapy private practice, and specializes in trauma and mood disorders. She is also a creative mental health coach, meditation guide, certified Reiki healer, and the founder of @healingartretreats.

BETTER DAY BOOKS®
HAPPY • CREATIVE • CURATED

Business is personal at Better Day Books. We were founded on the belief that all people are creative and that making things by hand is inherently good for us. It's important to us that you know how much we appreciate your support. The book you are holding in your hands was crafted with the artistic passion of the author and brought to life by a team of wildly enthusiastic creatives who believed it could inspire you. If it did, please drop us a line and let us know about it. Connect with us on Instagram, post a photo of your art, and let us know what other creative pursuits you are interested in learning about. It all matters to us. You're kind of a big deal.

it's a good day to have a better day!

www.betterdaybooks.com
better_day_books